IMAGES
of America

ORACLE AND THE
SAN PEDRO RIVER VALLEY

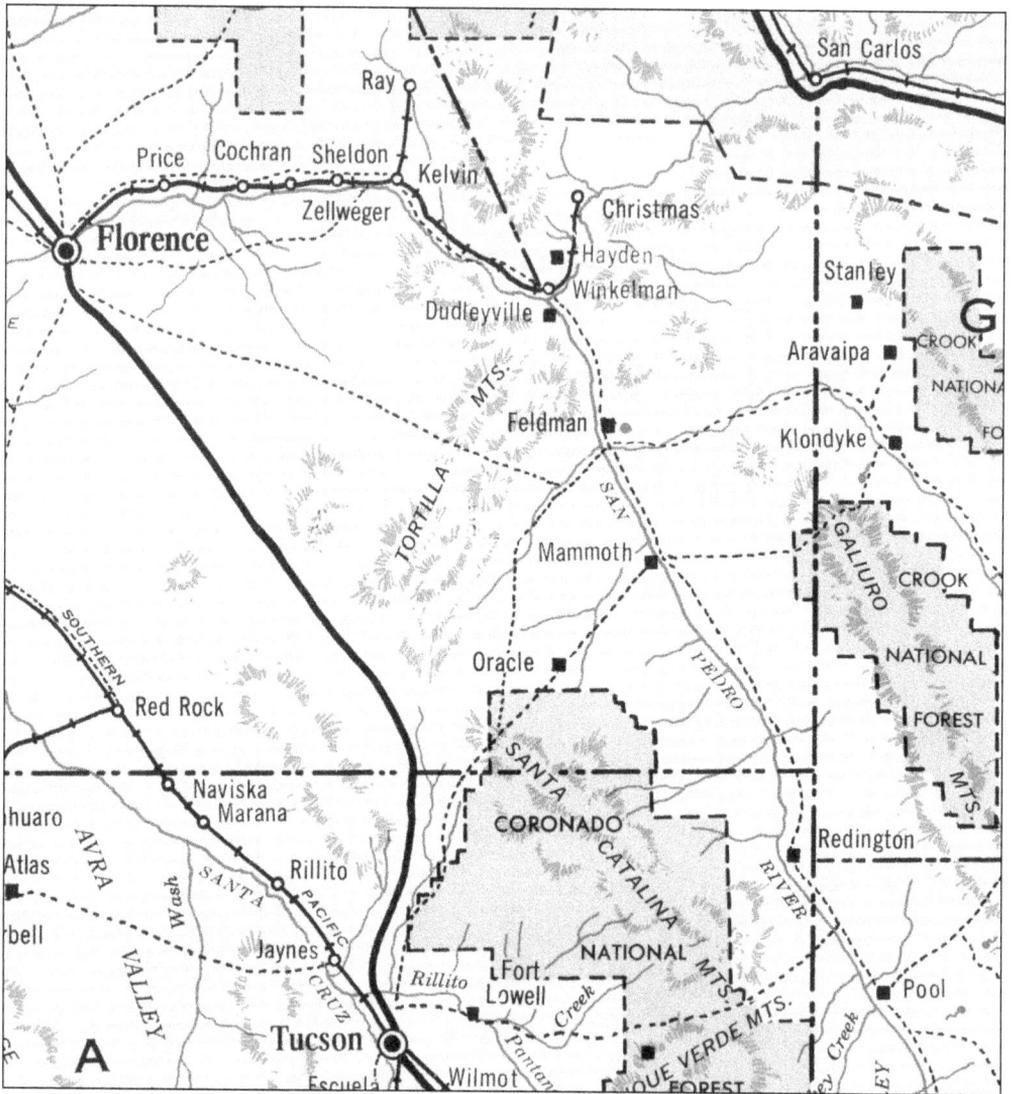

This 1912 map, covering the area from Florence to Tucson and east to the Galiuro Mountains, shows the towns of Oracle, Redington, and Mammoth. San Manuel is, of course, a much younger town and therefore not on the map. It lies directly east of Oracle, almost to the San Pedro River. (Catherine H. Ellis.)

ON THE COVER: During a 1922 visit to Oracle, friends of the Gilliland family pause for a photograph on the rocks. These large boulders are part of an extensive granite mass on the North Slope of the Santa Catalina Mountains. The Oracle granite (quartz monzonite) is pre-Cambrian and is the oldest rock in the area. (Arizona Historical Foundation Gill-809.)

IMAGES
of America

ORACLE AND THE
SAN PEDRO RIVER VALLEY

Catherine H. Ellis

Arizona Historical Foundation

ARCADIA
PUBLISHING

Published by Arcadia Publishing
Charleston, South Carolina

Library of Congress Catalog Card Number: 2008921011

For all general information contact Arcadia Publishing at:
Telephone 843-853-2070
Fax 843-853-0044
E-mail sales@arcadiapublishing.com
For customer service and orders:
Toll-Free 1-888-313-2665

Visit us on the Internet at www.arcadiapublishing.com

To David Ellis, the best companion and critic

CONTENTS

ACKNOWLEDGMENTS

Of all the people who lived in Oracle during the 1920s and 1930s, more photographs were saved and archived from the Charles Gilliland family than any other (about 1,000 images at the Arizona Historical Foundation [AHF] in Tempe). Ironically, very little is known about this family. The Gillilands spent their winters in Oracle as early as 1914 and their summers in Pennsylvania, where they were associated with Aberfoyle and Galey and Lord, textile manufacturers. In 1914, Hyrum V. Smith stated that Aberfoyle "manufactures fine novelty wash goods and shirting and does yarn mercerizing and dyeing." The business gave "steady employment to 1,000" people. Aberfoyle pioneered the manufacture of "artificial silk," or rayon, and the mercerizing of cotton thread in this country. Mercerizing treats cotton with caustic soda to strengthen the thread, provide luster, and make it more receptive to dyes.

The Gillilands built Rancho de los Robles and St. Helen's Catholic Church in the 1920s. In 1925, Charles Gilliland purchased the Phoenix Date and Citrus properties, renaming them Gilliland Groves, and became one of Phoenix's leading date producers. In 1936, he moved permanently to Phoenix. Although many of the people in these photographs are unidentified, the images provide an interesting glimpse into life in Oracle and the San Pedro River Valley.

Other important sources of photographs were the Oracle Historical Society (OHS), the Arizona Historical Society at Tucson (AHS-Tucson), and the San Manuel Historical Society (SMHS), including many Magma Company photographs, which were donated by BHP Billiton (SMHS/Magma/BHP). I also wish to thank all the individuals who have graciously shared images. Photographs without credits are from the collection of the author. References for each chapter are deposited with the Oracle Historical Society.

Many local residents generously shared information and rare books, particularly Ethel Amator, Evaline Auerbach, Linda Bingham, Marcia Black, Steve Brown, Frank Madrid, Juanita McLennan, Reg and Gloria Ramsay, Pauly Skiba, Chuck Sternberg, and Onofre "Taffy" Tafoya. Emily Düwel and Chuck Sternberg of the Oracle Historical Society and Janis Rapp and Mike Vos of the San Manuel Historical Society were most helpful. Karina Wilhelm and David Ellis read the manuscript and provided useful comments. Jared Jackson was always encouraging and helpful with difficult photographs. Thanks to all.

INTRODUCTION

Oracle has six buildings on the National Register of Historic Places—a large number for such a small town. American Flag Ranch was constructed in 1875 and housed the first post office. Acadia Ranch, also built in 1875, was used as a hotel, post office, and sanatorium and is now home to the Oracle Historical Society. The buildings at Rancho Linda Vista, originally a working ranch, were erected in 1900; the site now operates as an arts community with regular shows at the Barn Gallery. The All Saints Church (now Oracle Union Church) was built through the cooperation of community members in 1901. It is still used for nondenominational church services every Sunday. The Kannally Ranch House, built in 1925, currently serves as the headquarters of Oracle State Park. Finally, La Casa del High Jinks was constructed by William "Buffalo Bill" Cody's foster son Lewis "Johnny" Baker in 1925. Writer Dean Prichard lovingly restored High Jinks in the 1980s.

Situated in the foothills on the north slope of the Santa Catalina Mountains, the town of Oracle is nestled amid live oaks and huge granite boulders. The land to the east drops down into the San Pedro River Valley. East of the San Pedro River are the Galiuro Mountains. Both massifs are representative of the basin-and-range topographic feature: mountain islands in a sea of desert.

The earliest inhabitants in historic times were the Sobaipuris, who were farming the valley when Fr. Eusebio Francisco Kino came through in 1692. With the arrival of the Apaches, the Sobaipuris moved to Tucson and Mexico. The Apaches were nomads, making their living by raiding more peaceful tribes, especially the Tohono O'Odham and Pimas. These raids later included the Mexican population of Tucson and then Anglo Americans. The federal government tried to confine the Apaches to reservations in the 1860s, and Camp Grant, at the mouth of Aravaipa Creek, was constructed to oversee the Aravaipa Apaches settled nearby in their wikiups.

Anglo settlement of Oracle began with numerous mining claims. Albert Weldon, a Canadian, named his mine the Oracle after his uncle's ship. Colorful names such as Geesman, Bonito, Leatherwood, Apache Camp, American Flag, Southern Belle, Peppersauce, and Maudina were given to the mines, and the prospectors planned on becoming rich. Only a few actually did. The Bonito Mine is noted not for its ore but for its famous owner: Buffalo Bill Cody. Cody purchased shares in this mine about 1910, and the newspaper reported him saying, "I am now mining in Arizona, forty miles north of Tucson." When the riches did not materialize, Cody investigated, found little ore present, and left the area. In the early 1950s, the Magma Copper Company bought many mining claims, contracted with Del Webb to build a town, and opened the San Manuel Mine. It became the largest underground copper mine in the country and operated for 50 years.

Huge cattle ranches began along the San Pedro River; to the south was the Bayless and Berkelew Ranch, and to the north was the Joseph L. Clark Ranch. Clark was born in England and sailed to San Francisco about 1875. He came to Arizona and worked at the Silver King Mine as a tool sharpener and then a paymaster. With a move to Mammoth, he homesteaded a ranch along the San Pedro River. In the spring of 1880, Clark traveled to Texas and returned with 100 head of longhorn cattle. Cattle were limited by scarce water and sparse grasslands, and the ranges were

overstocked. Charles Bayless was one of the few who realized that many of the ranching problems were due to overstocking the ranges. He also understood that with the elimination of the beaver, the river was more susceptible to flooding. Today beaver are coming back, particularly along the upper San Pedro River and upper Copper Creek.

All people—miners, ranchers, wealthy winter visitors, and tuberculosis patients alike—recognized the stark beauty of the deserts and the beautiful panoramas of the mountains. Today Aravaipa Canyon is a world-renowned wilderness area, and Mammoth's flowers have become part of wildflower tours. Oracle's arts community brings visitors from around the world. Boy Scouts come to explore Peppersauce Cave, and retirees stop to tour Biosphere 2. The present day allows for comfort, but in 1873, Arizona offered only hardship. The following anomymous poem titled "Arizona Landscape," which was published in the book *The Image of Arizona*, helps illustrate the problems faced by the original pioneers:

> The stinging grass and thorny plants
> And all its prickly tropic glories,
> The [dark-skinned] starved inhabitants,
> Who look so picturesque in stories.
>
> The dusty, long, hot, dreary way,
> Where 'neath a blazing sun you totter,
> To reach a camp at close of day
> And find it destitute of water.
>
> The dying mule, the dried-up spring,
> Which novel writers seldom notice;
> The song the blood mosquitoes sing,
> And midnight howling of coyotes.
>
> Tarantulas and centipedes,
> Horn'd toads and piercing mezquit daggers,
> With thorny bushes, grass and weeds
> To bleed the traveler as he staggers.
>
> Why paint things in a rosy light,
> And never tell the simple fact thus—
> How one sits down to rest at night,
> And often squats upon a cactus?

One

LOS APACHES

The Spanish explorers who found Native Americans in the mountains of southern Arizona called them *Los Apaches*. Fr. Eusebio Francisco Kino's first trip down the San Pedro River was in 1692; he found *trinchera* (canals) enabling the Sobaipuris to use water from the river to grow *calabazas* (pumpkin or squash) and other vegetables. At harvest time, Apaches would raid this Pima tribe. The Spanish never felt comfortable (meaning safe from Apache raids) with mountains on both sides of the valley, so although Father Kino had given the Native American settlements Spanish names, the Spanish made no permanent settlements along the San Pedro River. In time, the Sobaipuris moved to San Xavier del Bac and Sonora.

An Athapascan-related tribe, the Apaches are relatively recent immigrants to southern Arizona, probably pushed south by the warlike Comanches. By the early 1700s, Spanish maps were labeling the Chiricahua, Pinaleño, and Galiuro Mountains as Apacheria.

The Apaches grew some food but mainly raided other tribes, making them immediate enemies of the Tohono O'Odham and Pimas. Mexicans confederated with the more peaceful tribes and became fierce enemies of the Apaches also. In Sonora, a scalp bounty law was established in 1835; professional killers hunted Apaches for the bounties. As Anglo American fur trappers and adventurers came to Arizona in the 18th century, this Mexican-Apache conflict simply transferred. The Apaches developed a reputation of fierceness, which, coupled with a desire by many Americans for their extermination, made a peaceful outcome of the conflict unlikely. In 1889, historian Hubert H. Bancroft wrote, "If any of these parties is to be blamed on the whole, it is not the citizens, the military, the Apaches, or even the newspapers and Indian agents, but the government, for its half-way measures, its desultory warfare, and its lack of a definite policy, even that of 'extermination,' which is sometimes attributed to it."

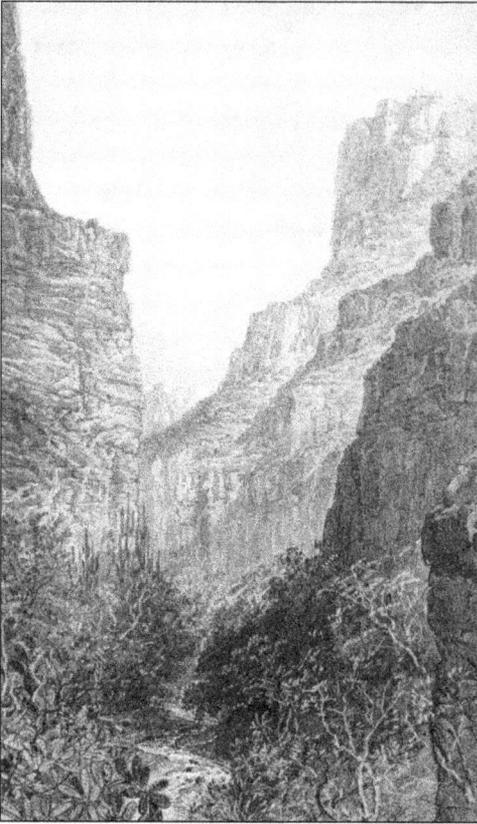

At the north end of the San Pedro River Valley is Aravaipa Canyon, a cut in the Galiuro Mountains east of the river. The lithograph (pictured left) of the canyon, drawn from a photograph in 1870, is reminiscent of the heroic proportions of Thomas Moran's art. However, slot canyons 6 feet wide and 100 feet deep (and 300 feet wide and 800 feet deep) really do exist in the Galiuros. Below, Charles Gilliland's friends visit one such canyon in the mid-1920s. (Left, lithograph by William A. Bell; below, AHF Gill-291.)

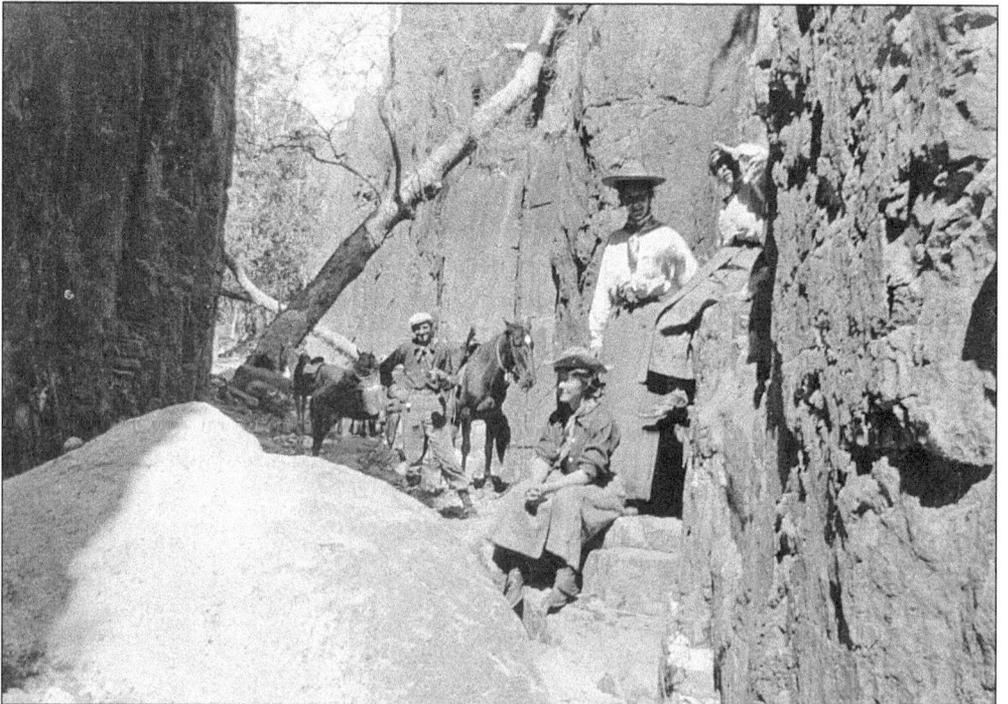

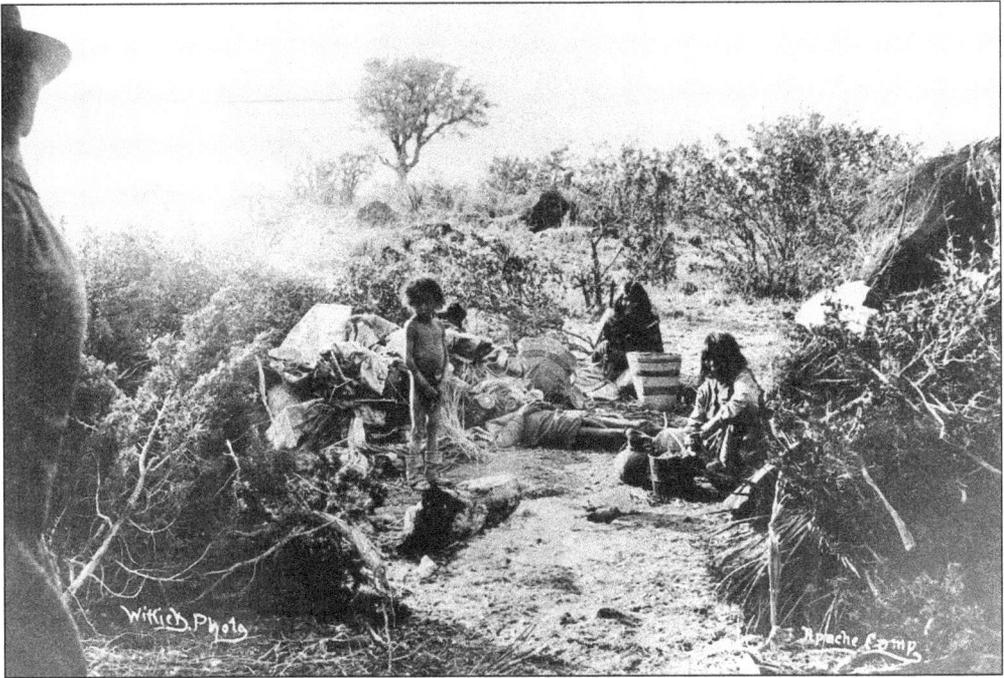

When the Spanish and Anglos first arrived, various Apache tribes were using nearly one-quarter of present-day Arizona. The Tonto, Pinaleño, Coyotero, and Aravaipa bands were part of these Western Apaches. Their camps, called *rancherias*, were scattered villages at permanent agricultural sites, though the Apaches produced only limited crops. These photographs bear the signature of Ben Wittick, who operated out of Albuquerque, but they may have actually been made by A. Frank Randall, who had a studio in Willcox. The setting for these camps seems to more closely fit the San Pedro rather than the White Mountains, and attribution for Wittick's Apache photographs is in question. (Above, AHF ZO-40; below, AHF ZO-39.)

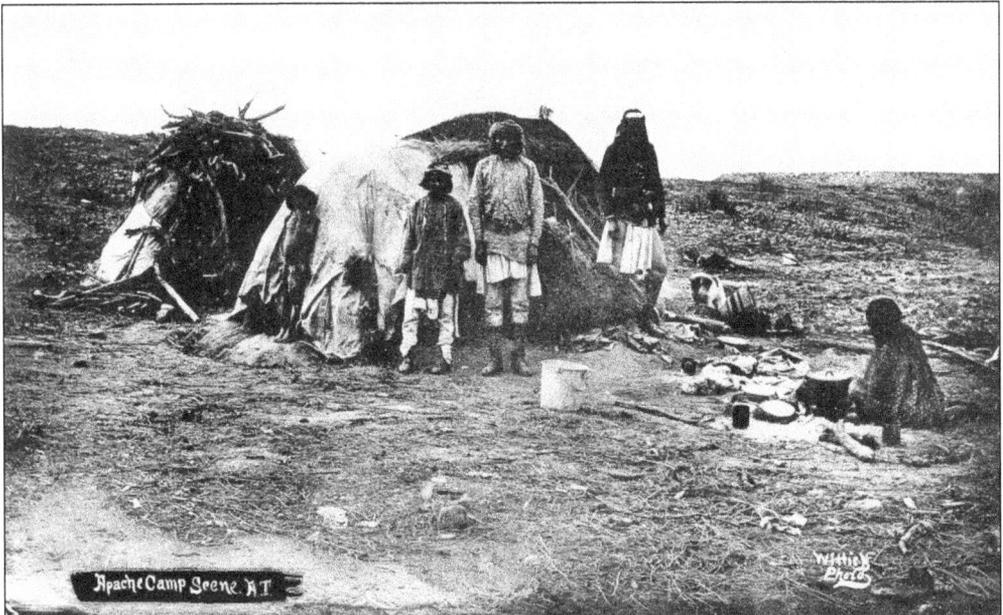

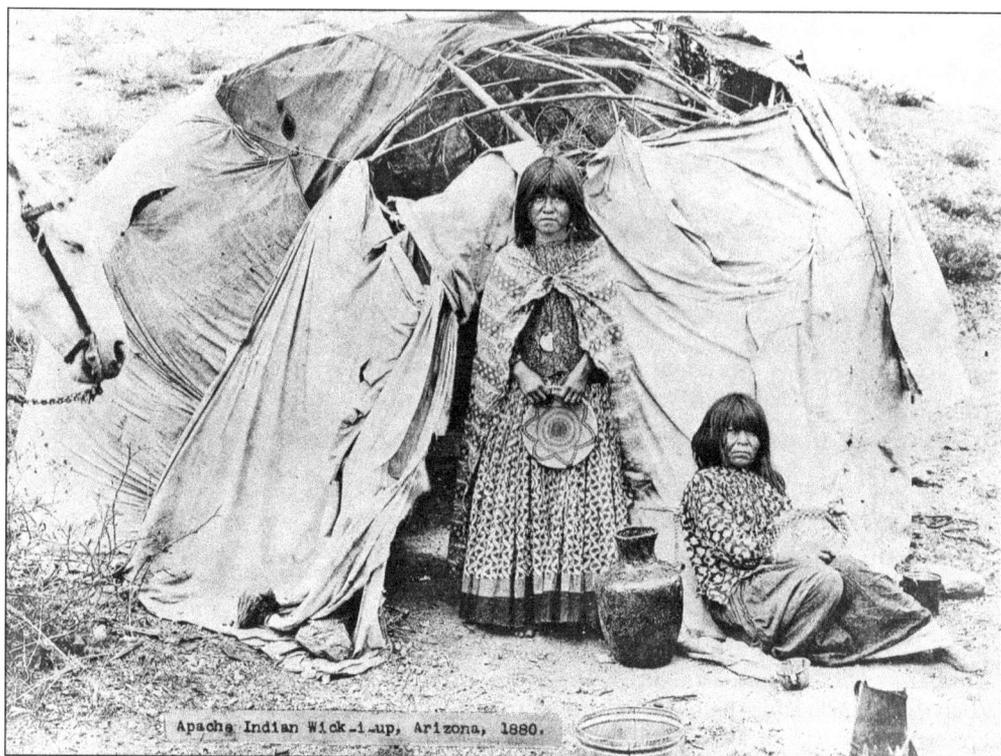

Apache Indian Wick-i-up, Arizona, 1880.

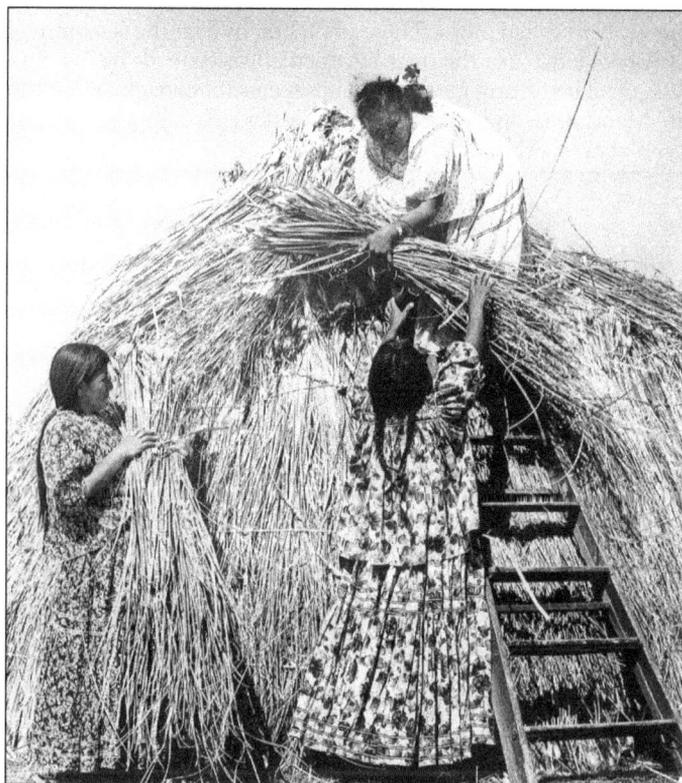

The traditional Apache home was a wikiup. Made of brush and often covered with skins or a tarp, these dwellings provided sufficient protection for the mild winters of southern Arizona. They also suited the lifestyle of the semi-nomadic people. Above, two Apache women pose in front of their wikiup in 1880. Note how the traditional ways have been combined with new instruments, especially the tin coffee pot, cup, and bucket sitting next to the clay pot and basket. Left, three Apache women use a ladder to construct their wikiup sometime in the mid-20th century. (Above, AHF IA-10; left, AHF IA-46.)

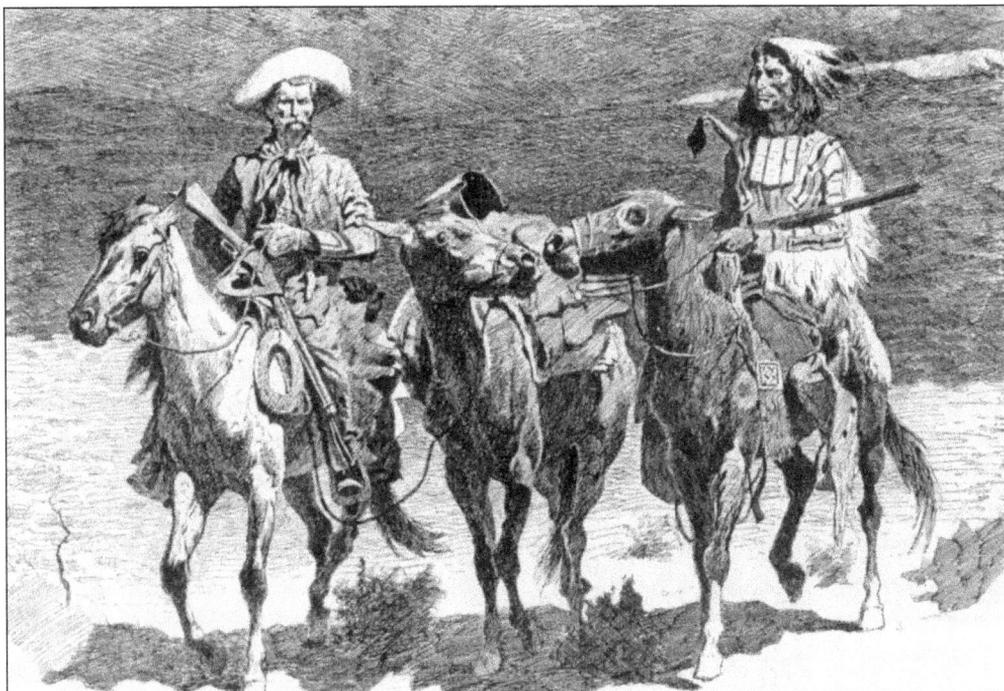

These Frederic Remington sketches illustrate Anglo attitudes toward Apaches in the late 19th century. Above, a prospector leads his pack horse, accompanied by a Native American guide, in a sketch titled "Questionable Company." Below, a lone Apache is poised to attack a wagon train in the Sierra Madre Mountains. Remington came to Arizona to document Geronimo's capture, but in reality, the Apache wars were ending when he published these illustrations. Oracle was the site of a May 26, 1870, Apache attack on a wagon train belonging to Hugh Kennedy and Newton Israel; two women, some children, and 21 men were killed. (Above, *Harper's*, May 1891; below, *Harper's Weekly*, August 9, 1890.)

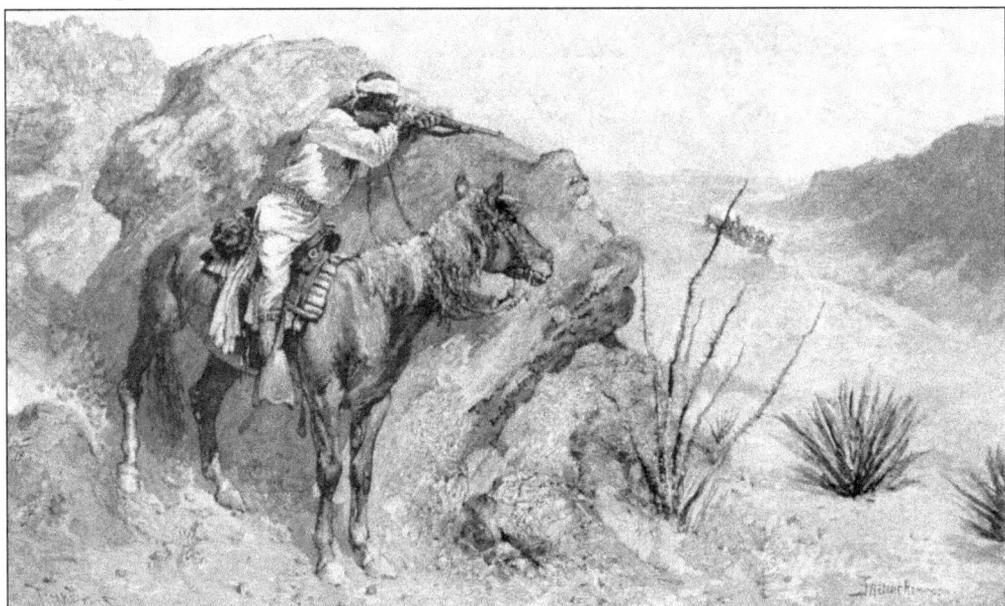

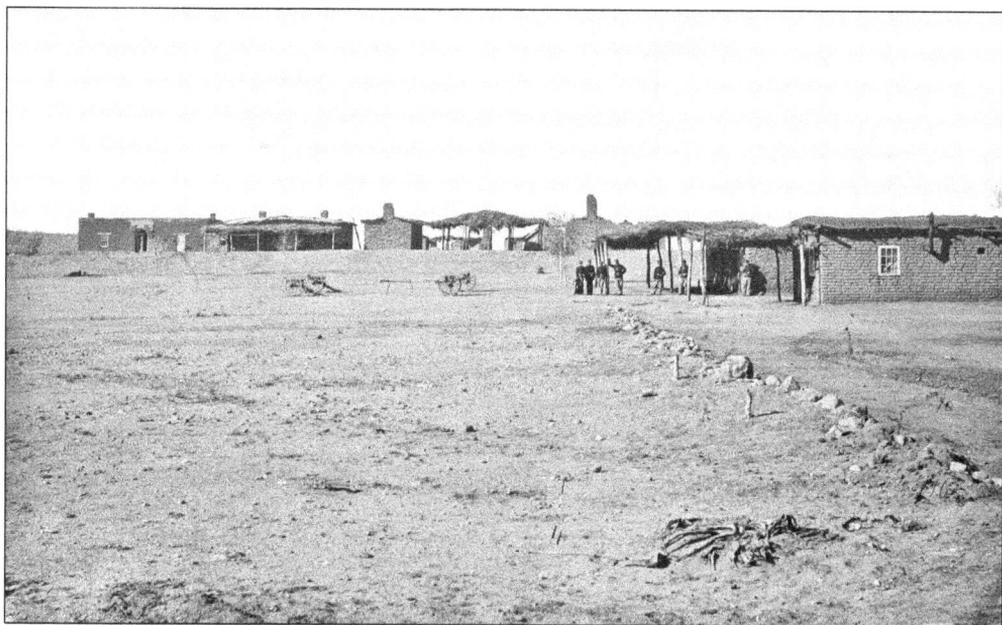

A military post was established at the mouth of Aravaipa Canyon in late 1859. In 1861, the post was burned when troops were withdrawn for Civil War service in the East. Old Camp Grant, as it was later known, was reestablished by the California Volunteers in 1862. Timothy O'Sullivan took this photograph in 1871 while serving as a photographer for the Wheeler Army Corps of Engineer expeditions. (National Archives 106-WB-100.)

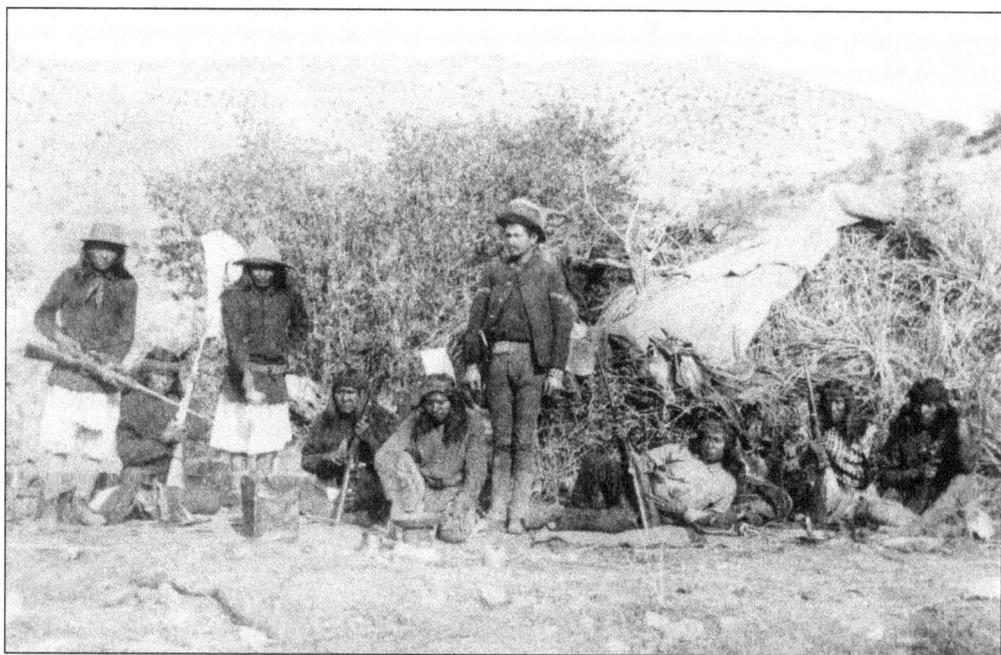

During the entire time of military conflict with the Apaches (lasting until 1886 when Geronimo surrendered the second time and was deported to Florida), some Apaches were peaceful and friendly to Anglos. Others were hostile and willing to raid both white ranchers and also the more peaceful tribes. These Apaches seem to be acting as scouts for the military.

Royal Emerson Whitman of Maine became Camp Grant's commanding officer in November 1870. The next February, five old Apache women, including the mother of Chief Eskiminzin, came asking for peace. Whitman gave them permission to resettle nearby, raise crops, and sell hay to the military. Whitman also provided rations—flour, sugar, coffee, corn, and meat. Eventually, over 200 Apaches settled near the fort. (AHF.)

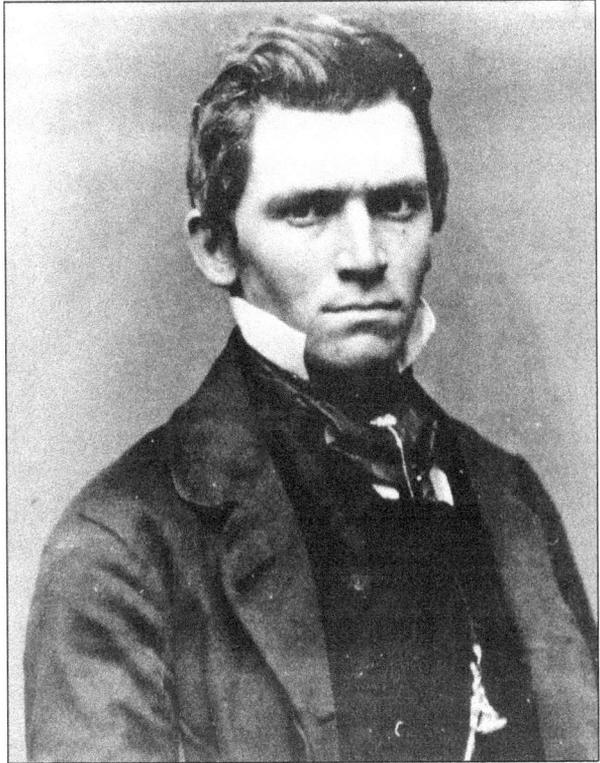

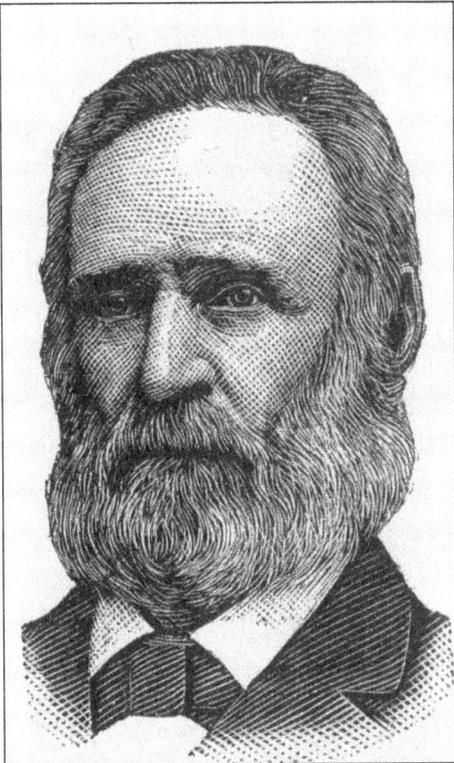

William S. Oury, a noted promoter of the Arizona Territory, came to Arizona from Texas via the California Gold Rush. He ranched with his brother Granville south of Tucson and urged Arizonans to join the Confederacy during the Civil War. Regardless of all positive virtues, today he is remembered for leading Tucsonians and Papagos to Camp Grant. (*The Image of Arizona.*)

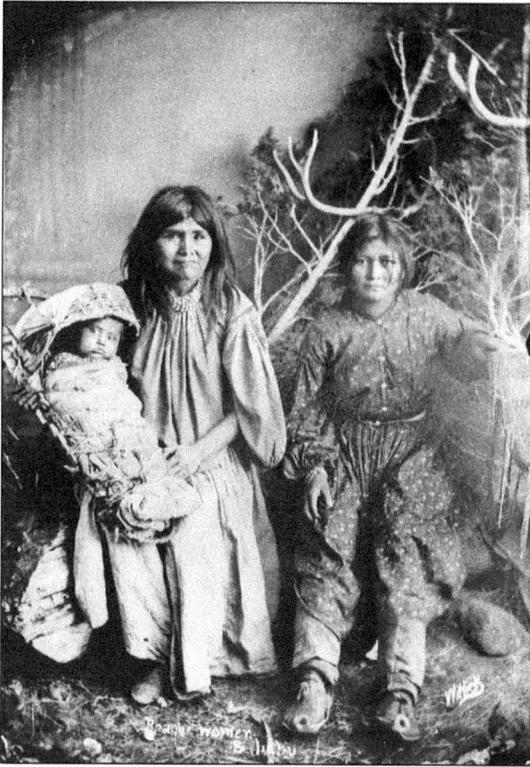

Camp Grant was the location of the worst massacre of Apaches. During the early morning hours of April 30, 1871, approximately 140 men (92 Tohono O'Odham, 42 Mexicans, and about 6 Anglos) from Tucson descended upon the Apaches camped near Aravaipa Creek. After less than an hour, more than 100 Apaches lay dead. Most were women and children like those pictured on the left; another 11 to 35 children were taken to be sold into slavery in Sonora. William S. Oury led the Anglos, while Jesus Maria Elias guided the Mexicans. More Anglos were likely involved; John H. Cady (below) always claimed to be part of the planning and massacre, but his name does not show up in any of the court records. In 1914, he wrote, "It was bloody work; but it was justice, and on the frontier then the whites made their own justice." (Left, AHF Z0-60, photograph by Ben Wittick; below, *Arizona's Yesterday*.)

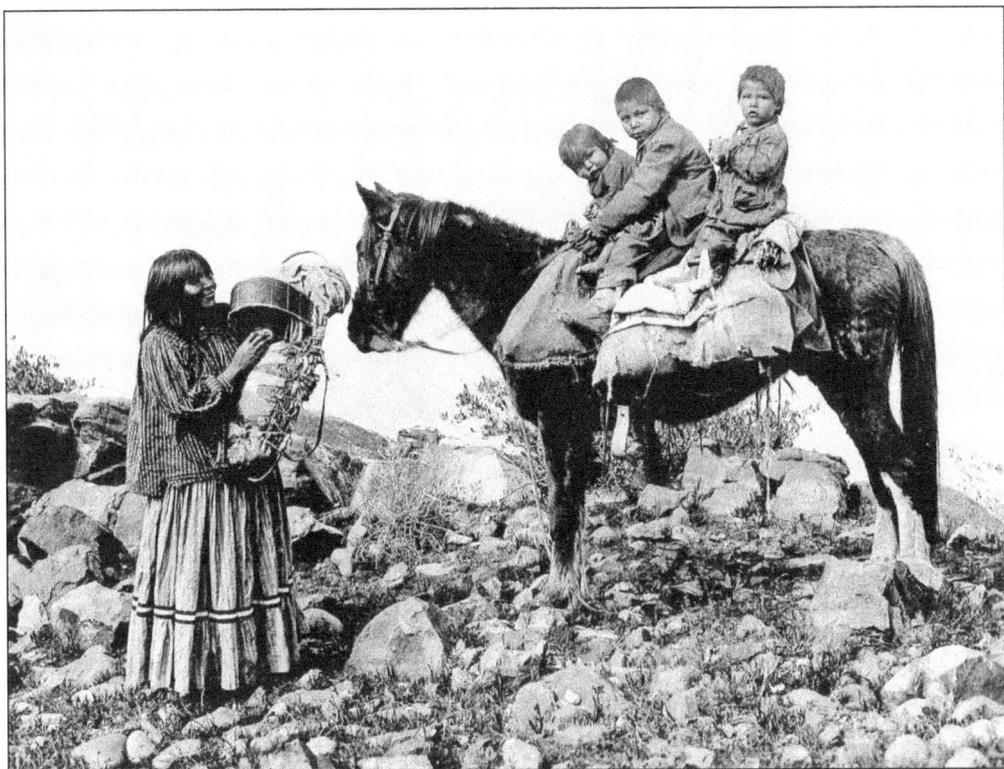

Most of the Apache men were away from Camp Grant on that fateful morning. In 1948, Richard van Valkenburgh published an oral history from an Apache named Lahn who was harvesting acorns near Oracle. Lahn said that "the screams of the dying ripped open the clear morning air" and woke Eskiminzin. As Eskiminzin rushed from his wikiup, "a Papago club crushed his head" but did not kill him. When he awoke, "the buzzards were beginning to circle." His wikiup "had not been burned. But before him on the ground lay the bodies of his young wives and their five children! Then from under a bundle of grass he heard the whimper of a baby. Bending over he pulled back the grass and picked up his only living child—the tiny Chita!" Lahn called the perpetrators "human wolves." An Apache woman is pictured above with her children. Right, Eskiminzin poses with two of his children born after the massacre. (Above, AHF IA-36; right, AHF IA-11.)

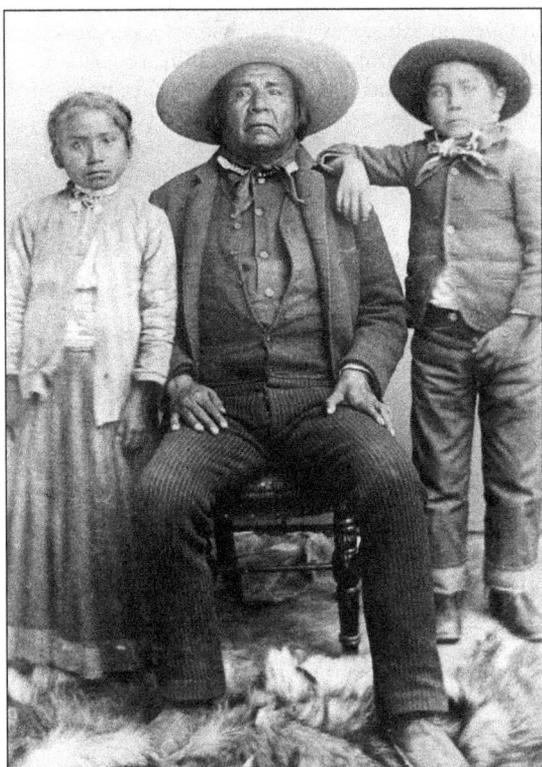

17

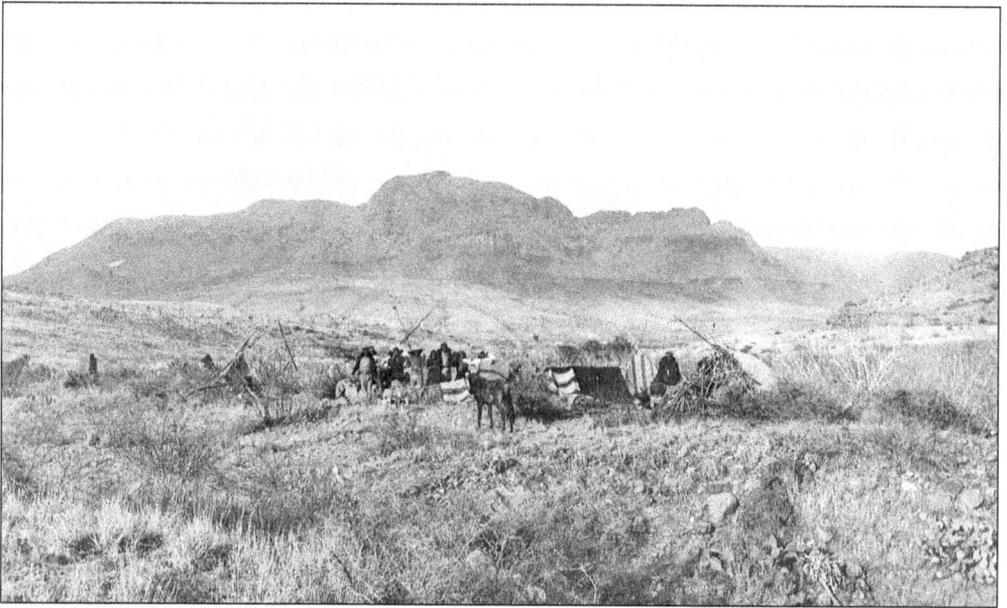

Whitman reported that when he received word of the attack, he "immediately mounted a party of about twenty soldiers and citizens, and sent them with the post surgeon, with a wagon to bring in the wounded, if any could be found." None were found alive. When people in the East heard of the massacre, they were horrified. Pres. Ulysses S. Grant told Gov. Rawghlie Stafford that the participants must be brought to trail. After the five-day trial, the jury deliberated a mere 19 minutes and exonerated the defendants. In December 1872, a reservation was established at San Carlos (above), and the Aravaipa people were persuaded to move there. The cavalry continued to patrol the Galiuro Mountains, and in 1887, the sketch below was made of cavalry in Copper Canyon east of Mammoth, who were there to protect mining interests. (Above, AHF IA-9; below, *The Image of Arizona.*)

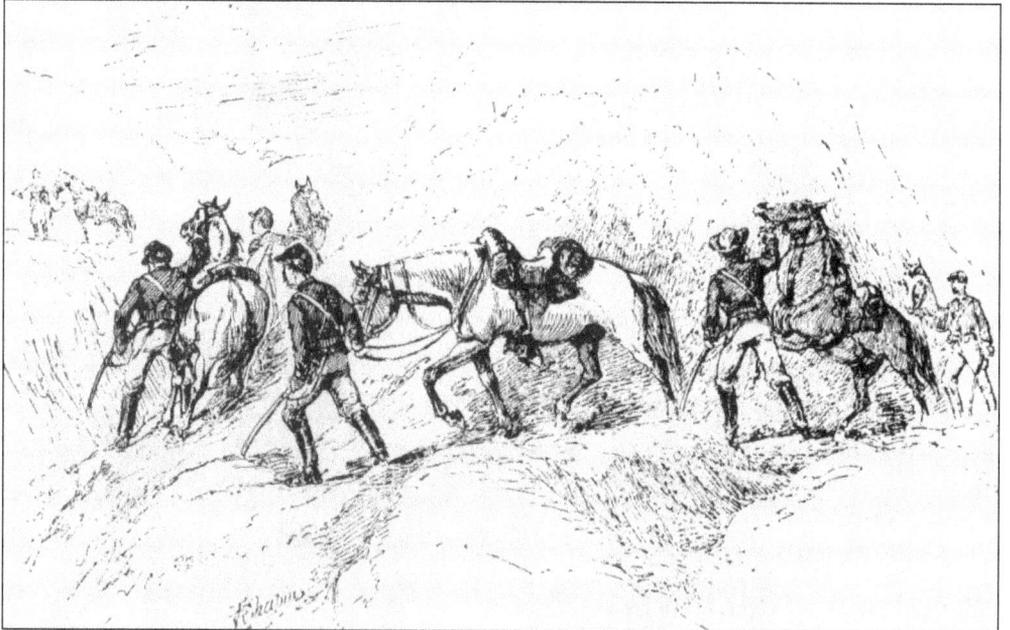

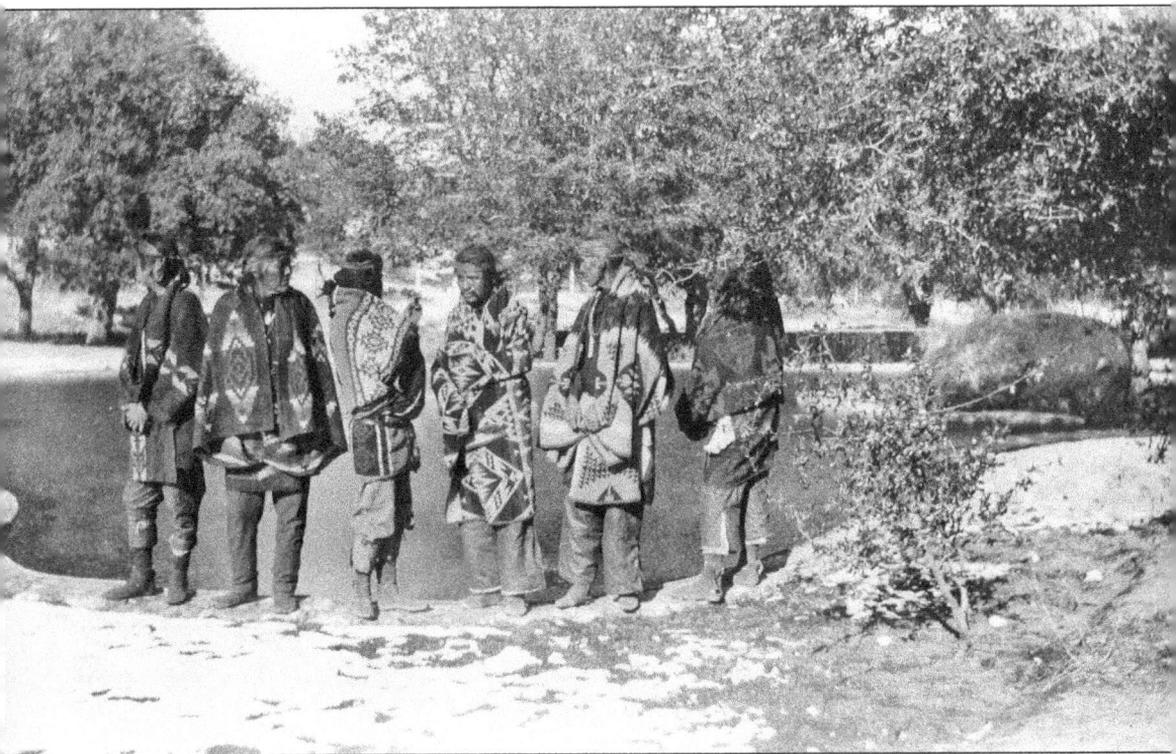

After Aravaipa Apaches were relocated to San Carlos, Apache Joe lived with his family in wikiups west of Oracle. He worked for Lavinia Steward. Elizabeth Lambert Wood wrote, "Often he had company from the San Carlos Reservation. In fact during the fall when bellotas, the small sweet acorn of the black oaks, were ripe, as many as a hundred Apaches rode over to camp in Cherry Valley and in other oak groves till the harvest was over." In 1901, *tiswin* (a fermented drink made from corn) and reservation friends proved Apache Joe's undoing. Making a ruckus when drunk ("every sober person thought at least a dozen victims were being murdered in cold blood"), he was no longer welcome in Oracle; today a street is named after him. Here Apaches gather at the duck pond at Rancho Robles about 1920. (AHF Gill-1010.)

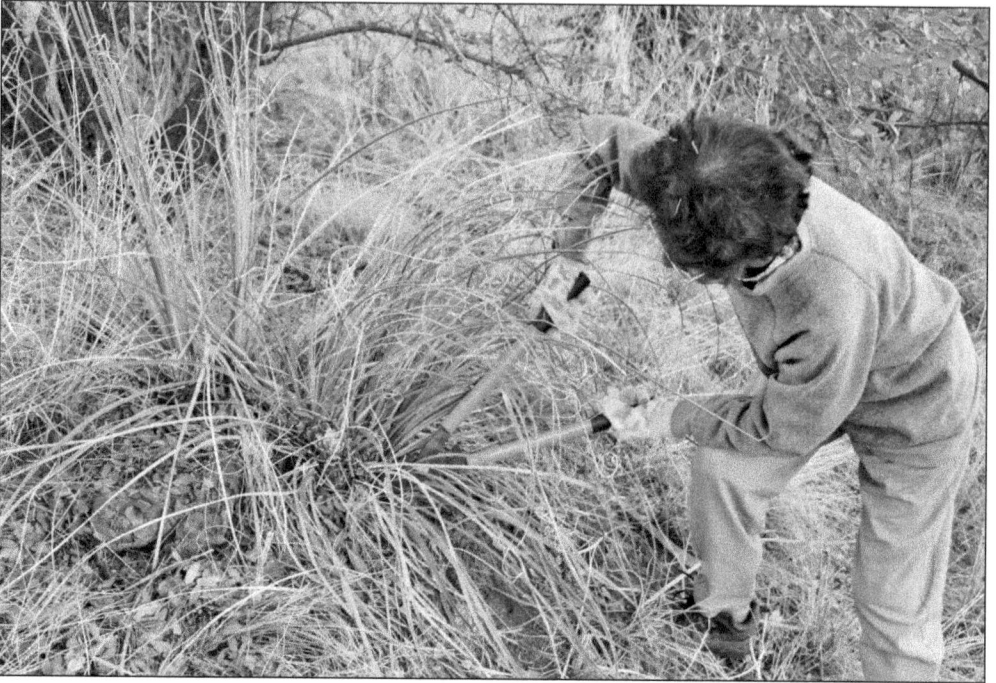

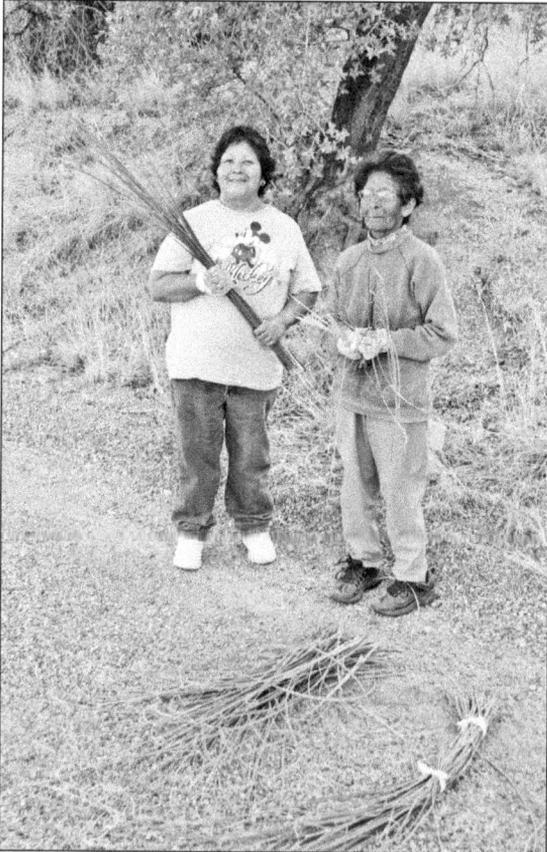

In November 2007, Kathryn Conde (above) and her daughter Charlene (pictured on the left with her mother) came to Oracle to cut bear grass for baskets. These Tohono O'Odham women live at San Isidro near Sells. When Conde was about 12 years old, she asked her mother to teach her how to weave baskets, and she has been making them now for more than 60 years. (Photographs by David Ellis.)

Two

THE MINES

An expert on Americana subjects, John Grafton wrote, "Nothing died harder in the Old West than the dream that there was a fortune to be made in the rocks just over the next hill." This could be said of lone prospectors, finance companies from as far away as London, England, and local businessmen who ran the mines.

Mining ventures in Arizona started in the late 19th century, later than in other states, for at least three reasons. The first was Native American depredations, especially from Apaches. Georgia had simply moved Native Americans west; California had killed most; and Montana, Alaska, and South Dakota had experienced only a few brief skirmishes. To the Apaches, however, raiding was simply a way of life, and miners often justifiably feared for their lives.

The next problem was transportation; railroads came late to Arizona because of the harsh, arid desert and the topography. Finally, ore in the Southwest was extremely complex, necessitating industrial expertise and machinery to extract it. Many claims were never worked until substantial backing was found. As Rossiter Raymond wrote in 1875, "At present only such gold and silver lodes as would elsewhere be considered surprisingly rich can be worked to advantage, and scores of lodes that would pay handsomely in California or Colorado are utterly neglected, while the great copper interests of the Territory (for copper is nowhere more abundant or of greater purity) are for all practical purposes without value."

Large-scale gold and silver mining finally came with the discovery of silver at Globe in 1876. By 1882, Globe's silver mine had become a copper mine, and copper mining—both underground and open pit—was king in Arizona. Many of these copper towns were company towns; San Manuel was a company town for Magma Copper from 1953 to 1996. Both Oracle and Mammoth began, directly or indirectly, with mining ventures.

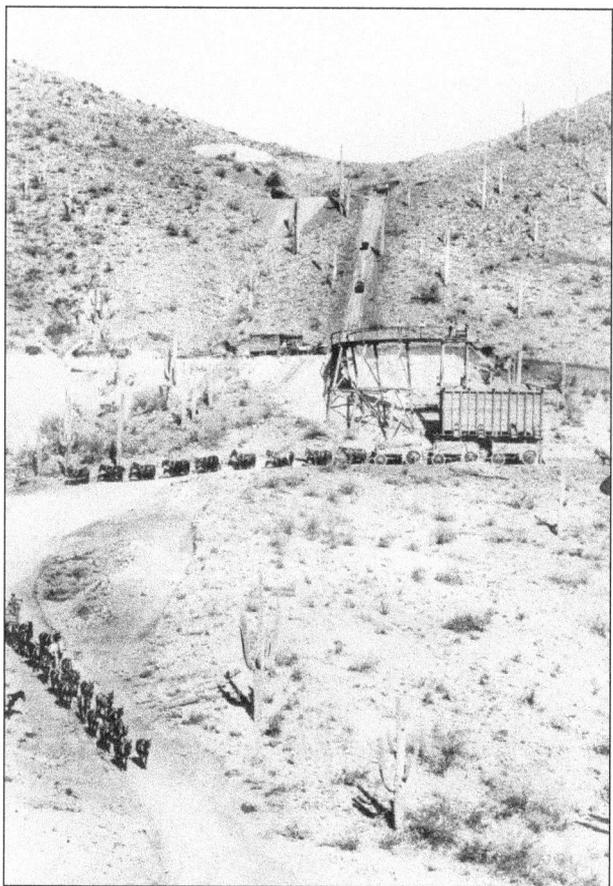

The first mining claim near Mammoth, the Hackney, was located by Charles Dyke and T. C. Weed in July 1879. This mine was operated by Frank Schultz, an Austrian immigrant, possibly as early as 1883. The site, eventually known as the Collins vein, was worked by surface cuts. In February 1882, Frank Schultz recorded the Mars and Mammoth claims. The photograph on the left, labeled 1891, may be the first image of the Mammoth Mine. Ore was transported to the mill by 18-to-20-mule teams hauling triple wagons. By 1884, the shaft was 118 feet deep and well timbered. Men, ore cars, and the horses that worked the mine pause for their picture (below). (Left, Reg Ramsay; below, ASU Libraries CP.SPC.226:3.)

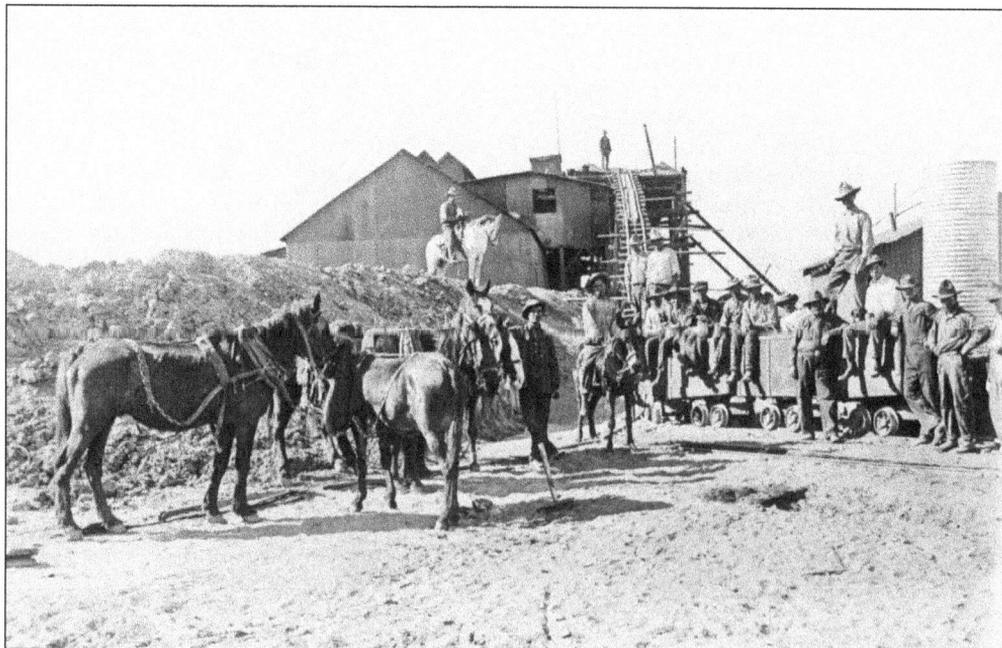

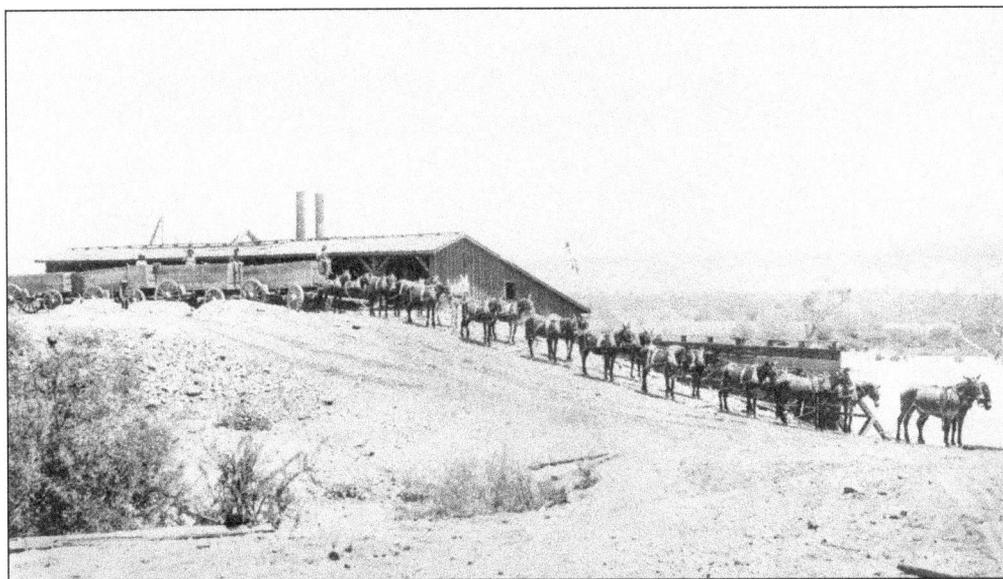

Unable to work the ore at the site, mine owners built a mill along the San Pedro River where water was available at a depth of 15 to 20 feet year-round. The first mill crushed 12 tons of ore per day, but according to Frank Murphy, "it was not put up right and was a failure." George Fletcher then purchased the fledgling mine in 1884 and hired Captain Johnson as manager. He constructed a 30-stamp mill about three miles from the mine, around which the town of Mammoth began to develop. Above, four wagons unload their ore, while below the mill is featured in a close-up. Both photographs were taken sometime between 1895 and 1915. (Both, Reg Ramsay.)

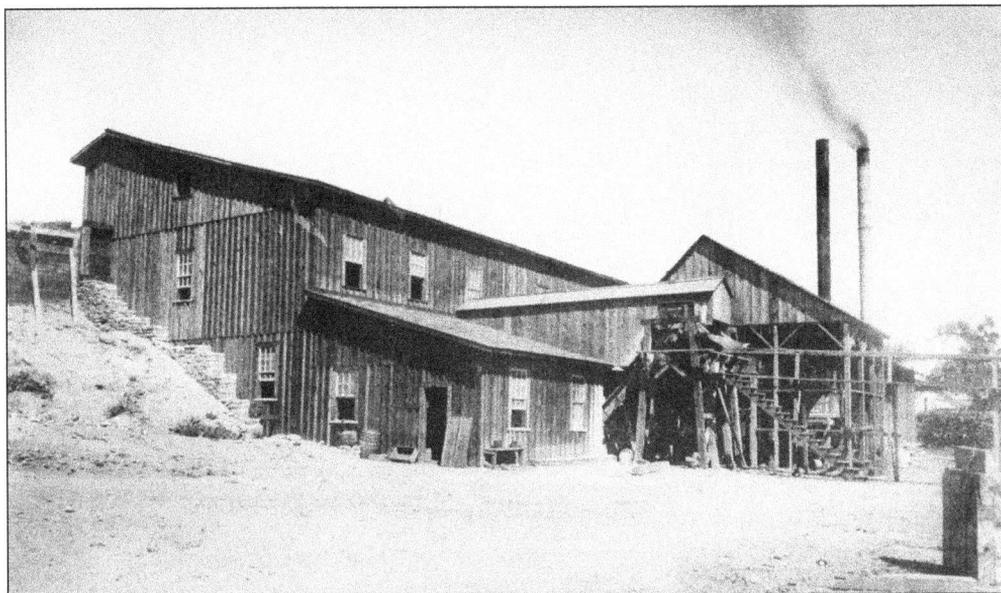

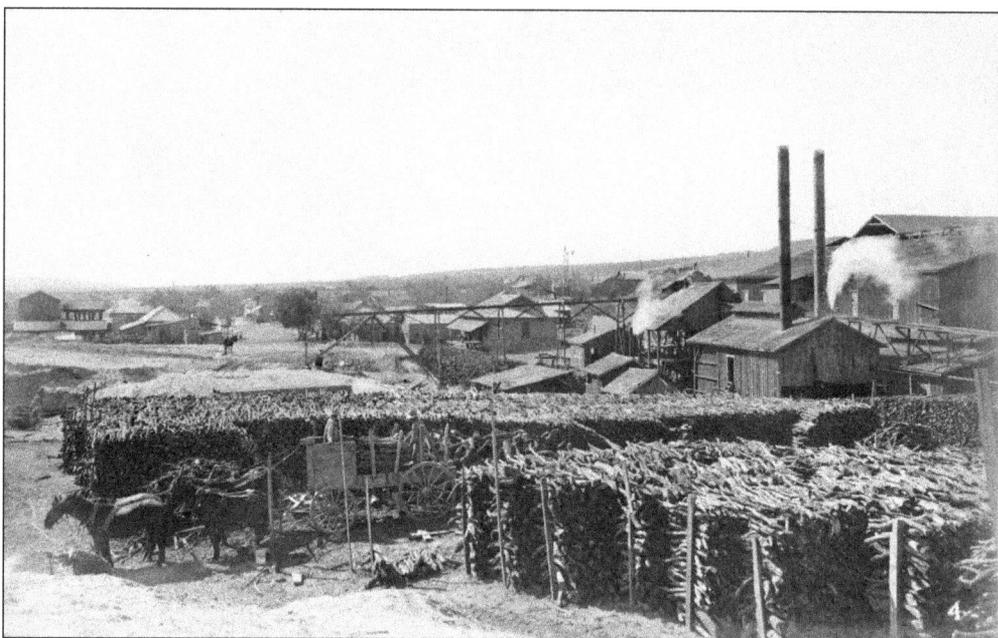

In addition to hauling ore from the mine, William ("Bill" or "Curley") Neal of Oracle also supplied the smelter with wood, as pictured here in the late 1890s. The wood was initially oak from Oracle, but when local residents and the federal government protested the number of trees cut, Neal switched to mesquite from the San Pedro Valley. When he transported the bullion to Tucson, he traveled without a guard, varied his schedule, and was never robbed. (AHS-Tucson 25,468.)

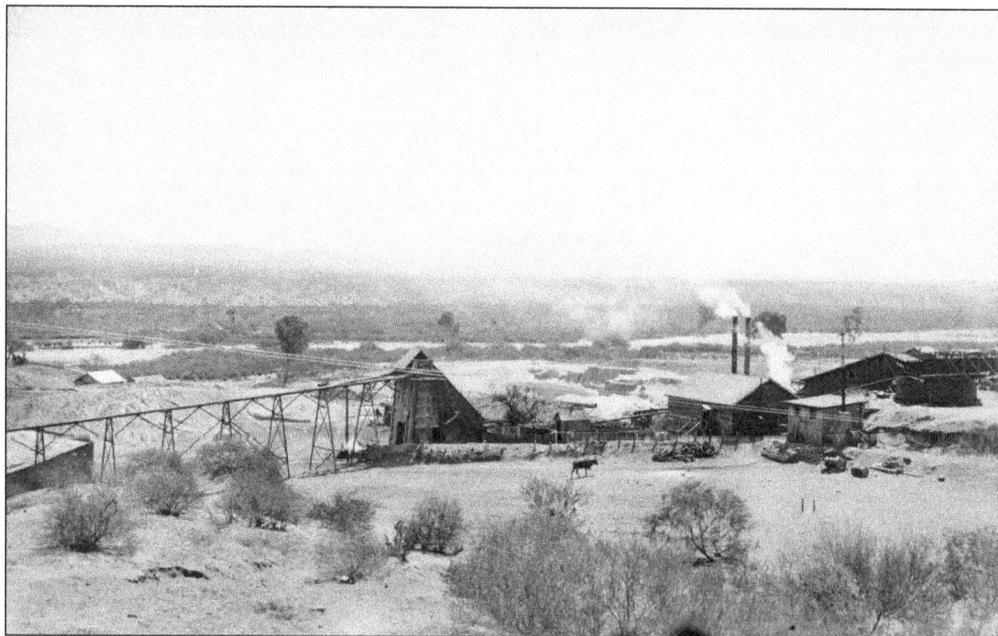

By 1899, ore from the Schultz/Mammoth/Collins Mine was being transported in buckets down a 2.75-mile wire cable installed in three sections. Each section was weighted down at a tension station to keep the rope taunt. Before loading, miners passed the ore through a grizzly to eliminate oversized boulders. Water for the mine was returned in the same buckets. (AHS-Tucson 25,457.)

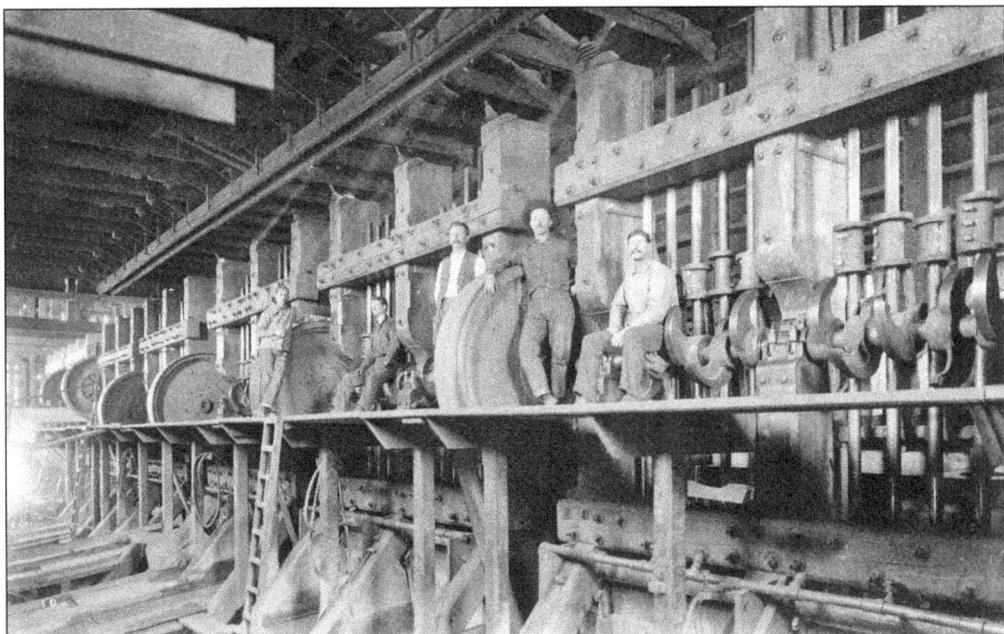

By 1900, the Mammoth Mill had 70 stamps in series of five, each stamp weighing 820 pounds and dropping six inches. Because the stamps fell 96 times per minute, vibrations could be felt at least three miles away. If a modern author needs an image of an early stamp mill used to crush ore, this photograph of the Mammoth stamps is often used. (AHS-Tucson 25,467.)

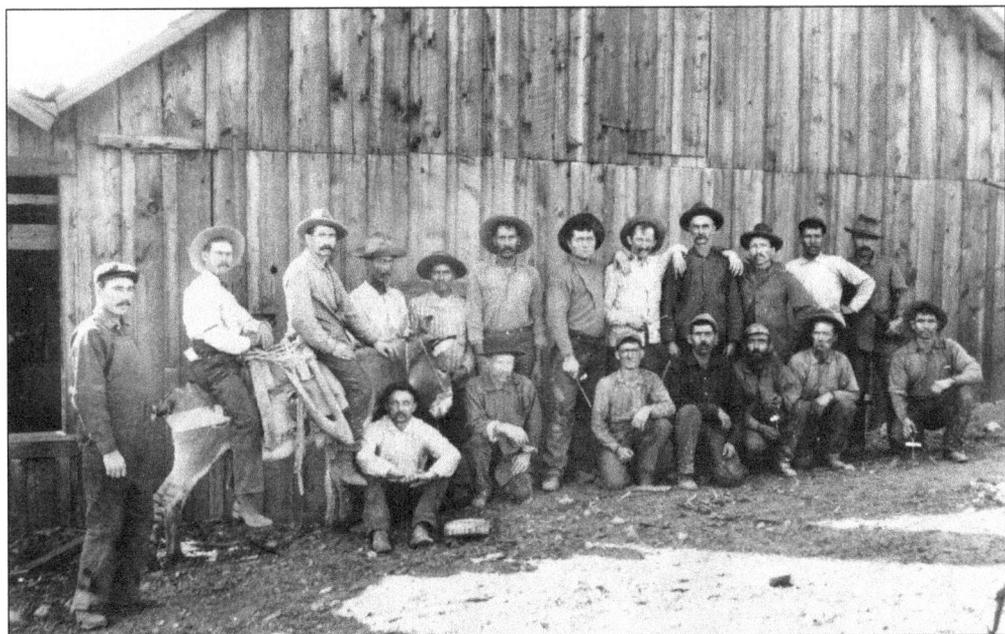

Franklin Wakefield Fish, a part-time student at the University of Arizona, was the assayer at the Mohawk Mill near Mammoth. His sister Clara Fish Roberts was reportedly the first student to enroll at the university. A large collection of her photographs is held at the Arizona Historical Society in Tucson. This view was taken behind the mine's hoist in 1898; all men are unidentified except Franklin Fish, astride a burro, second from the left. (AHS-Tucson 45,341.)

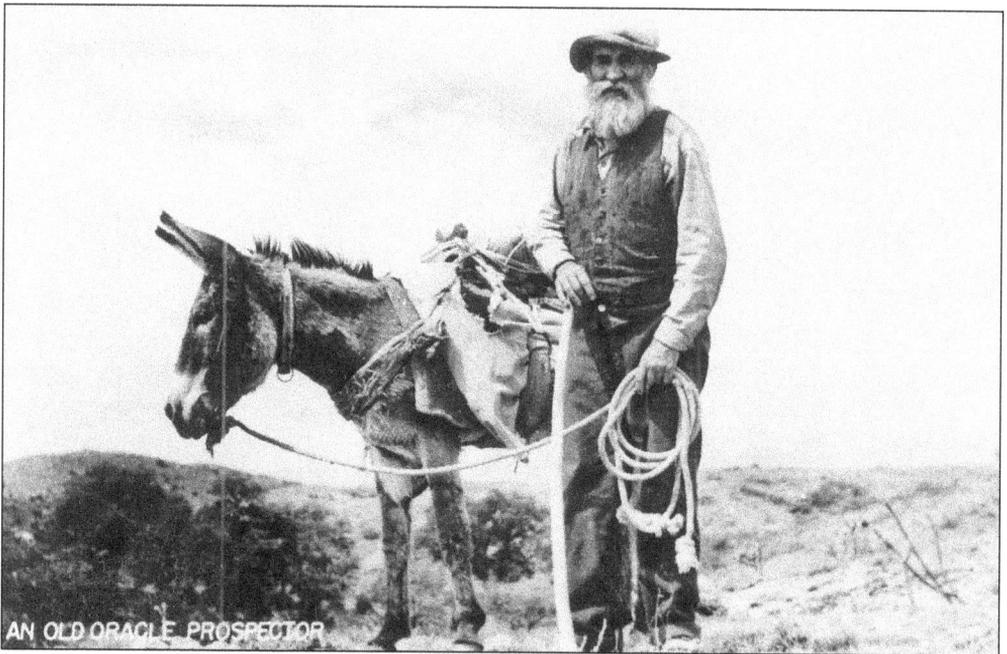

AN OLD ORACLE PROSPECTOR

Almost everyone, including this unidentified man, tried his hand at prospecting. Frank Murphy remembered Frank Schultz "stopping at [Albert] Weldon and [Alexander] McKay's at Oracle, eating their grub but spending his time prospecting. Finally he got angry at something and left, wandered down toward Mammoth, and located the Schultz mine." Most prospectors used burros to haul their picks, shovels, groceries, and bedding. (OHS 193.)

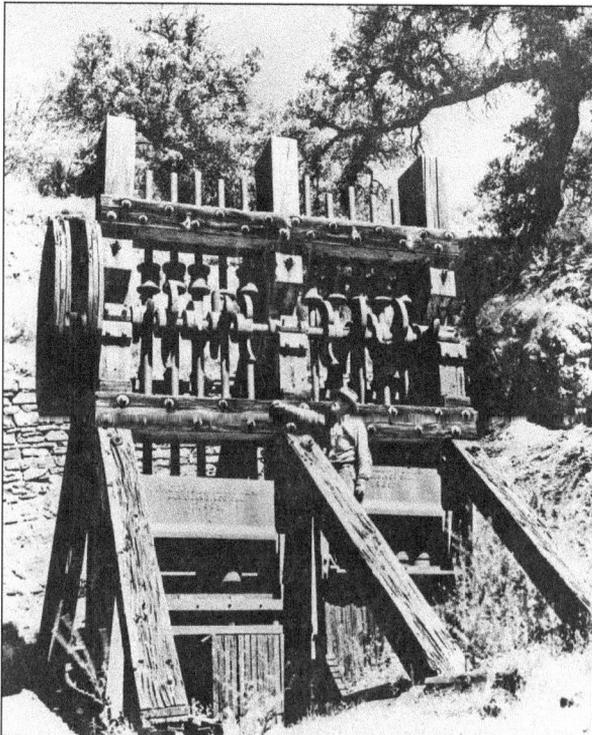

The most colorful and famous owner of a mining claim near Oracle was Buffalo Bill Cody. In 1881, a gravity stamp mill similar to this one brought by Cody to Campo Bonito was advertised in the *Engineering and Mining Journal*. It was listed as portable, though the entire mill weighed a ton; when disassembled, mules could haul the individual pieces to a remote mine. Homer L. Chaffee took this photograph at the YMCA camp near Oracle in the 1950s. (AHS-Tucson 46,882.)

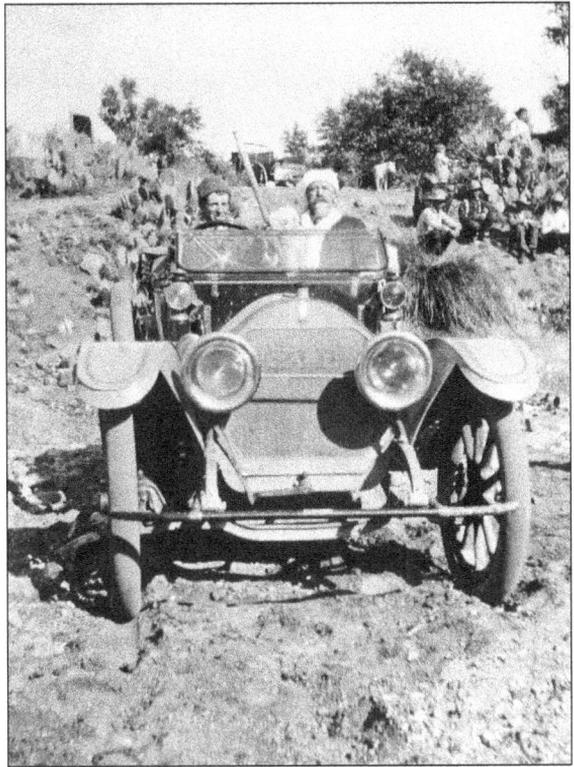

After Cody made his name and fortune with his Wild West show, he was persuaded to purchase mining stock in the Bonito Mine near Oracle. Arriving in 1910, he was at first very enthusiastic about his investments. He stated, as reported in the newspaper, "My principle ores are scheelite, gold, silver, copper and lead. Arizona will become the richest mining company of them all." By 1912, however, he realized his claims were not producing a fortune and returned to Wyoming. In Arizona, he is remembered for his love of little children. He organized the Boy Scouts and dressed up as Santa Claus, using his Case automobile to deliver Christmas presents to area children. (Right, Buffalo Bill Historical Center, Cody, Wyoming, P.69.1858; below, P.6.701.)

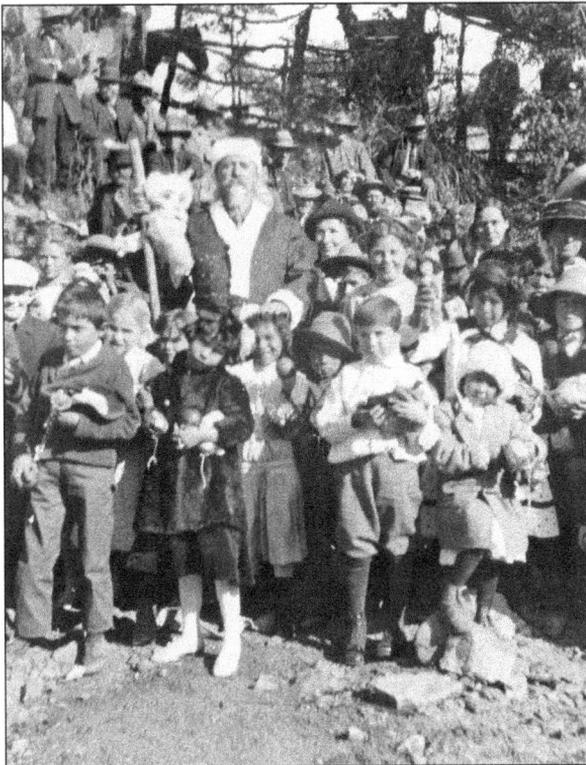

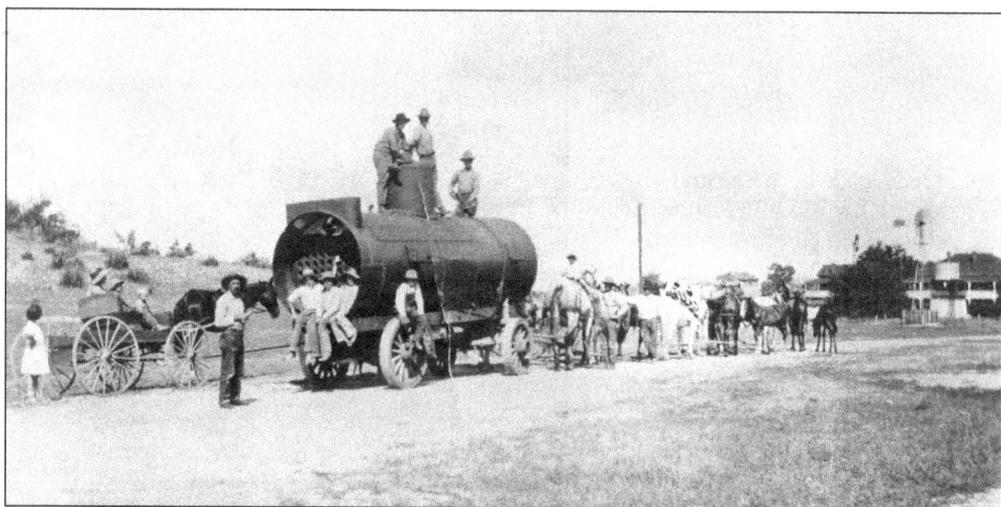

Many mines were difficult to access, especially those along Copper Creek, and equipment had to be hauled over primitive, windy roads. This boiler was shipped to Tucson by rail around 1910 and then brought to Cooper Creek by mule teams. Archie Ramsay and the other freighters made the trip to Oracle in two days but then encountered rain. More mules were used; the job took two weeks and 30 mules to complete. (Reg Ramsay.)

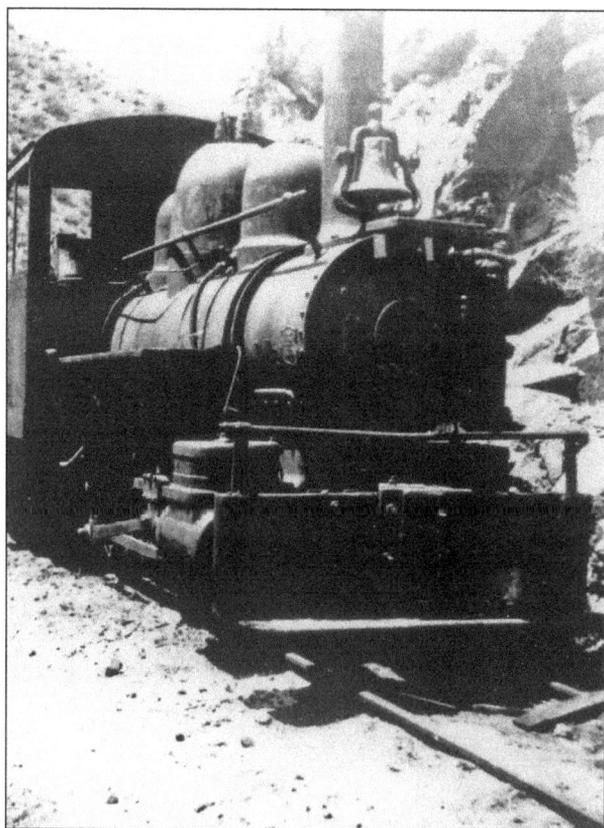

The ultimate load was this steam locomotive, transported by the Clark brothers from Winkleman to Copper Creek on a double wagon behind a team of 20 mules. After rails were laid, the narrow-gauge locomotive was used to transport ore two miles from the Old Reliable Mine up the canyon and around the arroyo to the mill on the opposite side. (Harry Hendrickson.)

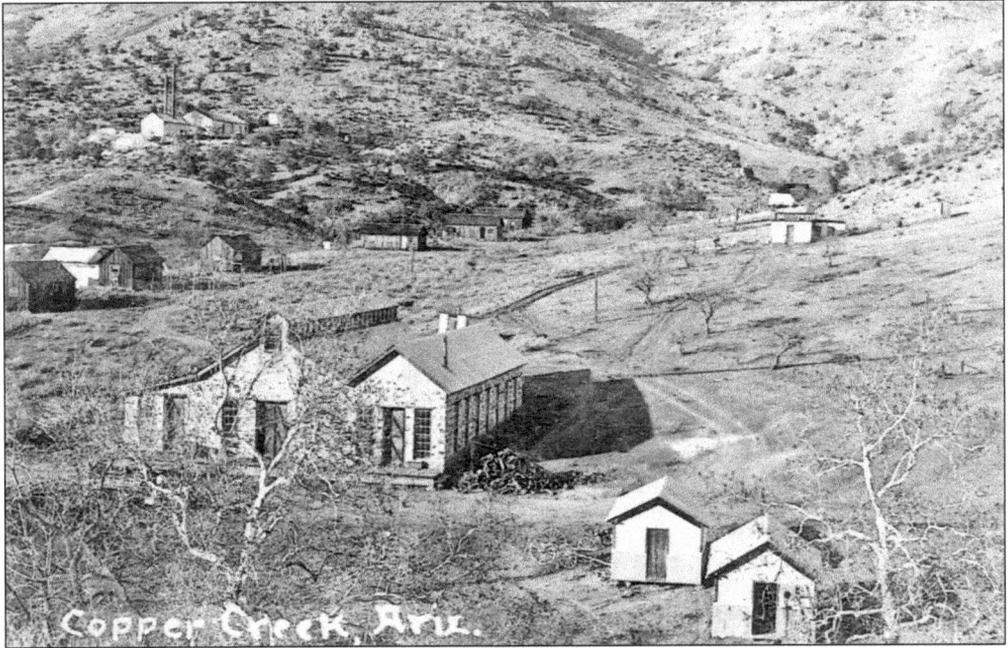

Copper Creek, Ariz.

The mine at Copper Creek operated intermittently, as did many others. It was worked from 1913 to 1914 as a copper mine and again in the late 1930s as a molybdenum mine. In 1937, the mine employed 200 men; the town boasted a general store, recreation hall, and movie theater (above). Copper Creek ceased production in 1939, but the *San Manuel Miner* noted that it was again being mined in 1954 with ore being trucked to Tucson and then sent by rail to the Douglas smelter. In 1982, the general store was just a shell (below), with windows removed where Kathy Matthews is standing. Today even these walls are just rubble. (Above, Harry Hendrickson; below, photograph by Carl Matthews.)

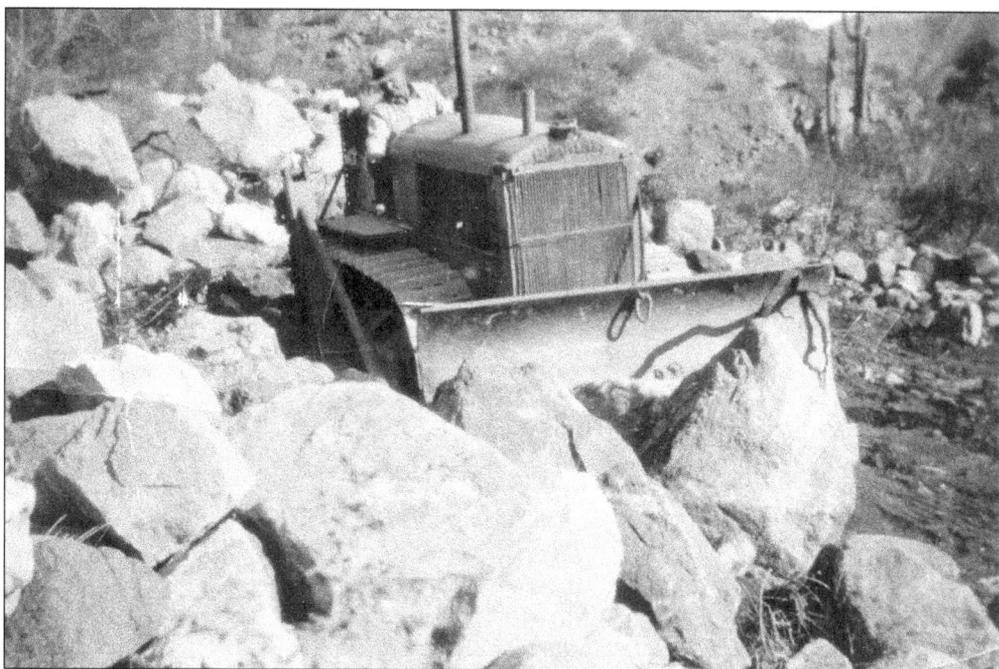

The construction of roads was often the occupation of Reg Ramsay Sr. Here he uses a Cletrac crawler tractor to move huge boulders, probably near the San Pedro River, as he worked on the road into Copper Creek. (Reg Ramsay.)

South of Copper Creek is the prominent landmark Sombrero Butte, where the children at Copper Creek attended school. An Englishman named Frederick Hart was the teacher. Both towns had mail delivered by Hugh E. "Shorty" Neal, shown relaxing at the end of the day in 1945. Earlier he had delivered mail by pony express, but in 1945, he was using an old car. An *Arizona Highways* article illustrated both methods. (Harry Hendrickson.)

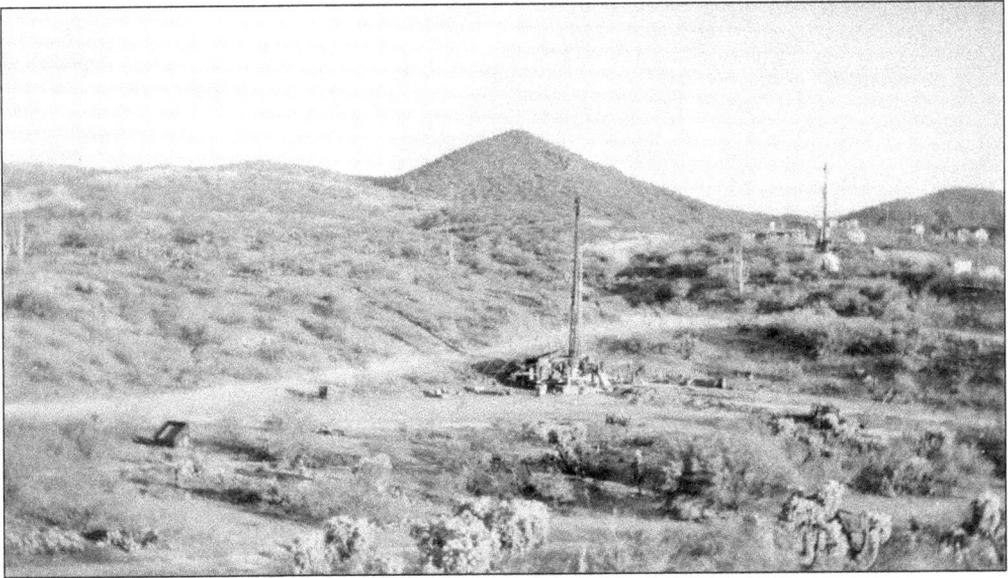

As early as 1870, claims were staked out on Red Hill, just southwest of Mammoth, which was purchased by Magma along with other claims in 1944. Before additional development could begin, Magma had to find answers to some important questions. Could the ore body be drained? Could it be mined by caving? Would the ore be profitable? Churn drills answered these questions. These drills are pictured in the above view with Red Hill in background. Pictured on the right is a close-up of a churn drill in 1946. The ore averaged .65 percent copper, or about 13 pounds of copper per ton of ore. (Both, SMHS, photographs by Frank V. Madrid.)

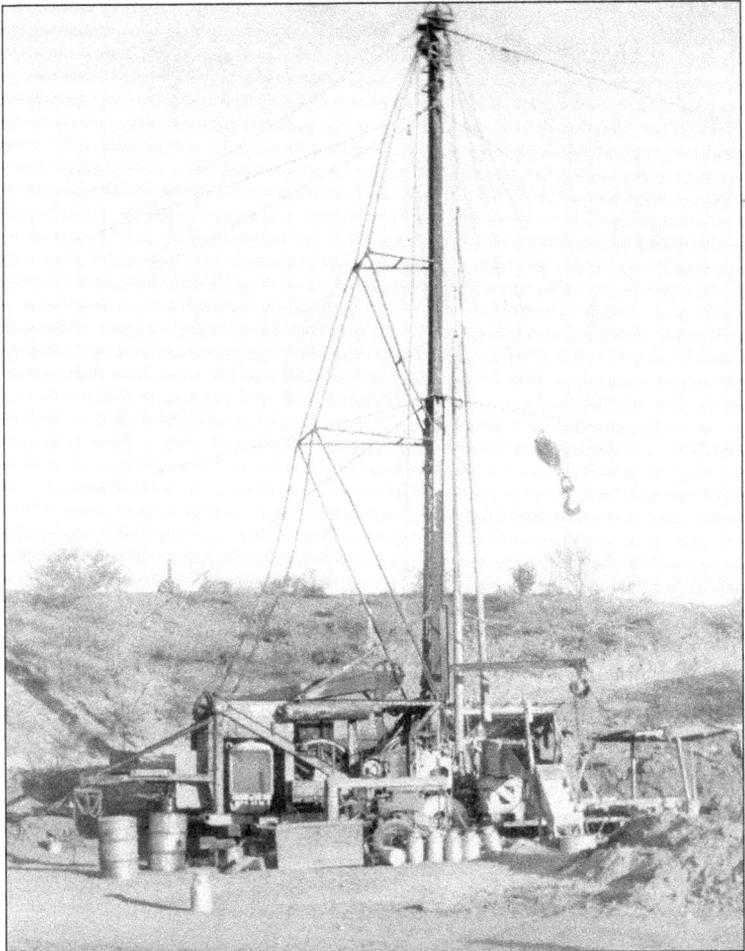

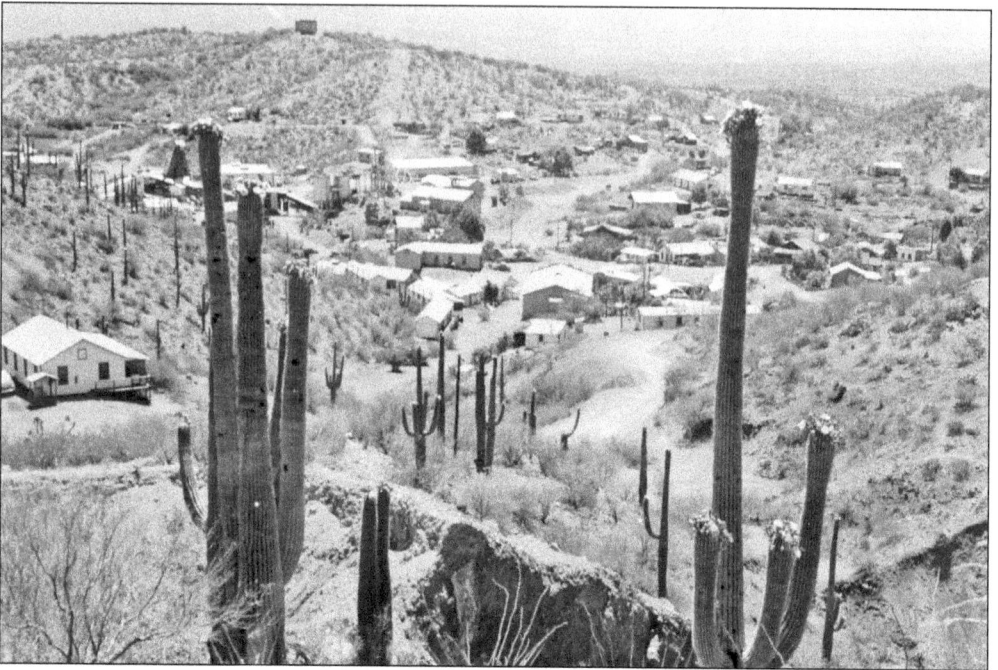

In 1939, the Mammoth–St. Anthony Company added the Mohawk and New Year Mines, thus consolidating all mines in the area under one company. The firm employed 260 men, and to serve them, a new town sprang up. There are many versions regarding the origin of the town's name; Harvey Willeford claimed to have polled the community for a choice between Tiger and St. Anthony. The people chose Tiger. When Frank V. Madrid photographed the thriving community halfway between Mammoth and Oracle (above) in 1946 and the bunkhouses (below) in 1948, the company was employing nearly 500 men. The community boasted dormitories for single men, a company store, a barbershop and beauty salon, several restaurants, a gas station, and a movie theater. (Both, SMHS.)

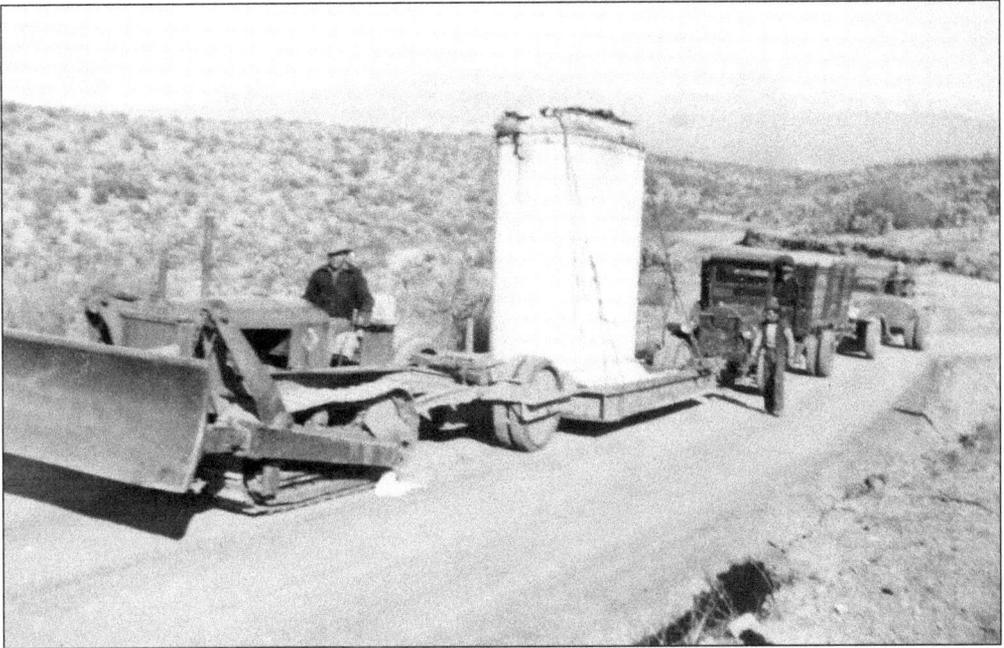

During World War II, the draft caused a shortage of mine workers, and in 1942 with the need for strategic metals, the U.S. Army sent 65 men to keep the mine producing. Tiger was one of only two mines in the nation that could separate molybdenum and vanadium from other metals. On Labor Day in 1944, the Mohawk shaft caught fire, and the mine pumps failed. Help finally came from water hauled in by Davis-Monthan Air Force Base. Reg Ramsay Sr. used his Cletrac crawler tractor to move this huge transformer (above) to the mine at Tiger in the 1940s. In the below photograph, taken by Frank V. Madrid, a diesel engine is moved to Tiger in 1949 to provide power. Today the Tiger Mine, although closed for decades, is remembered for its beautiful and rare minerals, specimens of which are found in all major mineral collections. (Above, Reg Ramsay; below, SMHS.)

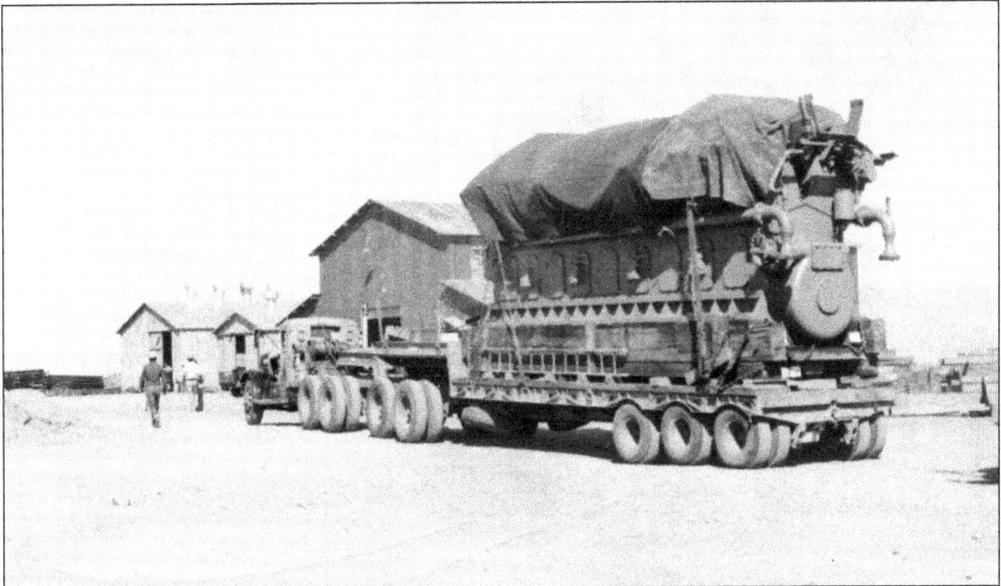

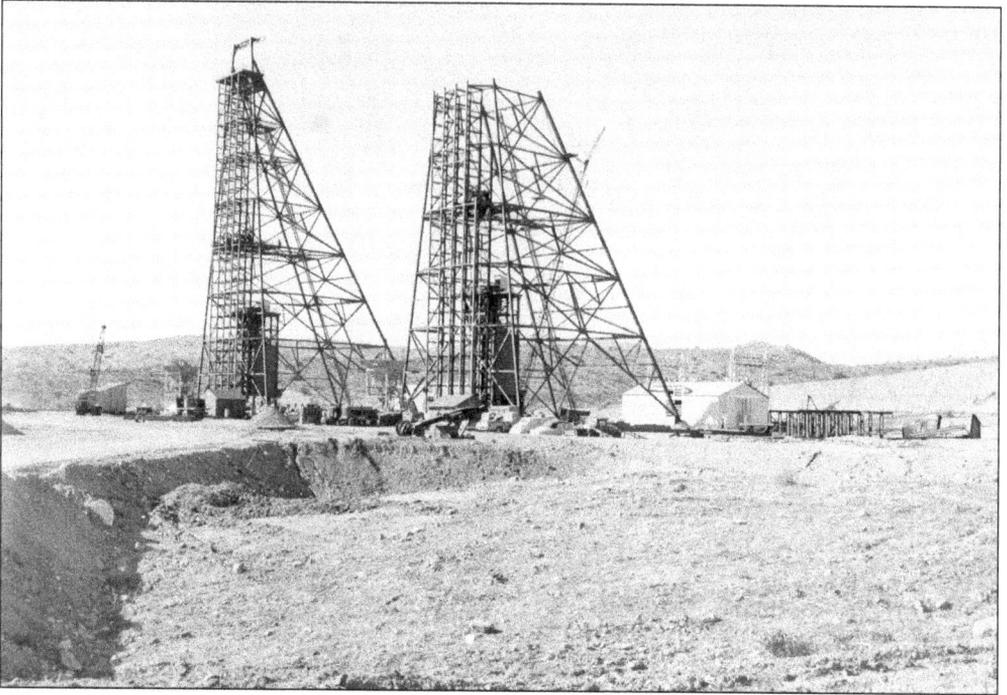

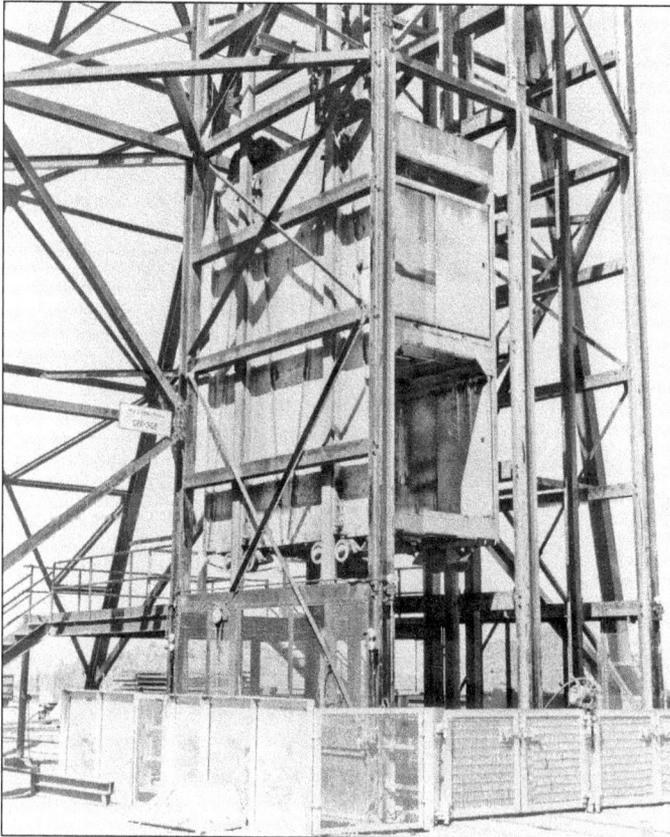

Shafts at the San Manuel Mine—four for production and three for service—dropped to depths of 2,700 to 4,100 feet. Each head frame was connected to a hoist house, which controlled the cables lifting or lowering supplies, ore, and men. Above, head frames 3-A and 3-B are under construction on March 31, 1954; permanent hoist houses had not yet been assembled at this time. Pictured left is a double-deck cage in the No. 4 shaft. Each deck could hold 50 men or one supply flatcar. (Both, SMHS/Magma/BHP.)

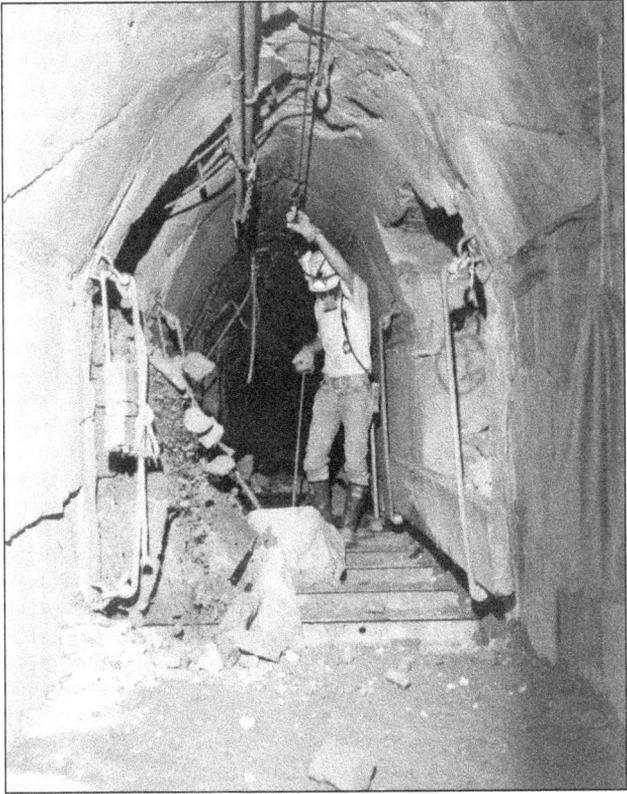

The entry-level job at the San Manuel Mine was chute tapper, pictured right. When the miner lifted the control boards on the left, ore from 15 feet overhead flowed out onto the grizzly, a chute with rails placed 14 inches apart. Anything small enough to pass between the rails dropped into a transfer raise and then to the haulage level 60 feet below. This man has a grizzly hook to pull the too-big rocks forward and a 16-pound double-jack to break larger boulders. He is tethered to an overhead cable, which prevents him from falling through the rails. Below, bottom-dump ore cars wait at a crossover in the haulage level, which is supported by steel-arch sets. (Both, SMHS/Magma/BHP.)

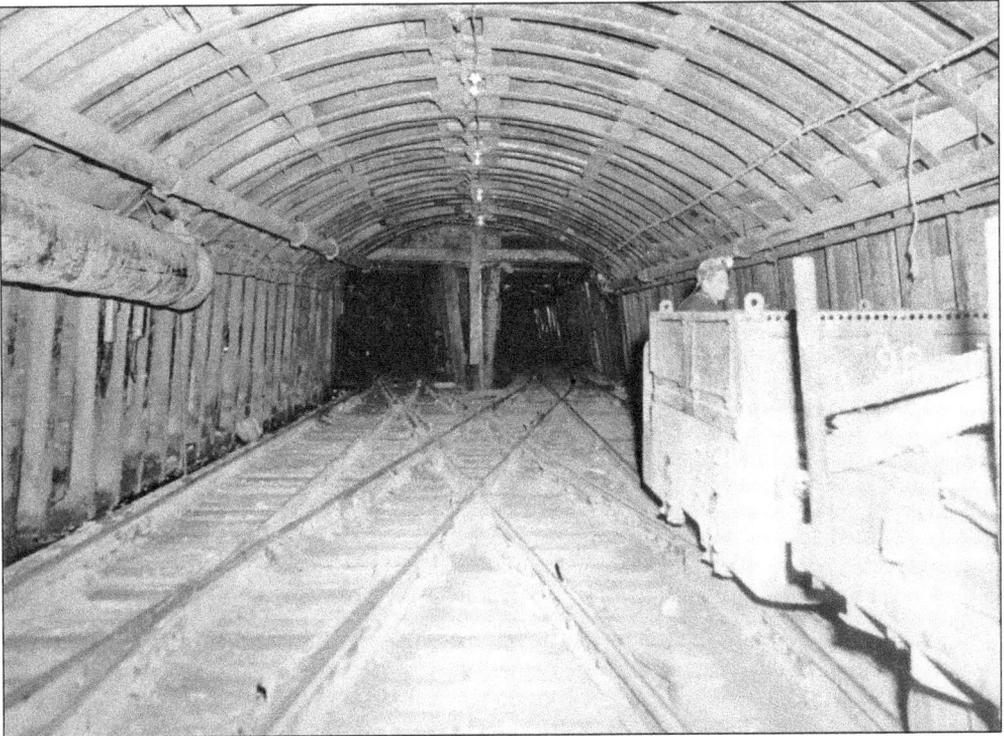

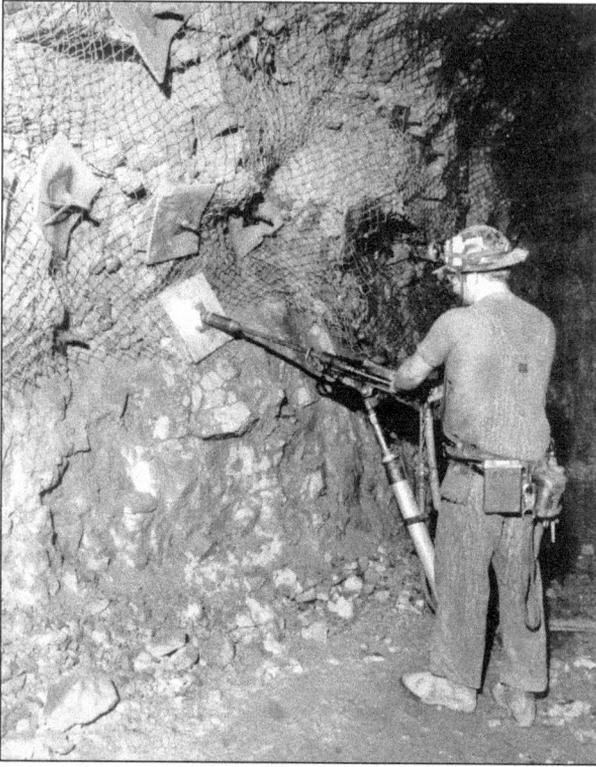

This underground miner uses a compressed-air drill called a jack leg. He is installing rock bolts and steel wire mesh to support the back and walls of a drift. Everything underground was supported either by timber, concrete, or wire mesh and bolts. (SMHS/Magma/BHP.)

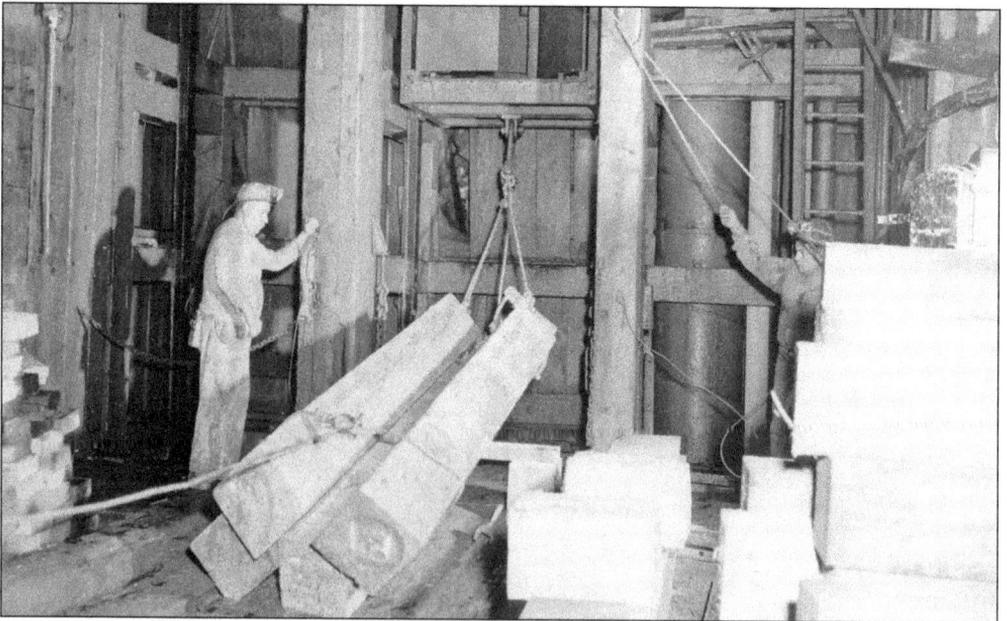

The 12-by-12-inch timbers used to support the ceilings of drifts were lowered deep into the mine, chained beneath the cage. The man on the left is Tio Burrola. According to Onofre Tafoya, "wood has a certain flexibility and elasticity to it, that allows it to bend and break in harmony with the slow, crushing weight, bearing down on it. Eventually, wood has to give way, but it will resist pressure in a way that steel and concrete does not." (SMHS/Magma/BHP.)

A battery-operated concrete pot train is pushed toward an area that has been formed and is ready to pour. Access and grizzly drifts were supported by 24 inches of concrete in the back and 18-inch ribs. (SMHS/Magma/BHP.)

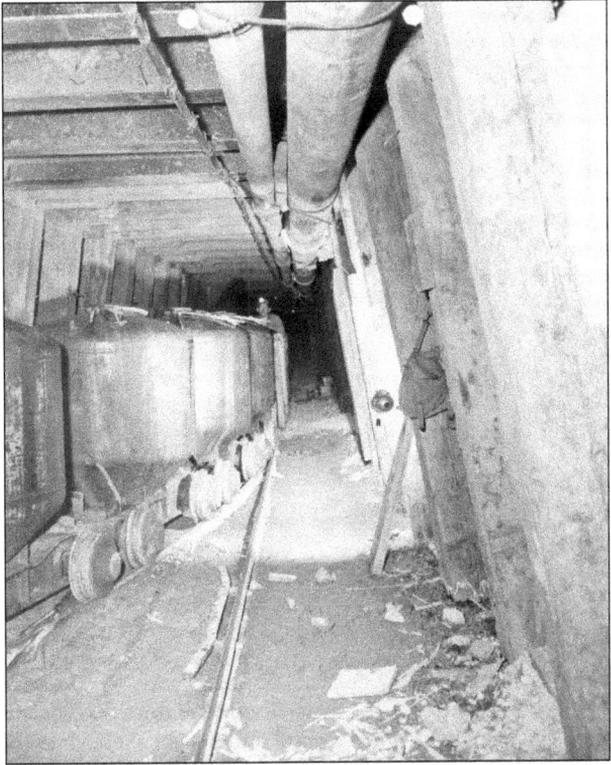

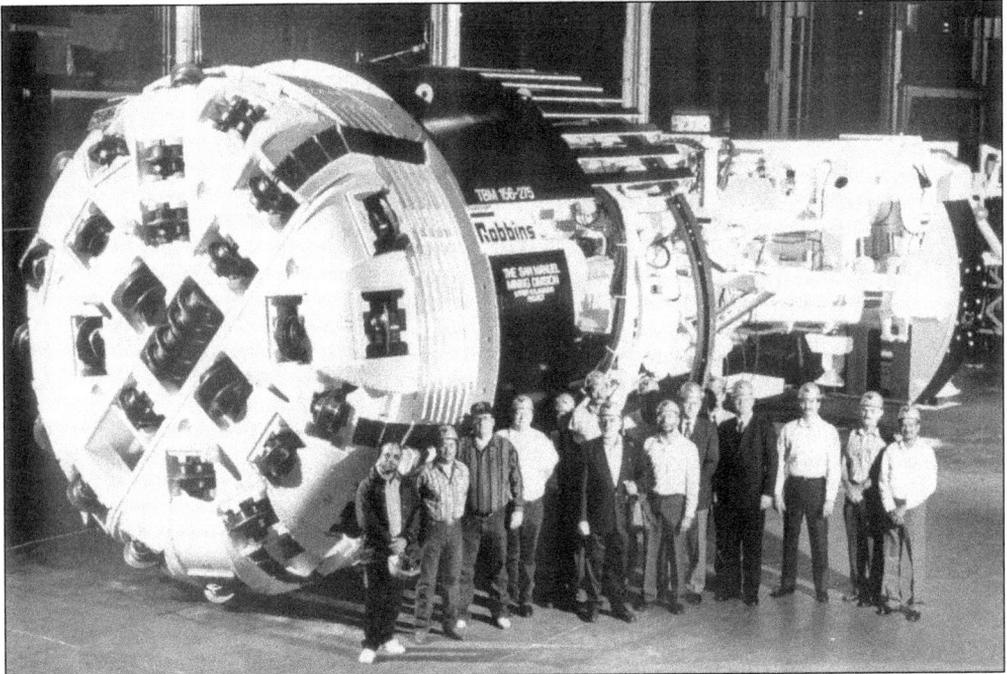

In 1968, Magma purchased the Kalamazoo ore body, located 8,000 feet to the west, and thus doubled the size of its reserves. This 18-foot tunnel-boring machine was used to drill thousands of feet of drift in the Kalamazoo ore body. (SMHS/Magma/BHP.)

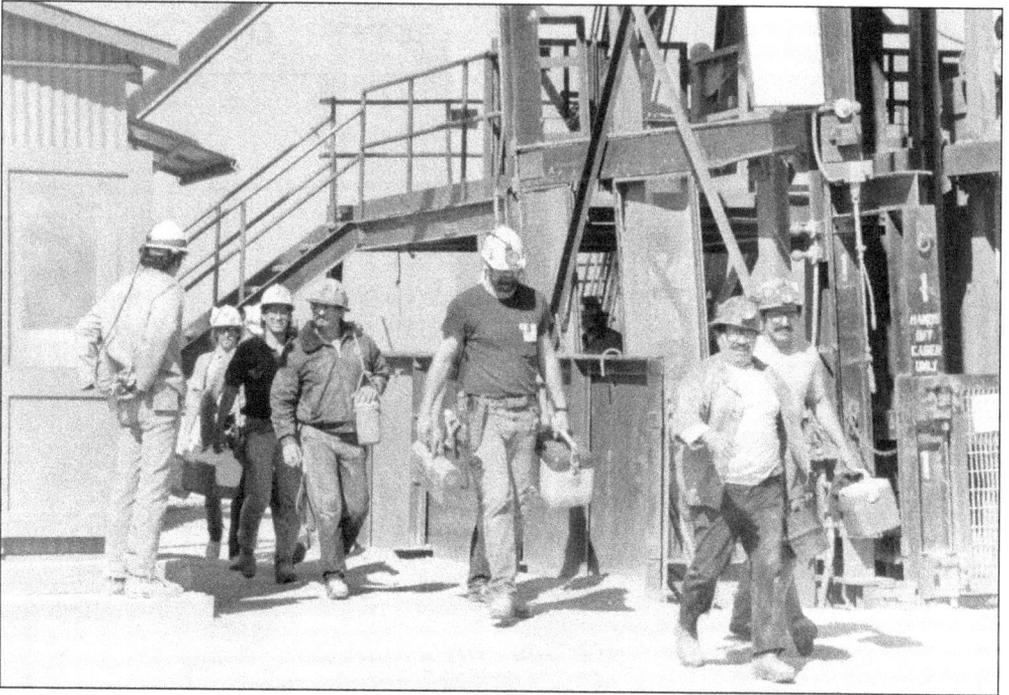

Underground mining is always about the miners. As Christine Marin wrote in the foreword to *Mother Magma*, "they were good and decent men, these miners: ready to do the most precarious work and at dangerous levels beneath the earth. They worked together and some died together." These men are just coming off their shift at the No. 5 shaft, lunch buckets in hand. (SMHS/Magma/BHP, photograph by Don Green.)

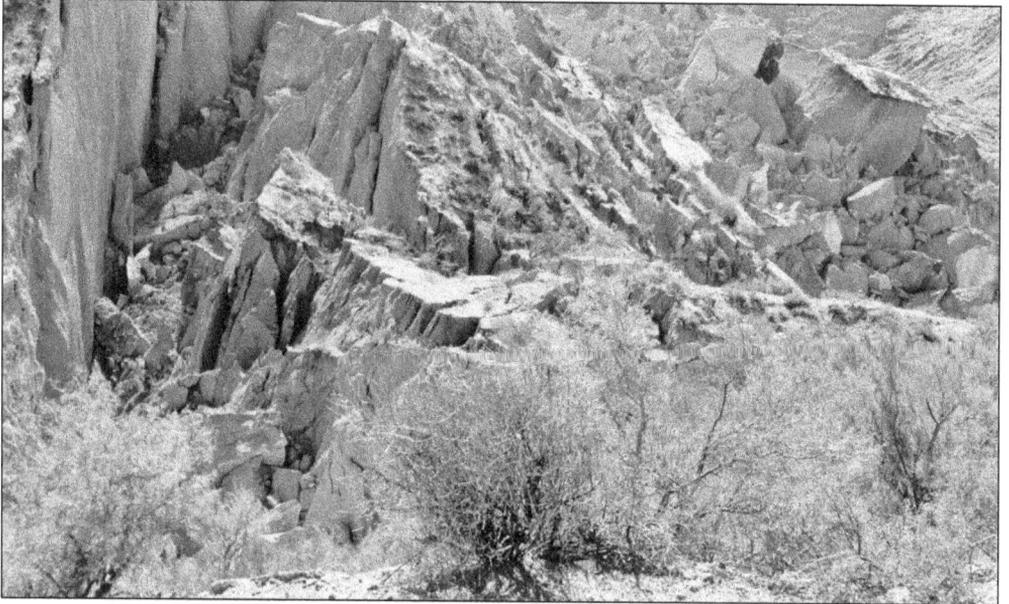

In cave block mining, ore is hoisted up from deep underground in 23- or 29-ton skips. Eventually, the surface begins to subside, and cave-in areas are seen on the surface. Here, over the south ore body, blocks of Gila conglomerate slump toward the center of the cave area. (SMHS/Magma/BHP.)

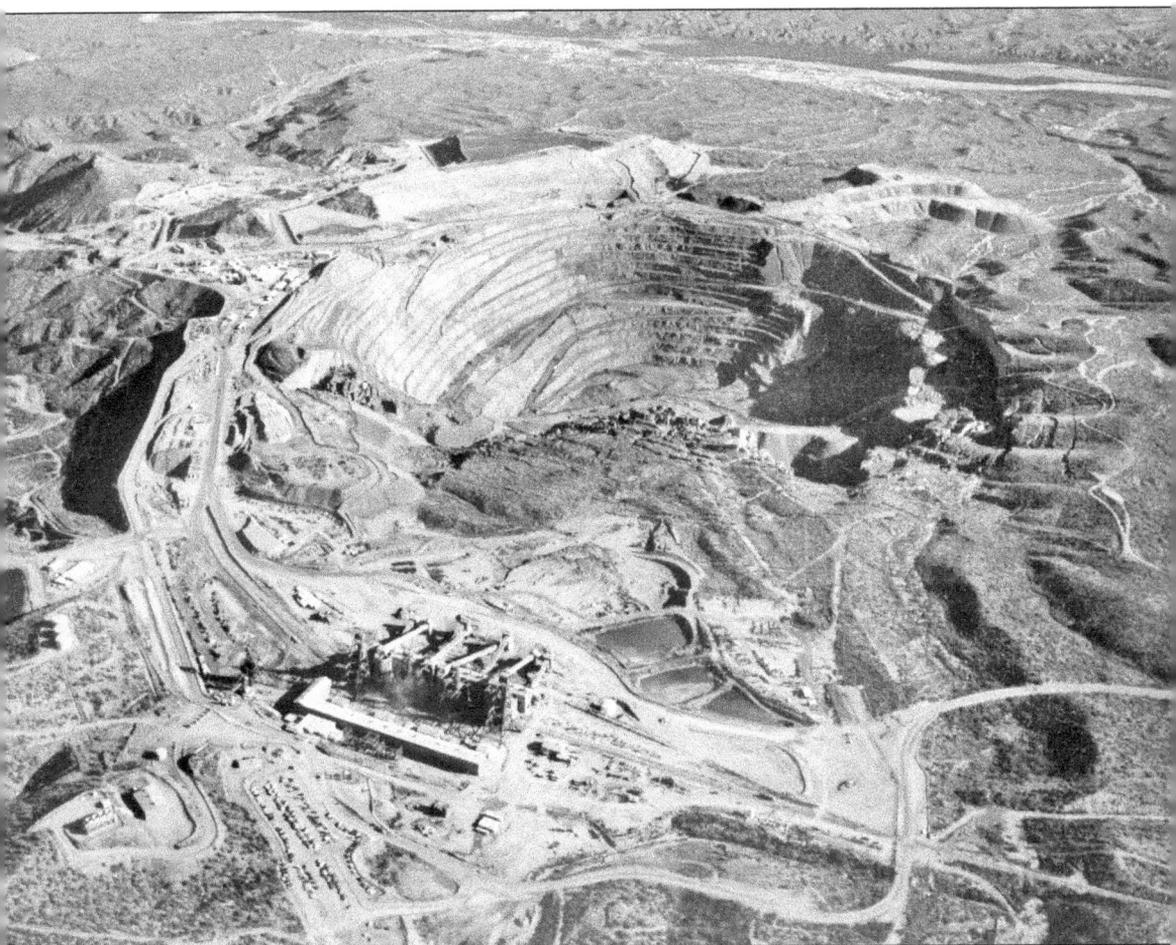

This aerial view of the San Manuel open-pit mine shows the entire mine area. The No. 3 shaft is in the lower portion of the photograph; the No. 1 and No. 4 shafts are at the upper left. The oxide pit is in the center and lies largely within the cave area. The roads were 80 feet wide to support the 100-ton diesel-electric haul trucks. Above the pit are the oxide leach dumps. A weak solution of sulfuric acid was continuously sprayed over the ore to dissolve the copper. To the right of the pit are the waste dumps. At the upper edge are Mammoth and the San Pedro River. (SMHS/Magma/BHP, photograph by Ray Manley.)

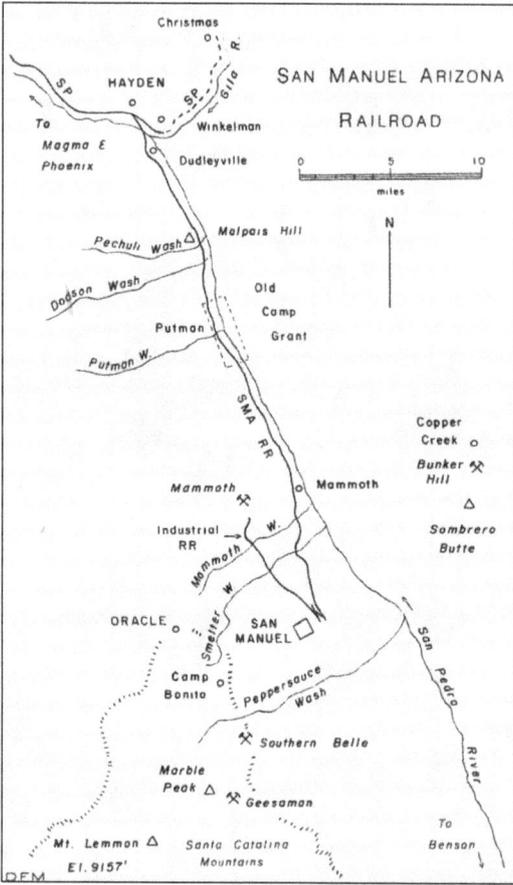

New railroad construction in the last 50 years is relatively rare in this country. One line built during this time was the San Manuel Arizona Railroad (SMARR or SMARCO), a 29-mile track that followed the San Pedro River from Hayden to San Manuel. Also shown on the map to the left is the 6.5-mile industrial railroad spur from San Manuel to the mine. The 26 trestles and 120 culverts, built so trains could cross the normally dry washes emptying into the San Pedro River, made the estimated cost of the SMARR $7.6 million. Below, a train crosses the wooden trestle bridge over Mammoth Wash in November 1994. (Left, map by David F. Myrick, *Railroads of Arizona* Vol. 2; below, photograph by John Petko.)

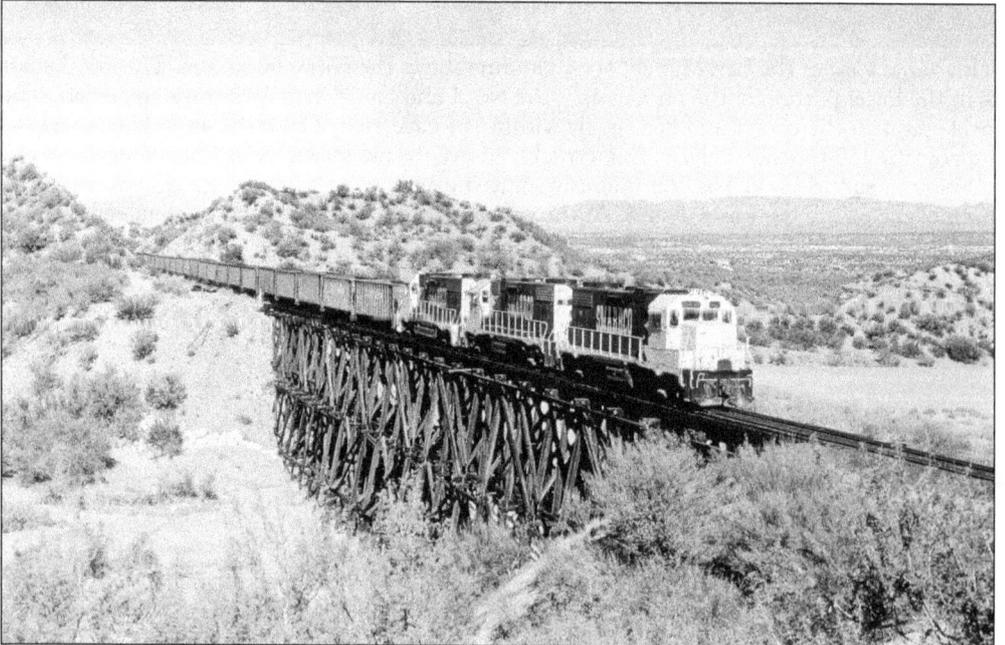

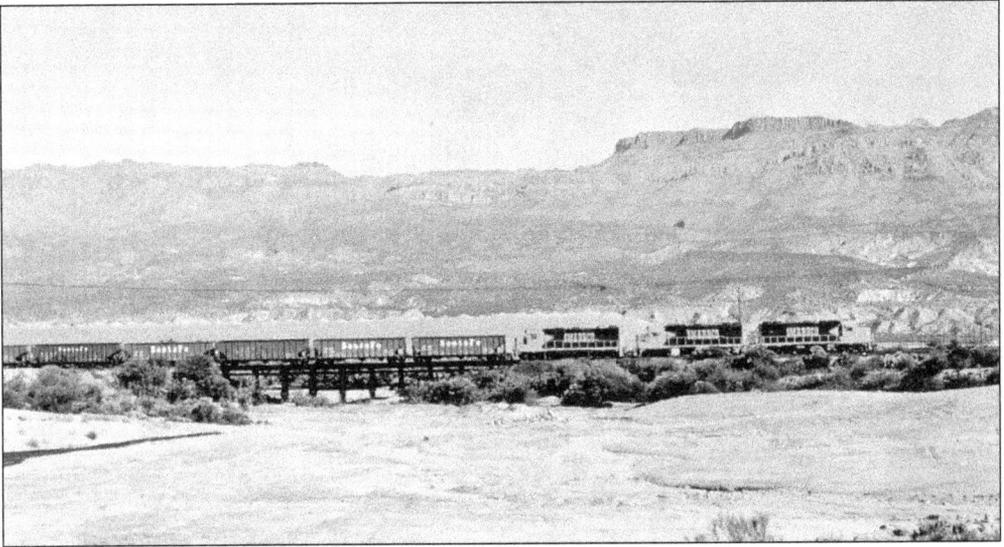

In December 1954, the steam engine *Jones Okie Flyer* became the first locomotive at San Manuel. In February 1955, the first diesel-electric engine arrived. Diesel-electrics were used exclusively with one exception. In 1958, an ore train and a relief train crashed head-on. While the engines were being repaired, a steam locomotive was brought in from Superior; it made one round-trip. Here the SMARR's yellow-and-blue GP-38-2 engines carry ore from the mine to the smelter. (Photograph by John Petko.)

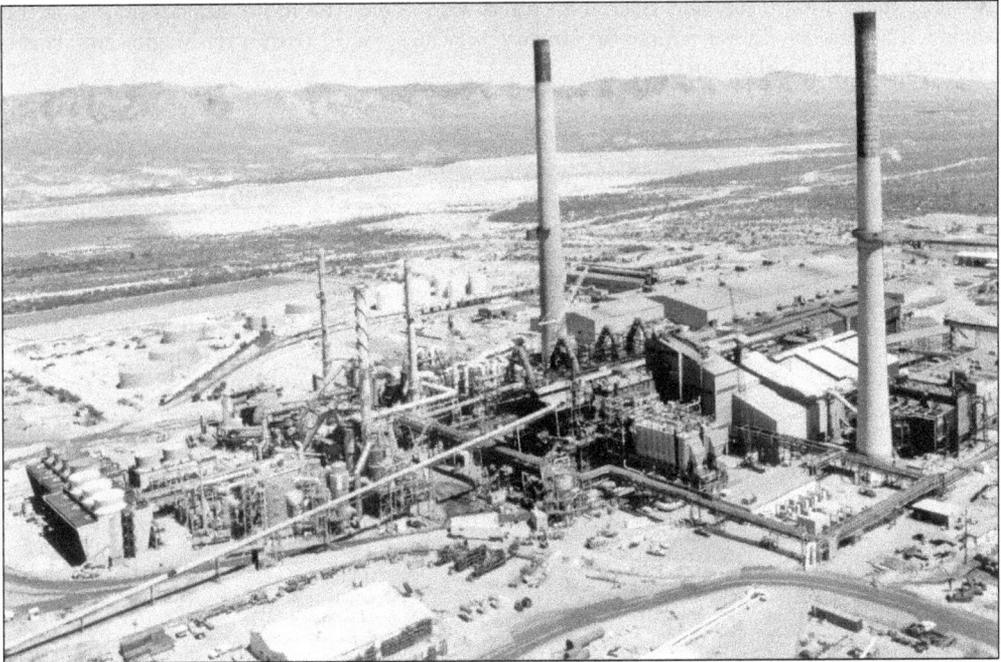

The destination of ore trains was the smelter, also the departure point for trains carrying copper products to market. Eulalia "Sister" Bourne discussed the smelter in 1970: "I look across the once clear-aired valley to the great mountains now dimly seen through smelter smoke. Oh, I'm glad to see that smoke! It means new shoes for all the babies, and good schools for our young citizens. But during the long strike, how beautiful the world was!" (SMHS/Magma/BHP.)

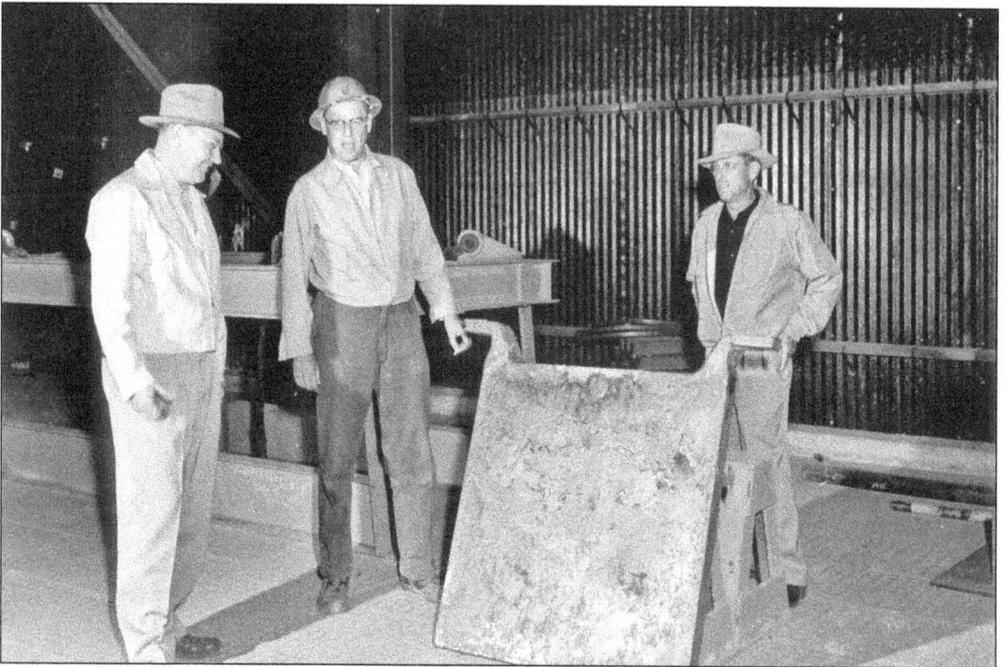

In electrolytic refining, copper is transferred from an anode (positive) to the cathode (negative). Here general manager Wesley P. Goss (left), smelter superintendent Robert Wilson (center), and assistant general manager John Buchanan stand with one of the initial anodes poured at the smelter. The first anode was poured on January 3, 1956, some 12 years after Magma first began exploration. (SMHS/Magma/BHP.)

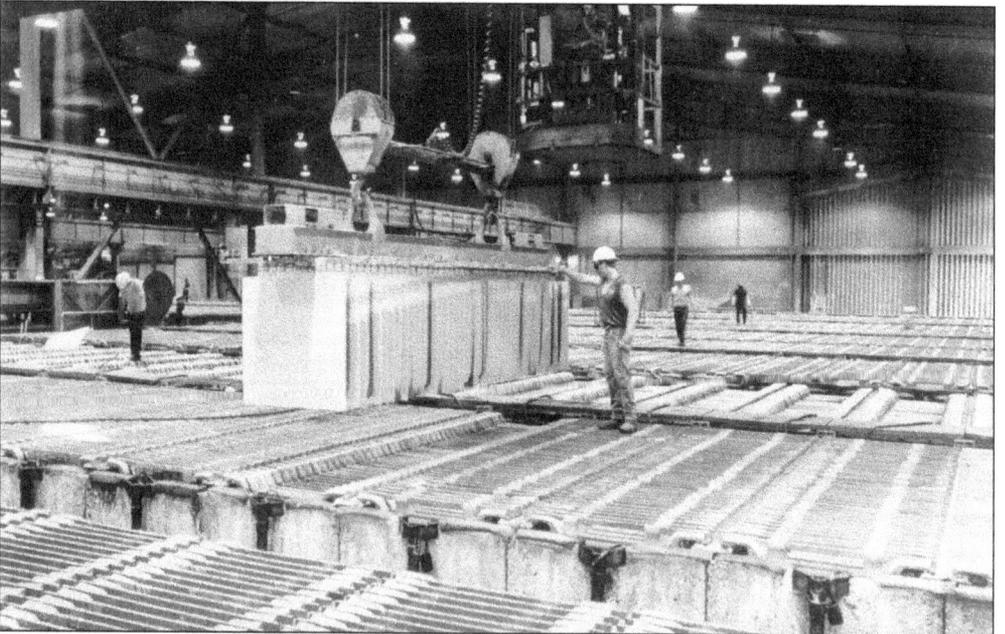

For the cathode, a 13-pound copper starting sheet is used. It is suspended in a solution with a weak electric current. The copper plates onto the cathode, and impurities settle to the bottom of the tank. At the end of 12 days, a 365-pound cathode is produced for market. (SMHS/Magma/BHP.)

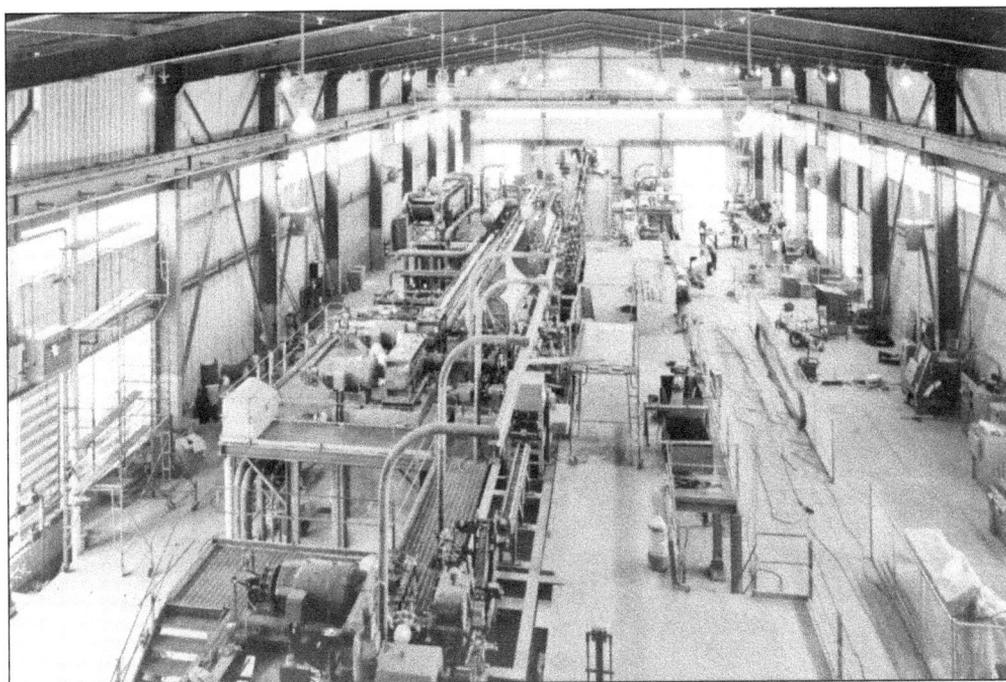

The principal finished product at Magma was a continuous-cast five-sixteenth-inch wire rod, produced in this portion of the plant. Cable was shipped in three-, four-, or eight-ton coils. The rod plant could produce 180,000 tons of wire per year. (SMHS/Magma/BHP.)

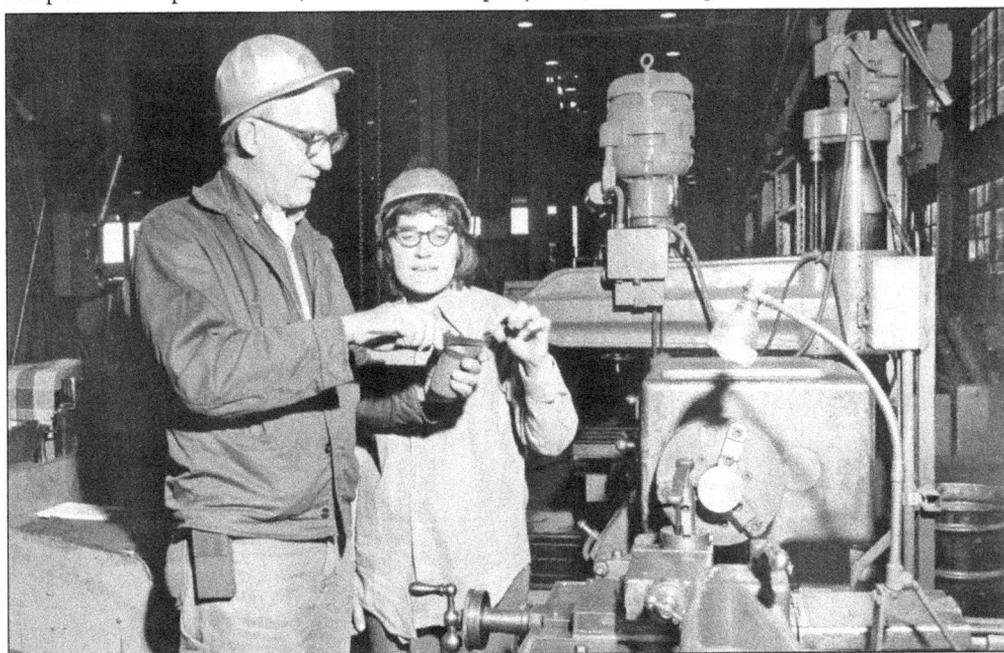

In the early 1950s, much of Arizona was segregated. Wesley Goss, however, made the decision that San Manuel would not be. In addition, Magma eventually began hiring women for most occupations. Here journeyman machinist Loren Pederson (left) is pictured with Pat Garcia, the first female apprentice, in the plant machine shop. (SMHS/Magma/BHP.)

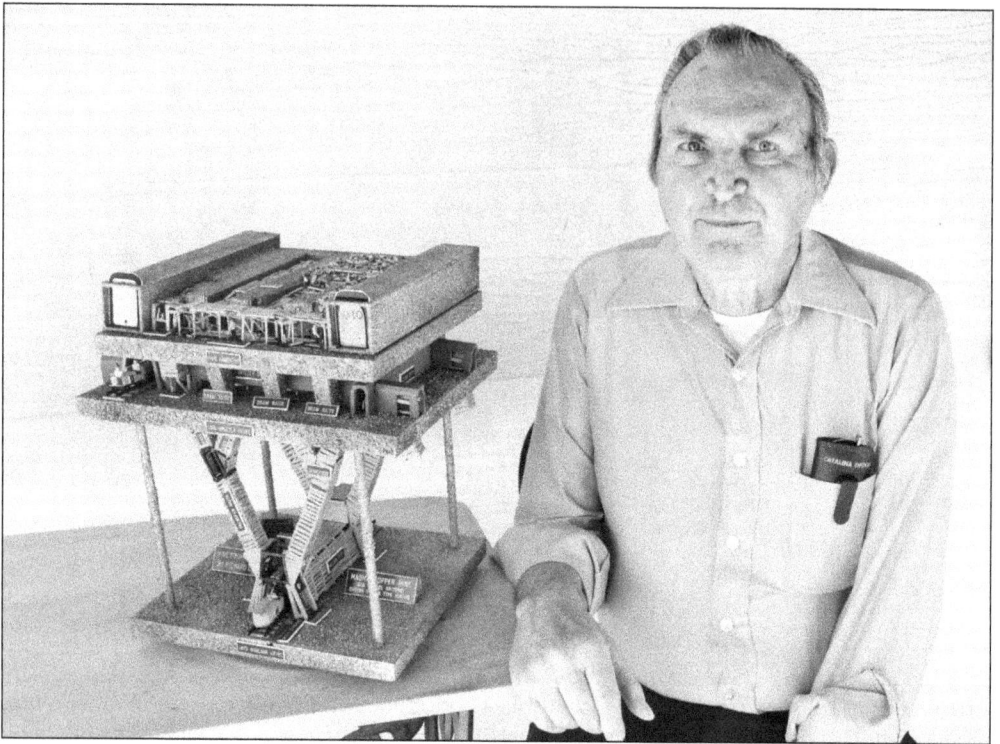

What do you do when you retire from copper mining? Onofre "Taffy" Tafoya wrote a best-selling memoir of life underground entitled *Mother Magma*. Richard L. Evans (above) has made models, including this working model of the mine. Sand at the top will fall through raises from the 1,395-foot undercut to the 1,415-foot grizzly level to the ore car or skip at the bottom. Below are models of two head frames: the No. 4 shaft (left) and an ore shaft. In addition to these free-standing models, Evans has also placed replicas inside bottles. One is on display at the Oracle Historical Society. A free-standing model is exhibited at the Flandreau Science Center's Mineral Museum in Tucson. (Photographs by the author.)

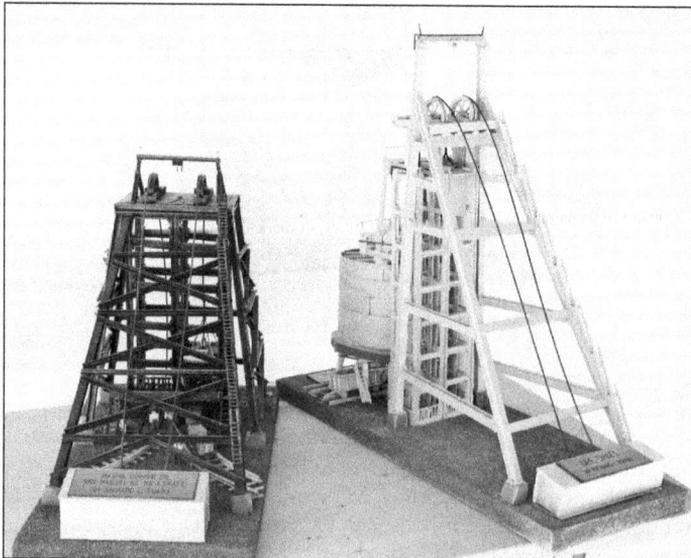

Three

ORACLE AND MAMMOTH

Early Mammoth history began with mining and smelting, while Redington's history began with cattle ranching. The history of early Oracle includes prospecting and mining, providing support services and oak trees for the larger mine and smelter at Mammoth, cattle ranching, and accommodating winter visitors—always the winter visitors.

In 1901, Dr. William Wood traveled to Albuquerque from Portland, Oregon, hoping to recover from tuberculosis. He found the winter nights of New Mexico colder than anticipated and continued on to Tucson. He wrote to his wife, "Some quail hunters just came in from a small place in the mountains north of here called Oracle. They praised the service and food of the hotel there, the Mountain View. I've decided we'll try it. We will hire horses and ride every day." Back in Albuquerque, Elizabeth Lambert Wood began packing the family's belongings, which she wrote included "a tent, blankets recommended by Dr. Trudeau for outdoor sleeping," and "a heavy meat press to squeeze out beef juice to increase Doctor Wood's weight." She traveled to Tucson by train, and then the couple took the stage to Oracle. She wrote, "We had arrived in Oracle, a place of delight to Doctor Wood till his death in 1923, and to me down to this year of San Manuel's beginning in Oracle's neighborhood in 1954."

William Wood was only one of the many who came to Oracle for their health. By 1914, William Neal was running both the Mountain View Hotel and the Acadia Ranch. He advertised the benefits of Oracle's climate in Tucson and Phoenix newspapers. The *Arizona Daily Star* promoted the Acadia Ranch "for the reception of people afflicted with tuberculosis. The cool summer climate of Oracle is its chief attraction. One can always find a cool spot. The nights are delightful. The air is invigorating, and no dust storms. The altitude is 4500 feet. . . . The management . . . insures fresh eggs, milk (plenty of it), green vegetables, meats in abundance. No canned goods."

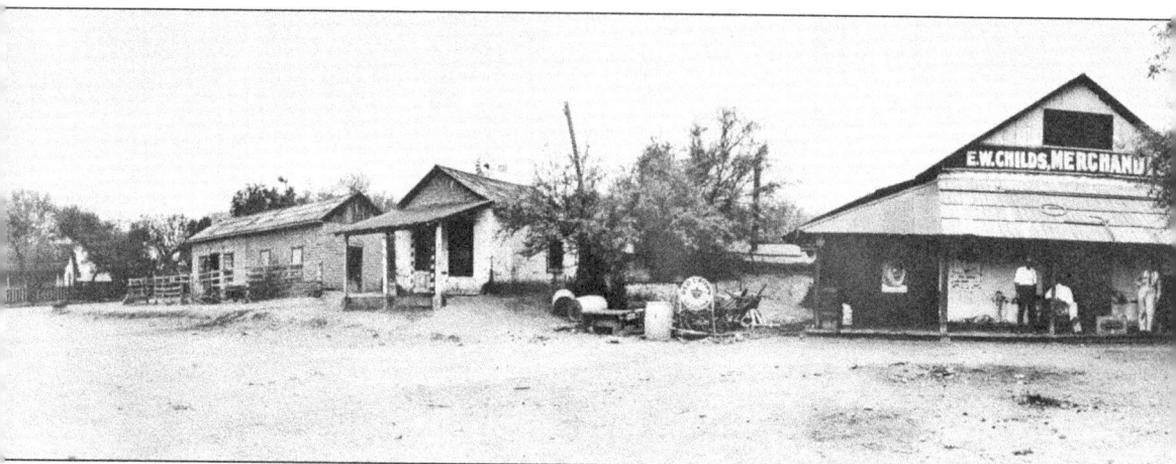

Eugene W. Childs came to Arizona from Oakland, California, and settled in Mammoth about 1895. He established a general store, and for 30 years, he was an important merchant in Mammoth. J. C. Leverton hauled freight for Childs, as the Clark brothers likely did as well. Childs also purchased various mining claims and helped establish regular mail from Tucson. The mail had

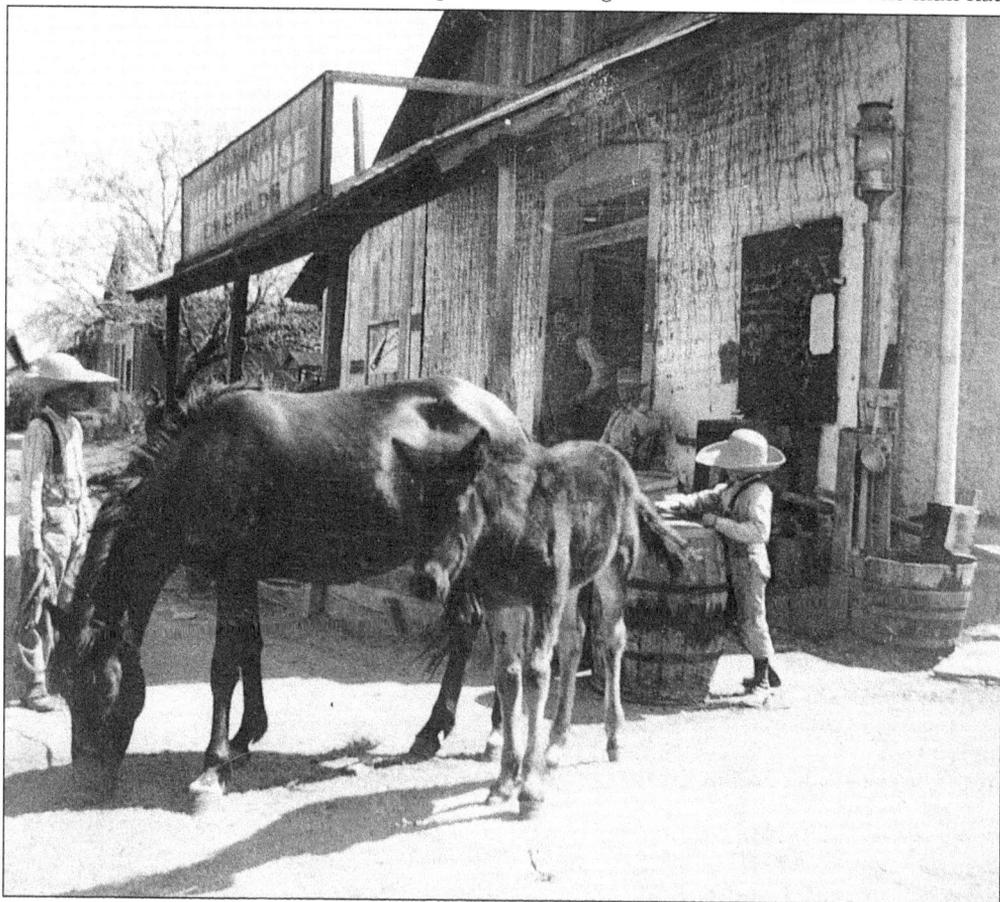

Two boys, a horse, and a mule colt stand in front of the E. W. Childs store around 1915. (AHF Gill-343)

46

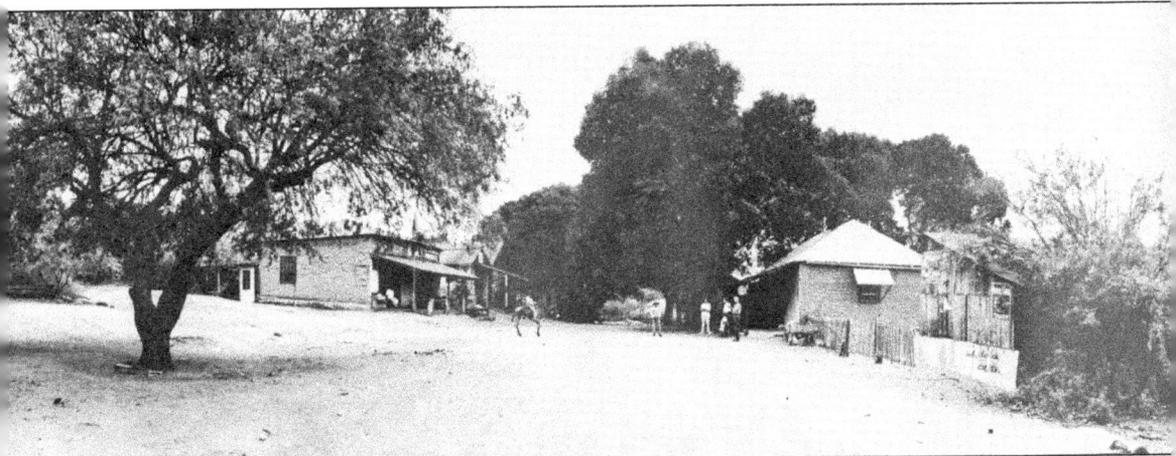

previously come from Winkleman, and often the river was too high to cross. This photograph of Mammoth was taken about 1920. (Herb and Dorothy McLaughlin Collection, ASU Libraries CP.MCL.85379.)

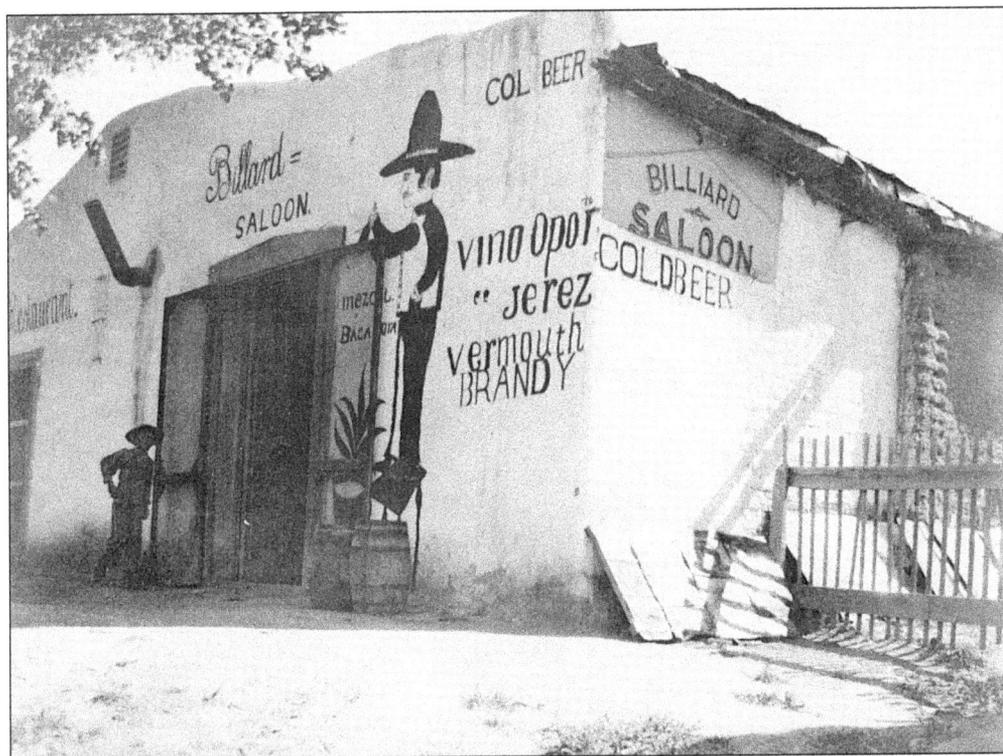

George Wilson described Mammoth in the early 20th century as "a tough little town." With his wife, he attended wrestling and boxing matches on Saturday nights at the saloon in Mammoth. He said, "Lambert Ramsay of Oracle was always the referee in the boxing bouts and really had a hard job as every once in a while one of the boxers would take a slug at the referee. In between rounds there were usually one or two fights going on amongst the spectators so you never had to wait for the bell to ring to watch a fight." One of Mammoth's saloons is shown above about 1915. (AHF Gill-342.)

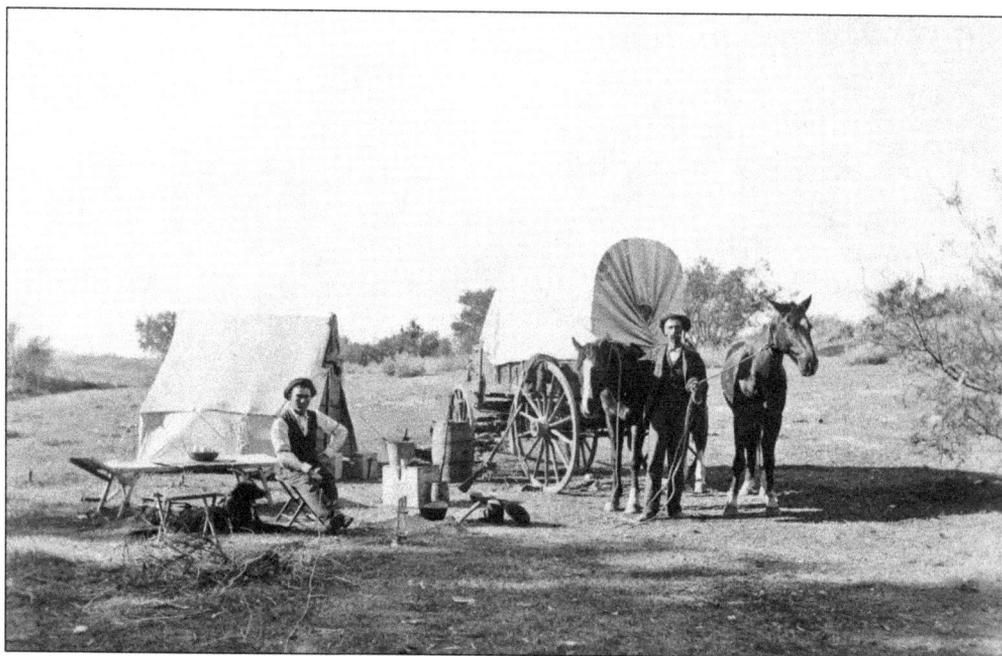

In the late 1890s, Charles R. Allen (right) came to Mammoth as a photographer. He poses here with his assistant, W. Jennings. Note the cord in Jennings's hand, indicating that he is taking the photograph. Allen described himself as a traveling photographer until he settled in Needles, California, sometime after 1900 and opened his own shop. (AHS-Tucson 25,346.)

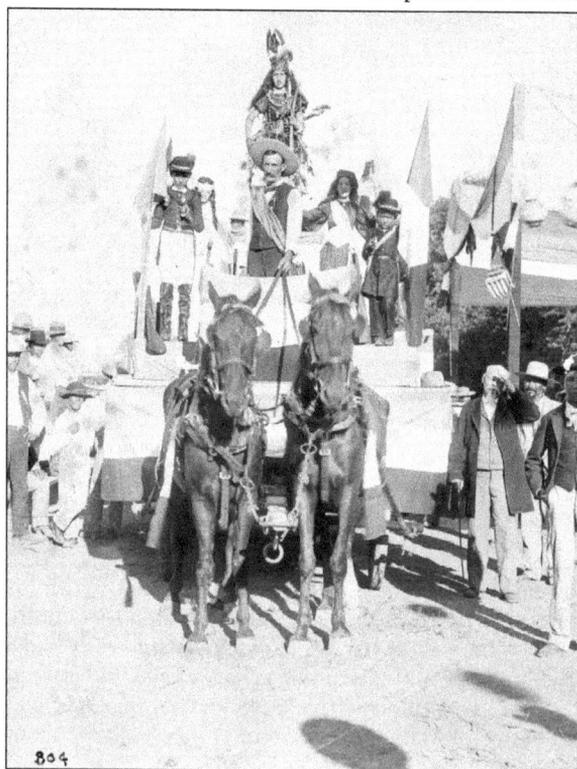

The vibrant Mexican culture in early Mammoth is illustrated in this 1908 image of Mexican Independence Day (September 16) celebrations. In two other Arizona Historical Society photographs, both the Mexican and American flags are being flown; one photograph includes the Childs children, while the other shows children in sailor costumes with oars. "Judge" Clarence Chrisman is on the right with the cane. (AHS-Tucson 804.)

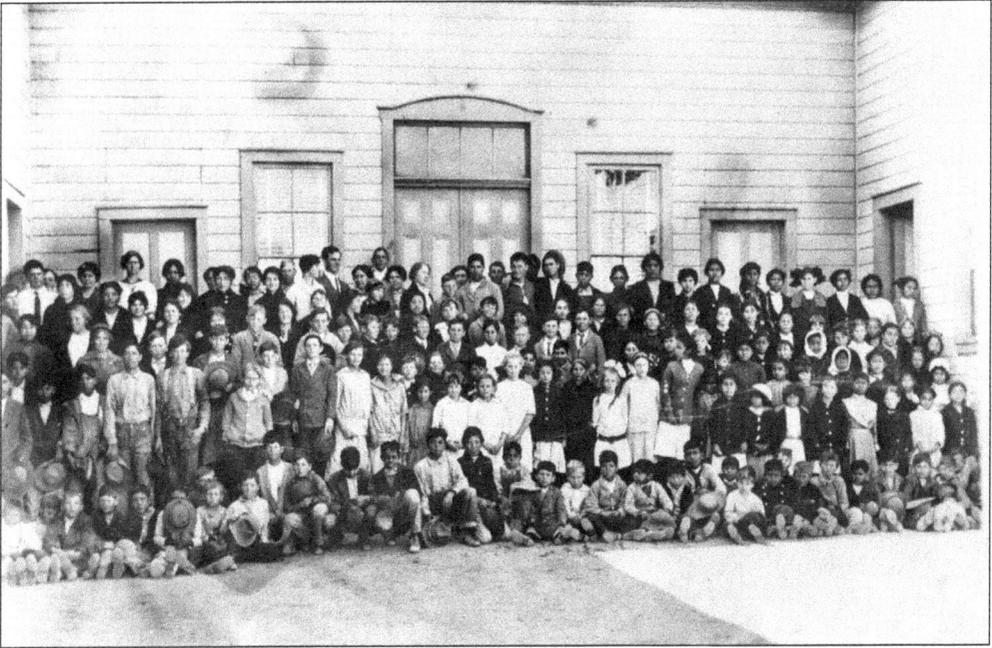

With the mine and the mill, Mammoth was a thriving town in the late 19th century. By 1890, it had a population of 600 to 700 people, and the school accommodated 70 students with one teacher. These photographs of the school at Mammoth were likely taken in the early 1900s. Above, about 150 students stand in front of the school. Pictured below is a classroom with students and their teacher; the class may be fifth grade, suggested by the number on the blackboard. Both images are from the Mercer family. (Above, AHS-Tucson 61,763; below, AHS-Tucson 61,762.)

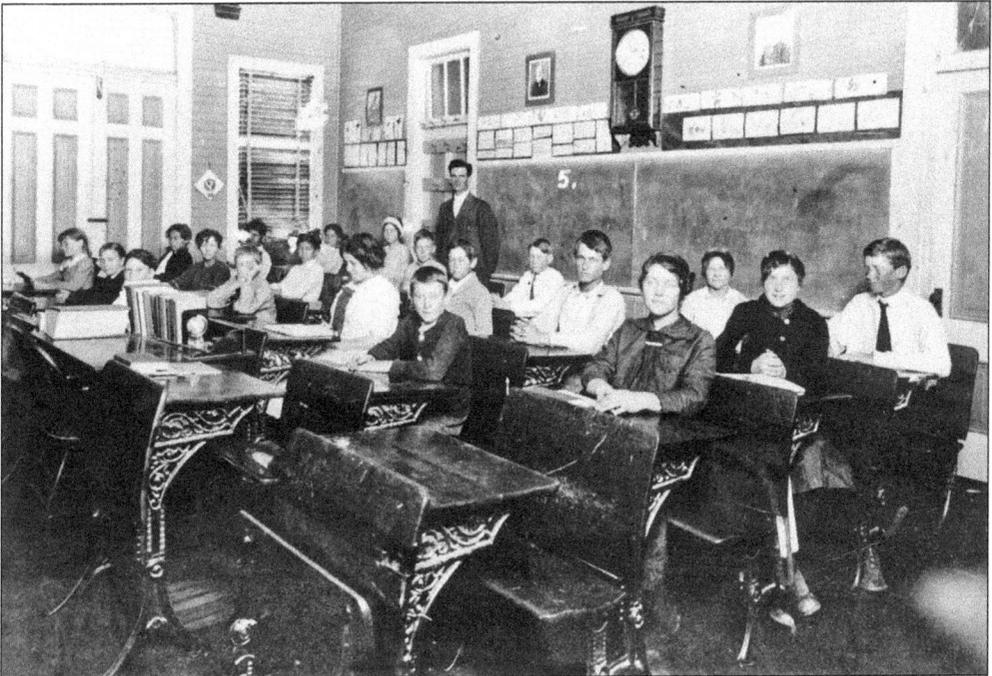

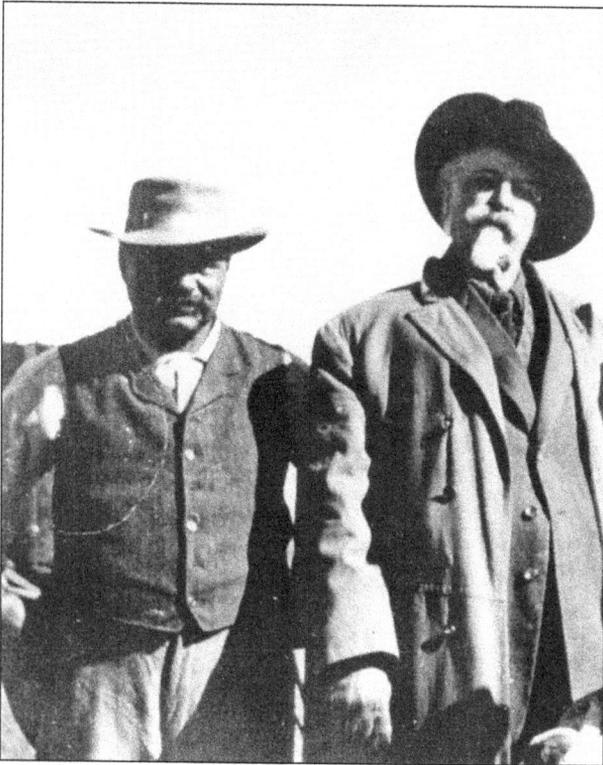

Alexander McKay, Jimmy Lee, and Albert Weldon are given credit for founding Oracle while prospecting for gold. The name Oracle is derived from the ship carrying Weldon from the East Coast. The first post office was established at American Flag Ranch. In 1898, William Neal (pictured on the left, with Buffalo Bill Cody [right] about 1911) built the Mountain View Hotel, shown below with visitors ready to ride. Its porches removed, the Mountain View is now part of a Baptist church. Oracle was always a mix of wealthy, mostly winter visitors and local residents who provided amenities for—and sometimes married—these visitors. (Left, AHF Schaus-G.Wilson-10; below, AHF Gill-308.)

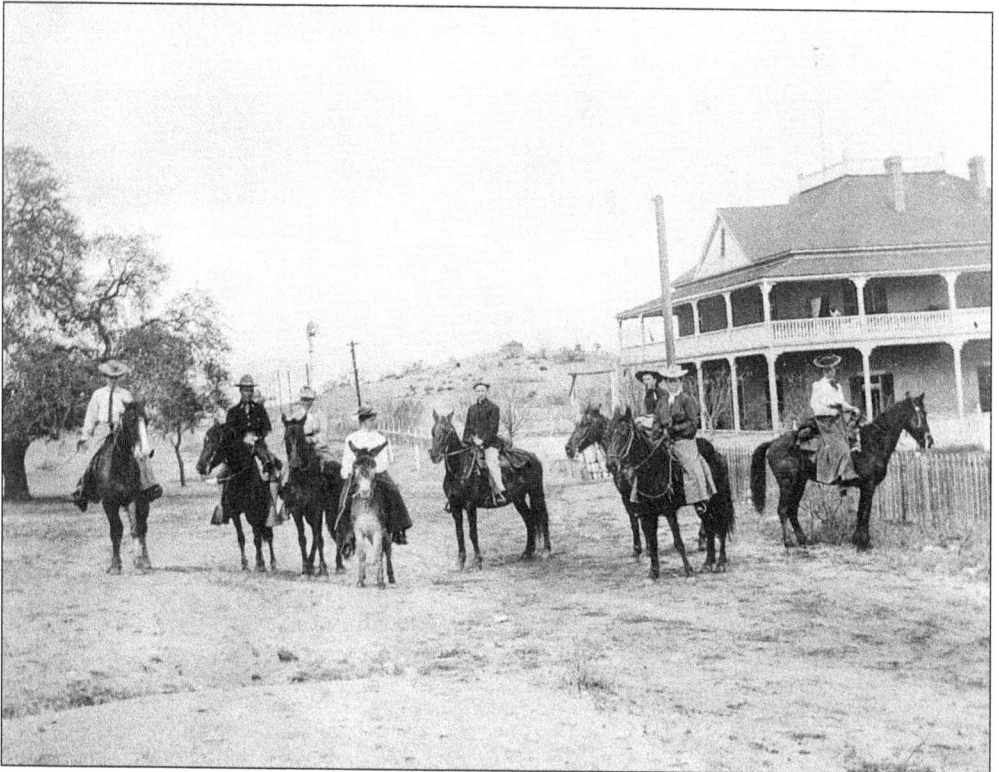

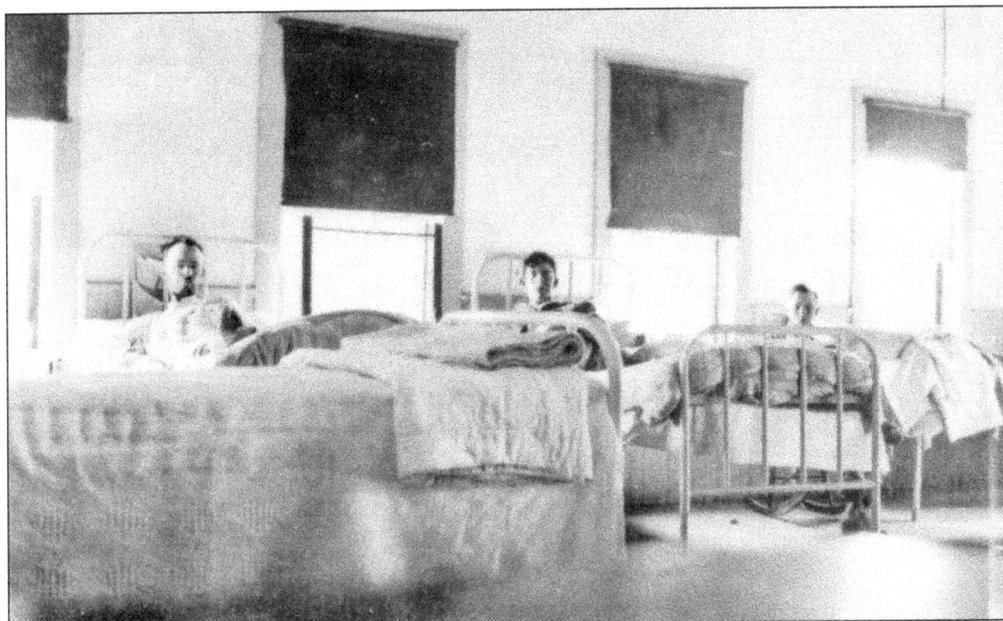

Edwin S. Dodge and his wife, Lillian, came to Tucson from Nova Scotia, Canada, about 1870. Believing the higher elevation would be good for his wife's health, Dodge moved to Oracle around 1880, bought goats and cattle, and called his ranch the Acadia after his homeland. He soon built the structure that now houses the Oracle Historical Society and rented rooms. Both wealthy visitors and tuberculosis patients (above) stayed at the Acadia. Seen below is the Acadia porch with its gramophone. The Acadia and Mountain View were friendly rivals, sponsoring dances, horseback riding, races, and shooting contests. (Both, OHS.)

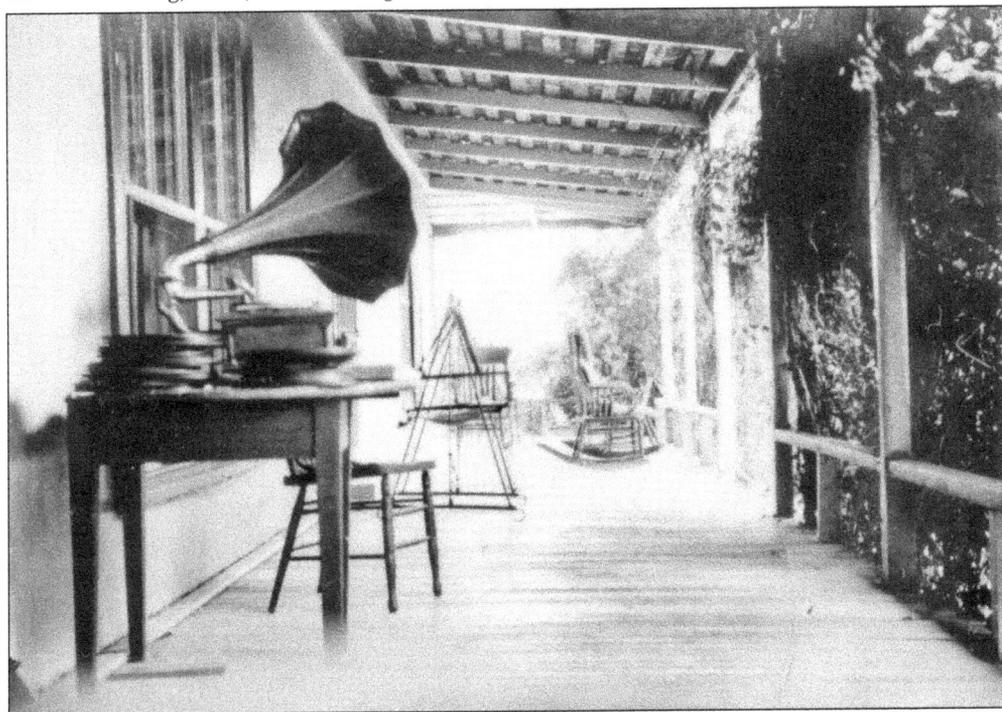

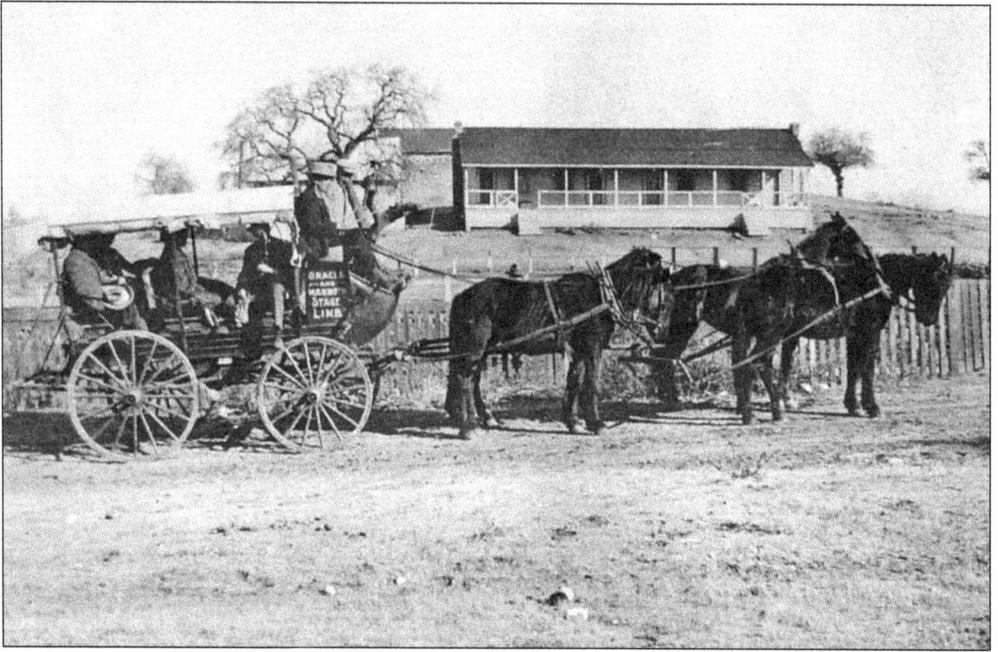

Before the advent of the automobile, horses were indispensable for travel between Tucson, Oracle, and the communities along the San Pedro River. Visitors to Oracle and residents from both Mammoth and Oracle traveled in light wagons. A sign underneath the driver's seat reads "Oracle and Mammoth Stage Line." Above, the stage is stopped in Oracle near a building behind the Mountain View Hotel. Shown below is a rough section of road, probably in the Santa Catalina foothills between Oracle and Tucson. Passengers occasionally had to walk up a particularly steep section or help clear the road of large rocks after a heavy rain. Both photographs were taken about 1915. (Above, AHF Gill-408; below, AHF Gill-409.)

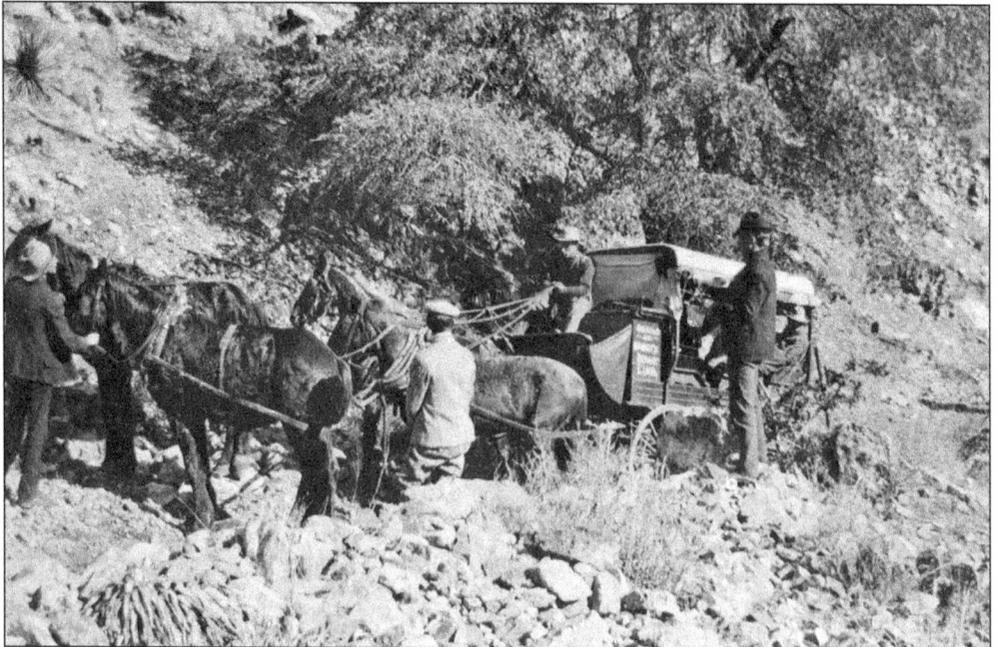

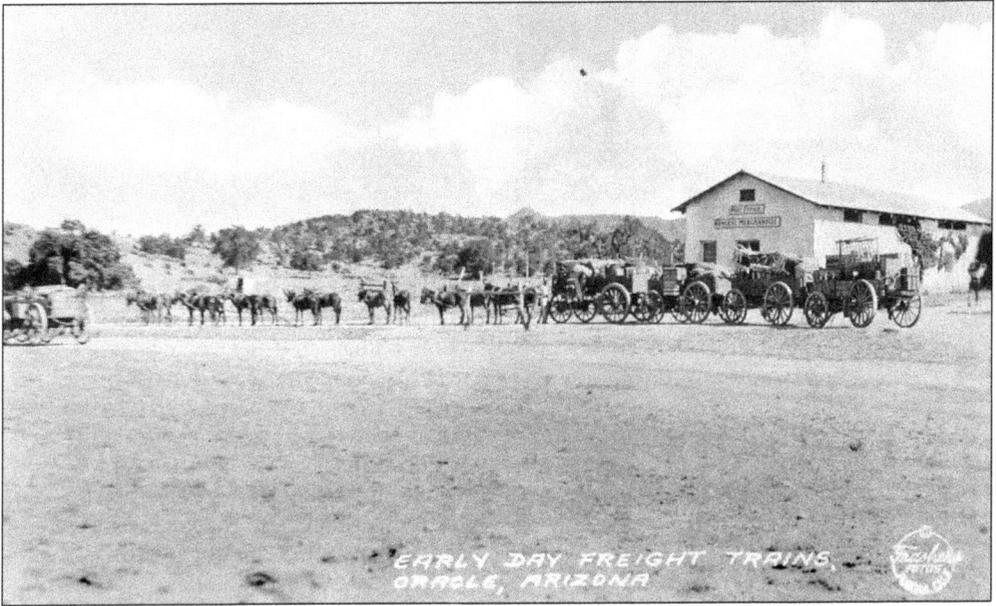

Freight was often hauled with a team of 10 to 20 mules or horses hitched to double or triple wagons, as pictured above in front of the Terry and Lawson store in Oracle. Most profitable were the wagons that hauled loads both ways. A 10- or 12-horse team (below) rests in front of the Mountain View Hotel. Note how the horses have been paired by color, with black in the front and white in the back. Both images date to around 1915. In 1893, freight hauled from Tucson to Mammoth cost $15 per ton. (Above AHF Gill-419; below AHF Gill-416.)

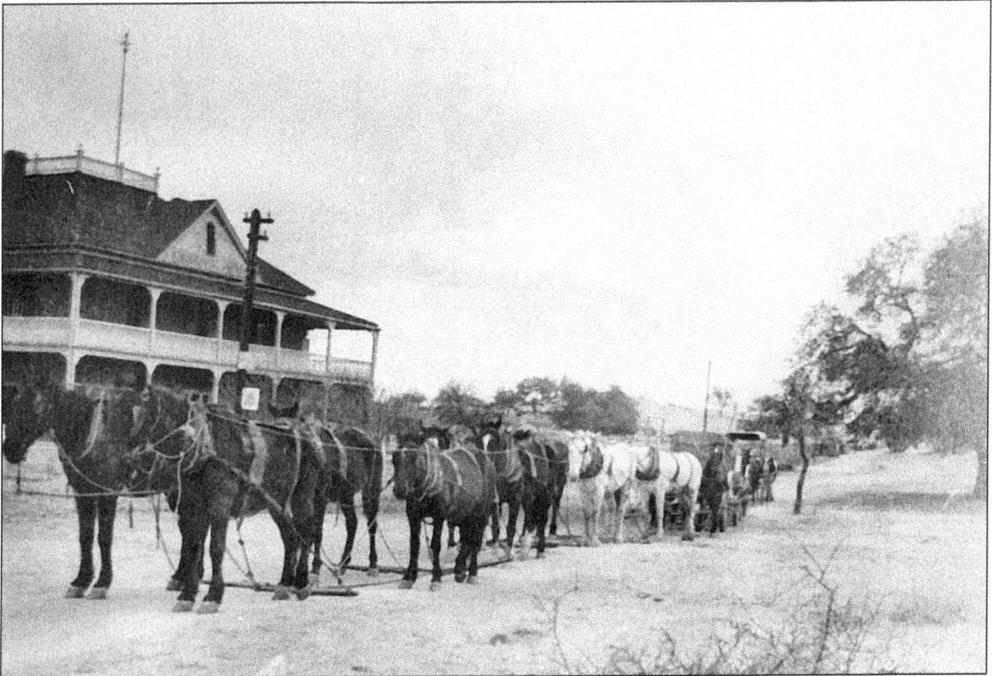

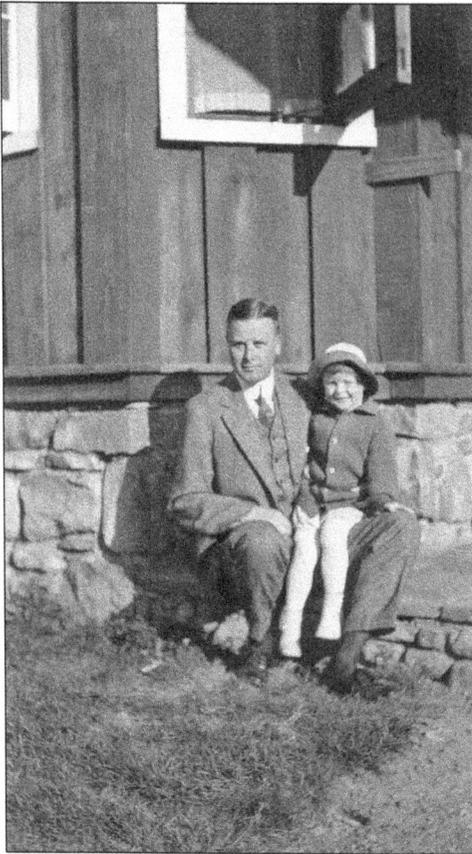

Born in Oregon, Charles Leslie Gilliland first traveled to Arizona in 1901. There he met Helen Galey, the daughter of manufacturing tycoon William T. Galey. In 1869 at age 17, Galey had emigrated from Ireland. Some 20 years later, he partnered with Charles E. Lord to operate Aberfoyle, a cotton mill in Chester, Pennsylvania, and the firm Galey and Lord to market fabrics to the apparel industry. Gilliland and Helen Galey were married about 1908, and the next year, their daughter Helen Fairrie Gilliland was born. Shown on the left is a snapshot of Gilliland with his daughter, who would not live many years beyond this photograph. Below, Helen Gilliland sits on a cot reading a book in front of the couple's Oracle tent house around 1915. Stoves were used for chilly winter nights; note that the stovepipe extends a few feet horizontally so the canvas tent will not catch fire. (Left, AHF Gill-5; below, AHF Gill-257.)

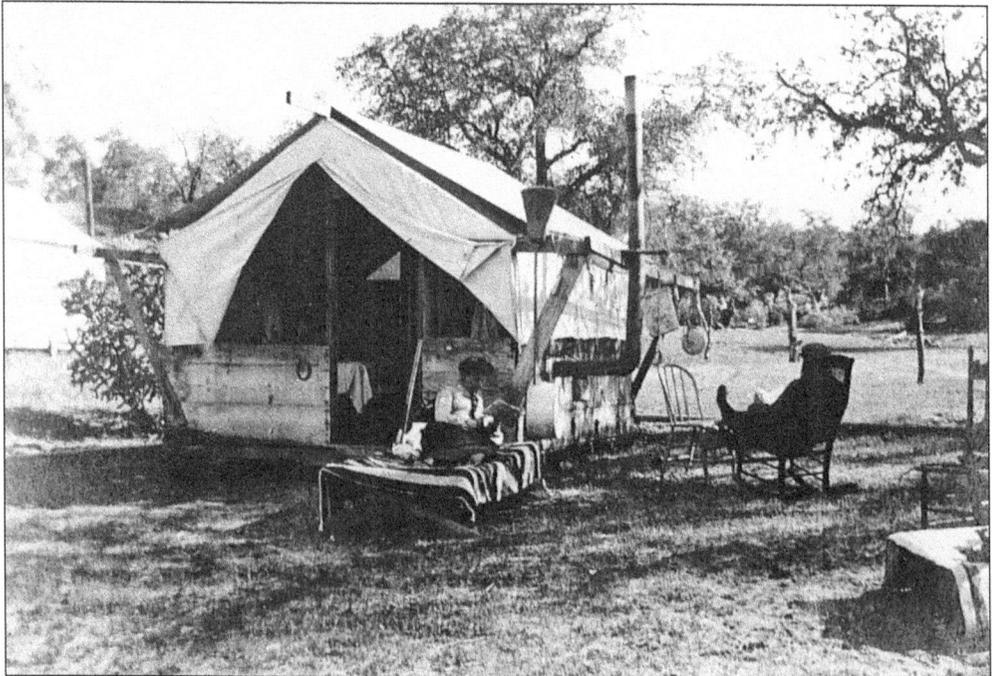

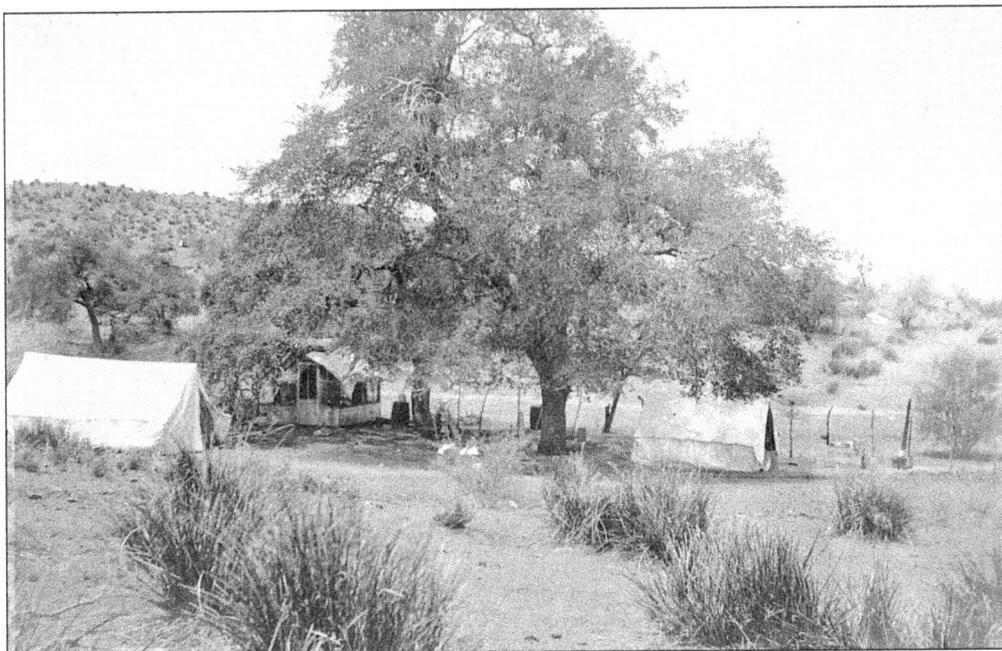

In Oracle, both residents and visitors lived in tents. When George Stone Wilson first came to Oracle in 1906, he stayed at the Mountain View Hotel. He wrote, "A great many of the guests had asthma or TB and coughed a great deal, which kept me awake." So after a few weeks, Wilson "asked Mrs. Neal if she would have a small tent house built somewhere near that I could use." When finished, it was located a quarter-mile from the hotel and under a big oak tree, similar to the photograph above from the Gilliland collection. Wilson also mentioned that "an old Mexican wood chopper lived in a tent about a hundred yards from mine." The tent below may have belonged to John Lawson. Not many of the tents in Oracle had a large front awning or porch, but Lawson's did. (Above, AHF Gill-275; below, AHF Gill-377.)

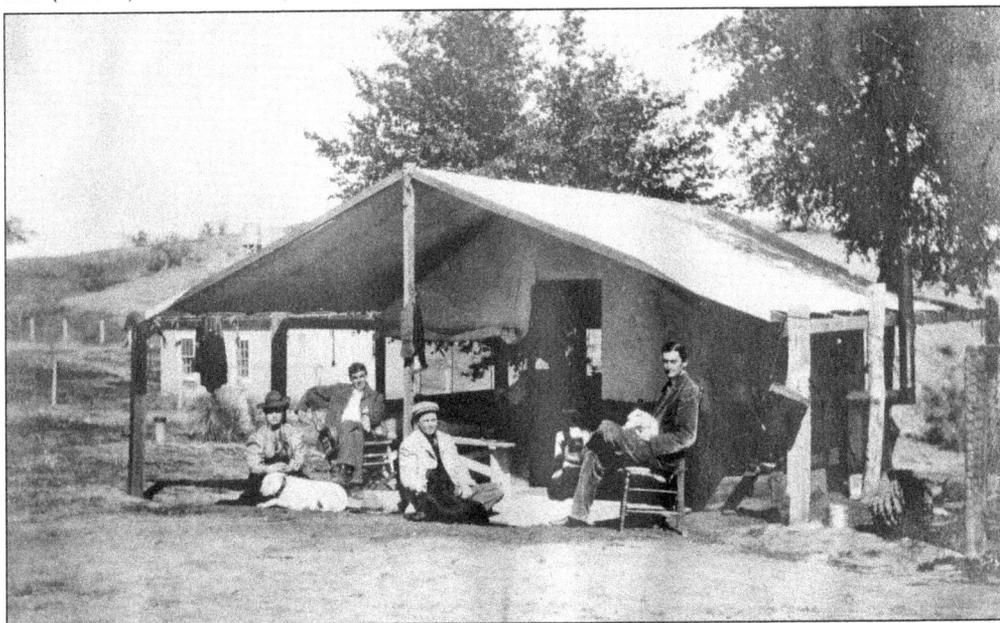

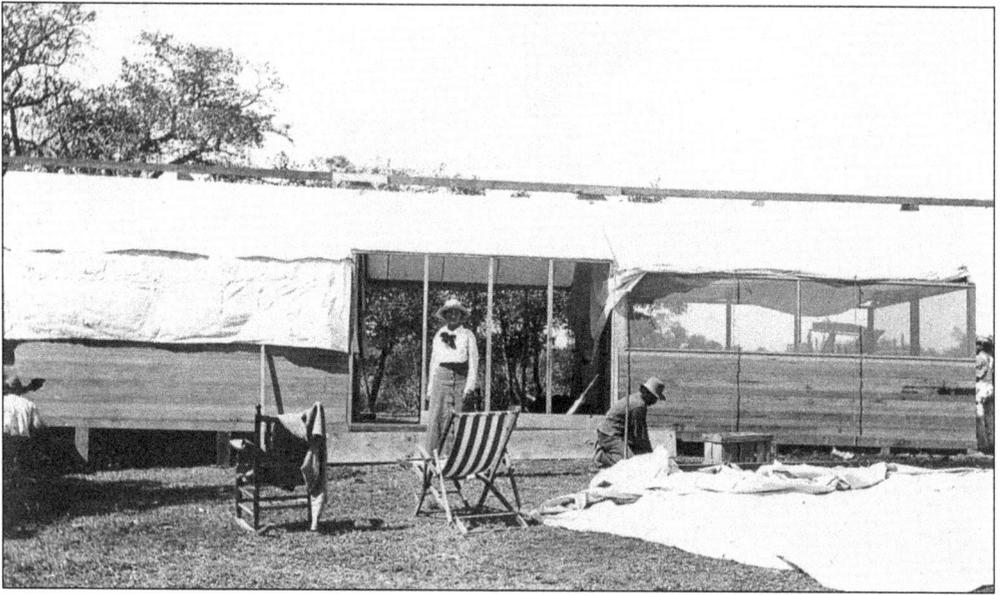

Wilson recorded that it took the carpenter about three days to finish his tent. Above, Helen Gilliland supervises the construction of their large tent; note the raised canvas with netting underneath on the right end, allowing a cool breeze to pass through. Below, Charles Gilliland stands in front of the tent, complete with American flag, clothesline, and olla suspended from the tree to keep water cool. (Above, AHF Gill-440; below, AHF Gill-437.)

Basking in the sun at the side of his tent house is a man identified only as "Uncle Bob," presumably a friend or relative of the Gilliland family. Note his hob-nail shoes. (AHF Gill-445.)

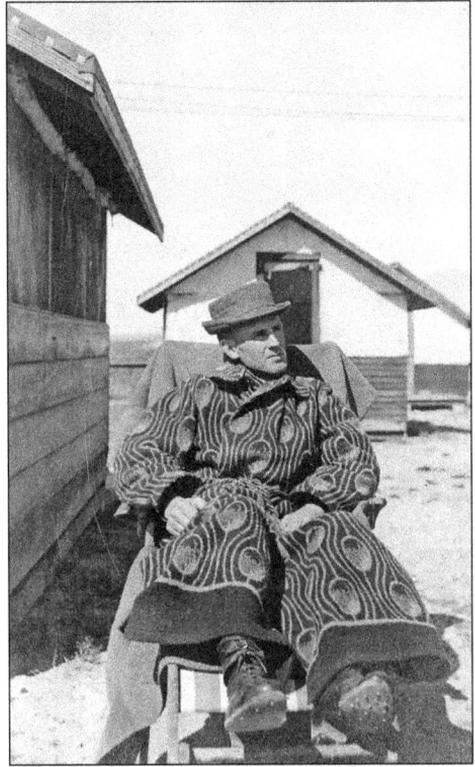

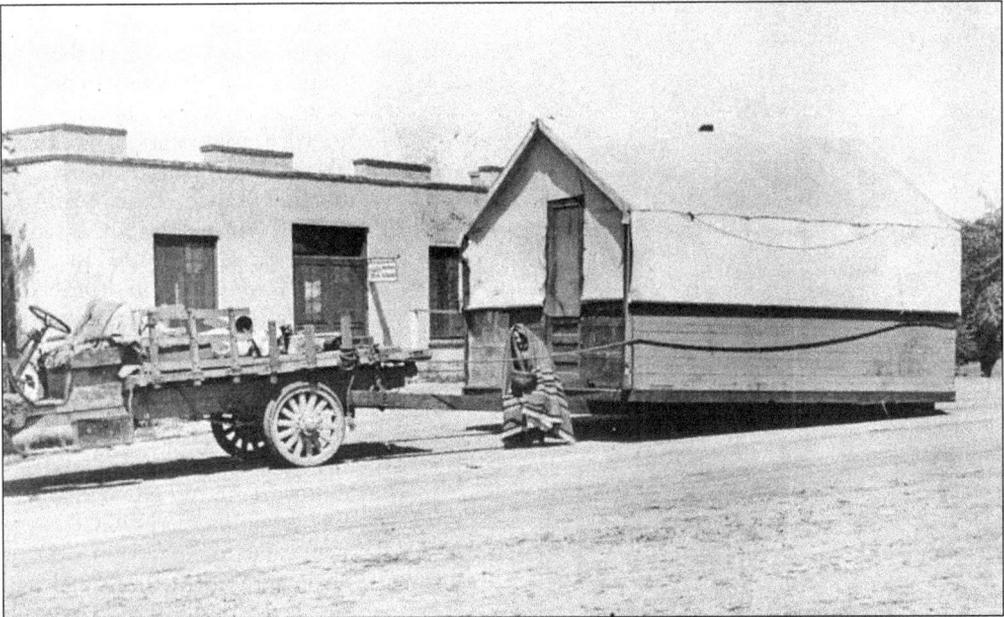

Tents were used from October to April for winter visitors and occasionally during the summer for Tucson residents who wanted to escape the heat. The notation on this photograph indicates that at least some of the winter-visitor tents were moved "at the end of the season." The building in the background is the Green Parrot Tea Room, although the signature sunburst above the door is too dark to identify. (AHF Gill-558.)

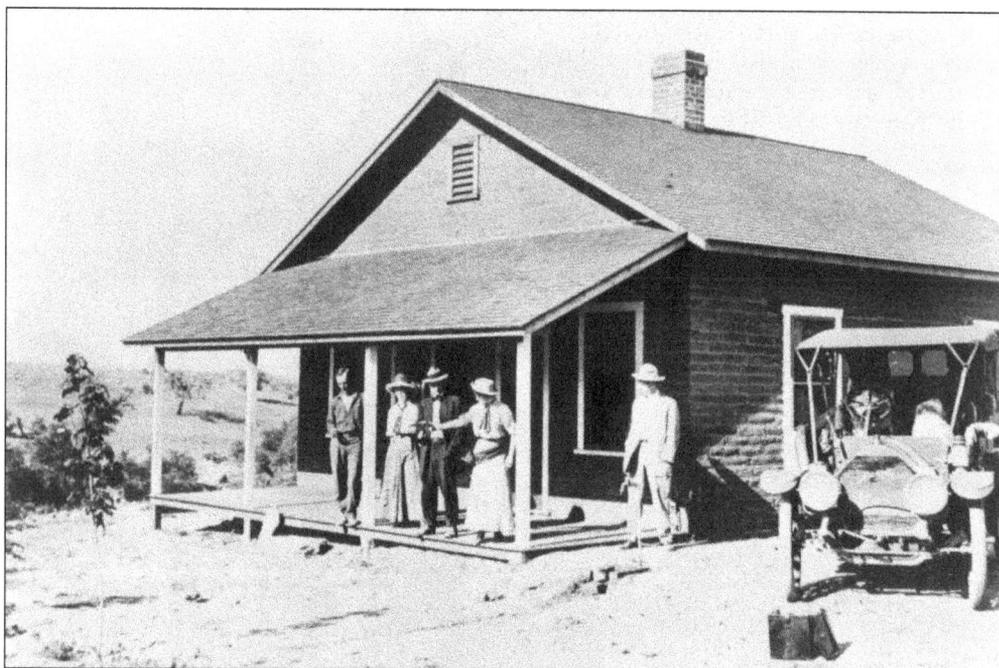

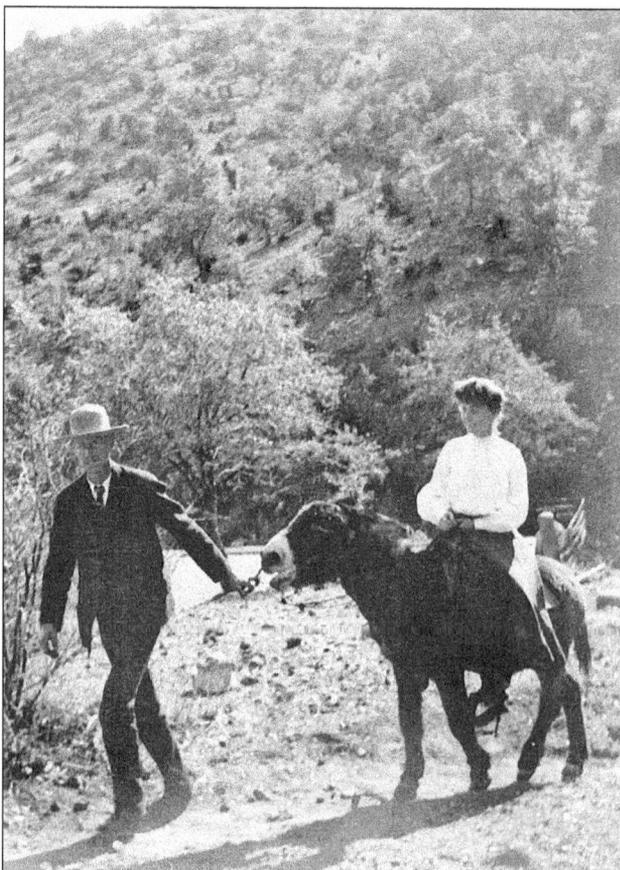

The Forest Reserves near Oracle were created by Theodore Roosevelt in 1907; the Coronado National Forest, created later, combined several reserves (mountain islands) from the Catalinas to Hidalgo County, New Mexico. The Catalina District ranger station, pictured above in 1911, was built just north of Rancho Linda Vista in 1907. James Westfall served as the ranger from 1907 to 1913. George Wilson described Westfall's wife as "a little on the tough side," so she may be the woman on the porch wearing the holster and pointing the pistol. Pictured left, a ranger leads the horse of a Gilliland family friend. When Civilian Conservation Corps (CCC) men came to Arizona in 1933, some were assigned to Oracle's ranger station. Today there are remnants of CCC watershed work, but the ranger station and CCC camp area have been bulldozed. (Above, Charles Sternberg; left, AHF Gill-300.)

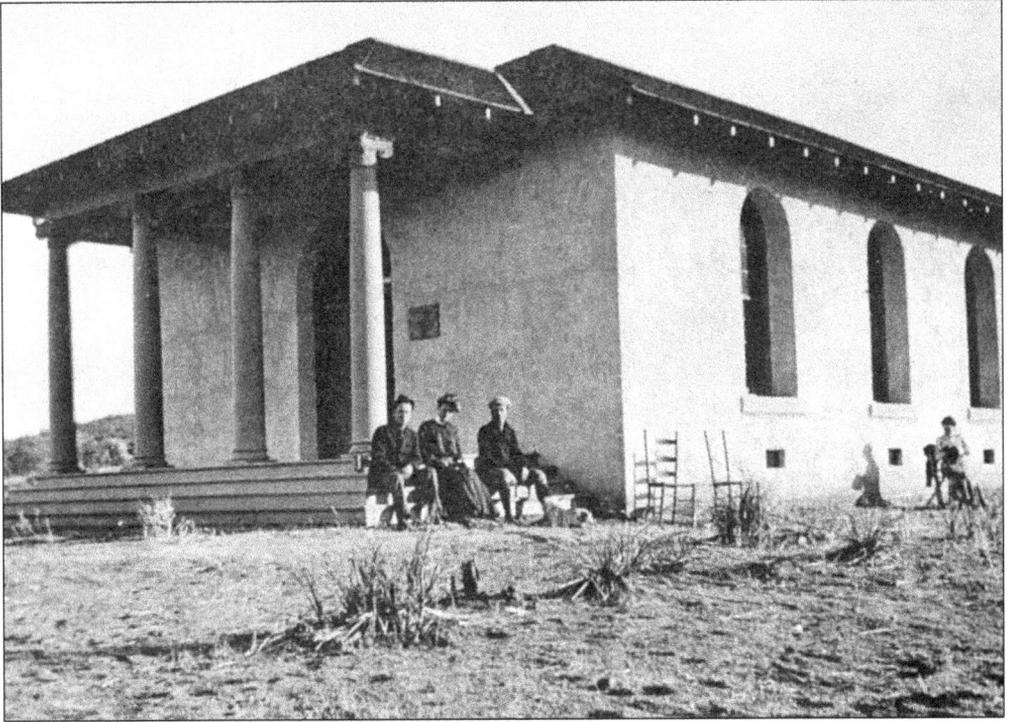

Lavinia Steward migrated to Oracle in 1898 with her husband, Henry, and her nephew Fred. Henry died four years later. In 1903, Lavinia had this adobe building constructed just east of her house as a library for the citizens of Oracle. It had two rooms—a reading room and a private sitting room. Frank Lockwood wrote on a later photograph, "Amid the trees gleam the white columns of a public library." By 1928, this building was being used for school classrooms. (AHF Gill-327.)

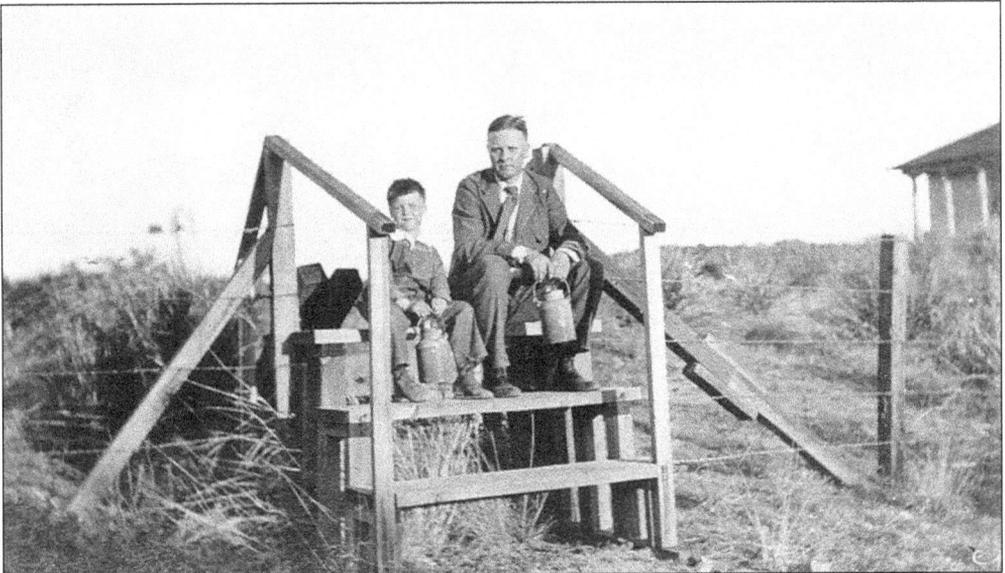

Around the library was a barbed-wire fence with this stile built for easier crossing. Here Charles Gilliland Jr. and Charles Gilliland Sr. pause for a photograph about 1915; their covered cans are presumably filled with milk. (AHS Gill-467.)

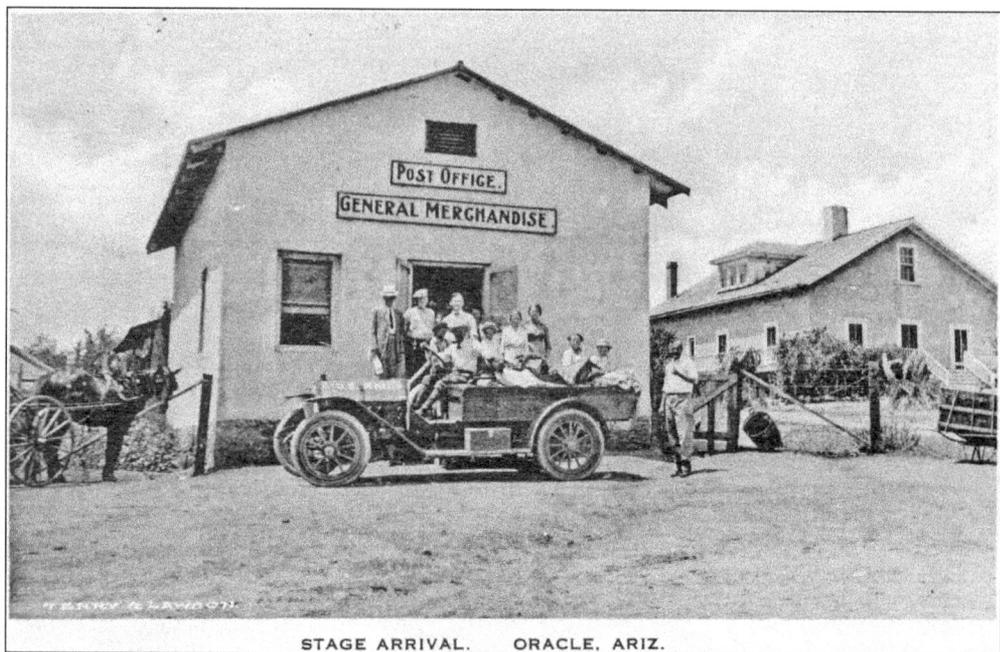

STAGE ARRIVAL. ORACLE, ARIZ.

In the early 1920s, merchants Leslie Terry and John Lawson printed a series of postcards to advertise the town of Oracle. Both the Triangle L Ranch postcard and the one above were part of this series. Mail was delivered to Oracle by automobile, a mode of transportation that also carried passengers and became the new stage. The above postcard was sent to Mr. and Mrs. S. W. Townsend of Wilkes-Barre, Pennsylvania, by Fred Kirkendall Jr. He mentions being "1½ miles from Oracle" on a ranch covering "75,000 acres and [having] 1,000 head of cattle." Kirkendall later became the mayor of Wilkes-Barre. Below, a wagon from Aravaipa delivers fruits and vegetables to Oracle and Tucson. (Below, AHS-Tucson 4114.)

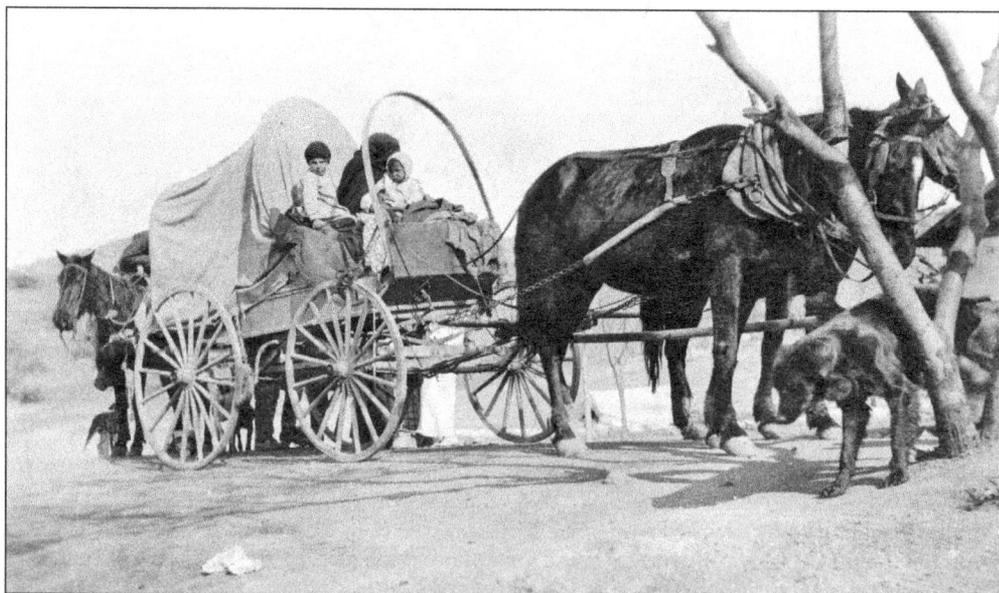

Born in Kentucky, Leslie Terry came to Arizona to establish a business partnership with Thomas McCauley. The two purchased the Oracle store; John Lawson later bought out McCauley's interest. Here Leslie Terry's youngest brother, Robert, washes clothes. (OHS 145.)

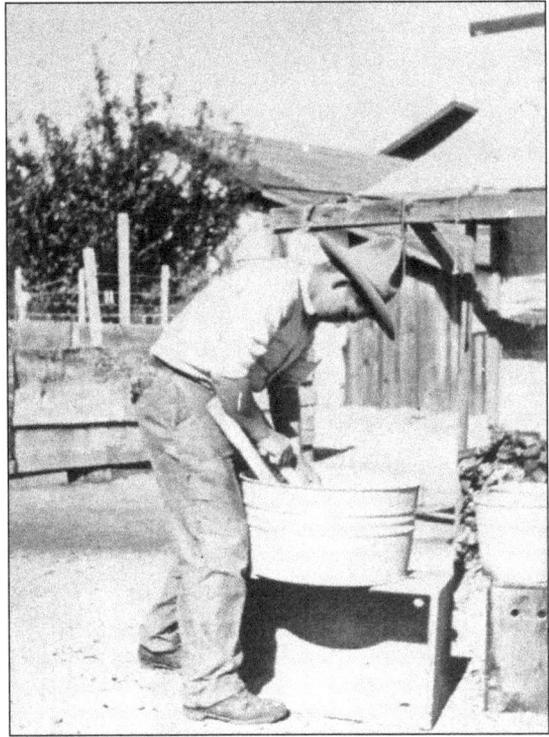

TRIANGLE "L" RANCH. ORACLE, ARIZ.

The Triangle L Ranch's most famous owner was William Bloodgood Trowbridge, who first traveled to Oracle in 1898 as part of an extended hunting trip across the country. In 1924, he bought the Triangle L and made it his permanent winter home. Trowbridge's philanthropic ventures included a new school for Oracle and the 320-acre Page farm, situated north of Tucson, for the University of Arizona and federal soil conservation service.

Archibald Ramsay journeyed to Arizona in 1885 to visit his uncle, Joseph Clark of Mammoth. Appalled by the desert, Ramsay returned to England, but then he wished he were back in Arizona. He returned in 1886 and 10 years later married Ora Black of Aravaipa. He homesteaded land in Oracle and was elected constable in 1919. Of his 32 years of service, Ramsay said, "I never drew a gun on a man, always settled things with talk instead." (Reg Ramsay.)

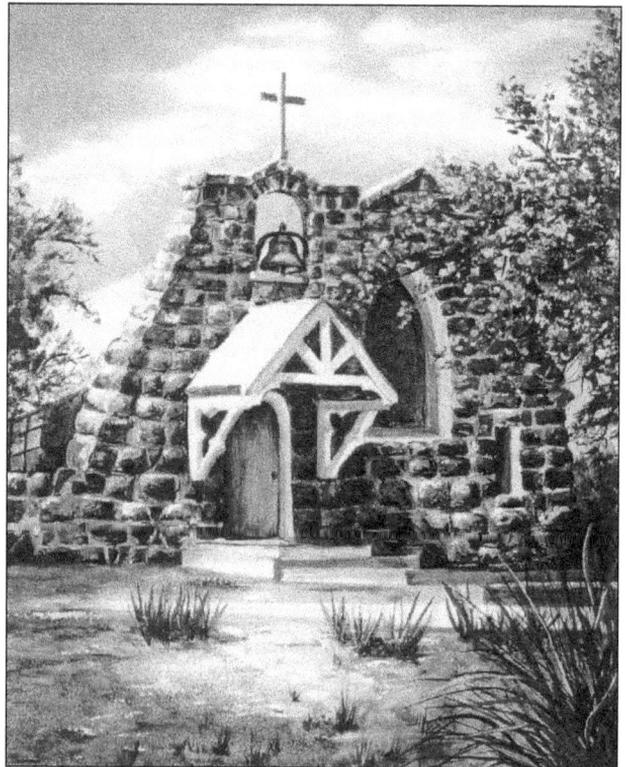

In 1901, the "little rock church" was built in Oracle through popular subscription. Archie Ramsay hauled rock, and Jesus Osoma served as stone mason. Always nondenominational, it was originally called the All Saint's Church and is now the Oracle Union Church. It was described on a postcard as "the most beautiful rural church in Arizona." This watercolor was created by Ethel Amator for the building's centennial. (Ethel Amator.)

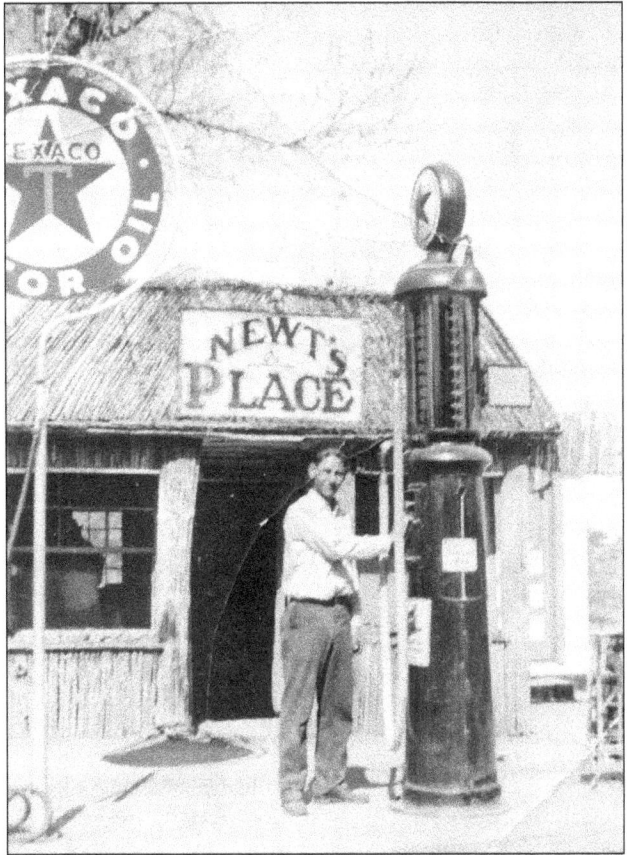

After automobiles arrived in Oracle, they needed both gasoline and repairs. One of Oracle's most distinctive businesses was Newt's Place, a combination gas station and garage with a pit. The building was made of saguaro ribs. George Musgrave stands beside the Newt's Place pump in the c. 1934 photograph on the right. Below, Reg Ramsay Sr. and his wife, Agnes, take a spin in their Ford Model T. (Right, Mike Muñoz; below, Reg Ramsay.)

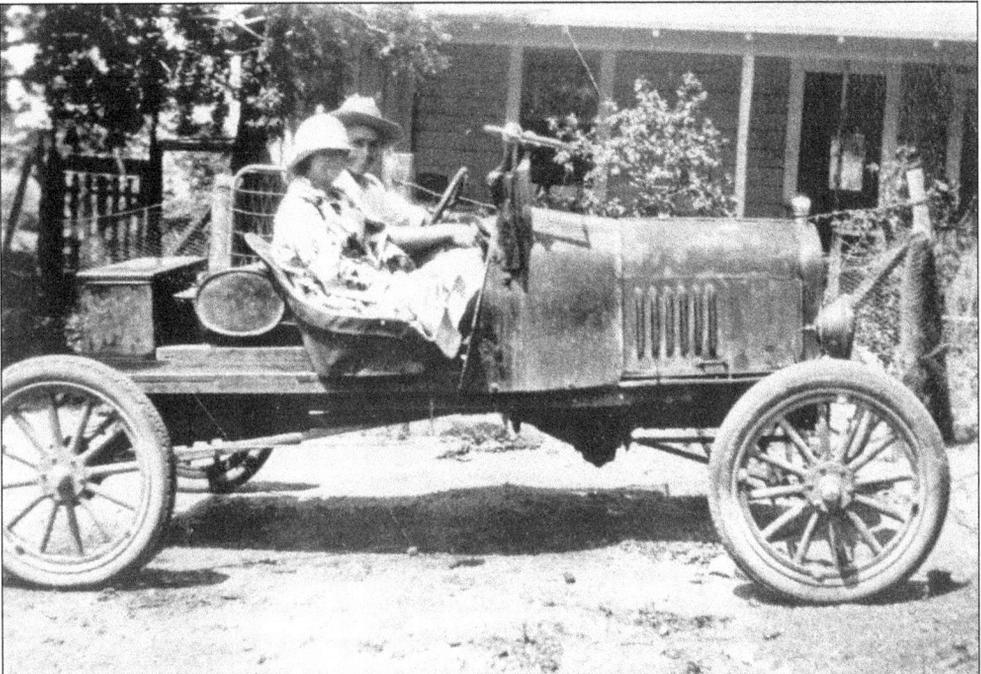

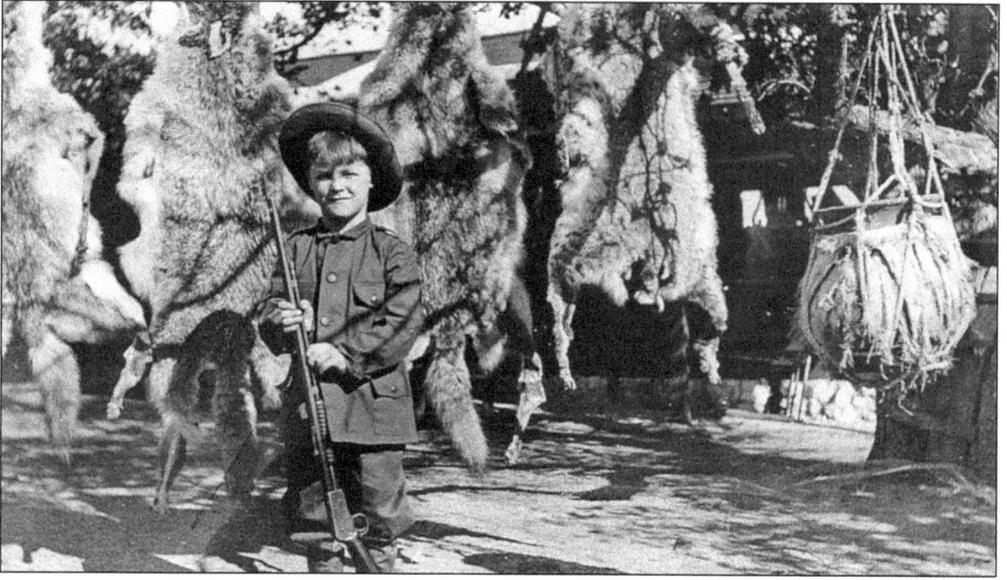

Oracle was an ideal place for a young boy to grow up in the early 20th century. Charles Gilliland Jr. is pictured in these *c.* 1914 images with coyote skins (above) and with an ax used to split wood (below). He grew up with animals, particularly chickens and rabbits; he fed lambs with a bottle and even had a pet raven. The family's mills in Pennsylvania specialized in cloth from mercerized thread, artificial silk (rayon), and khaki. Charlie's clothing, reminiscent of the style of Teddy Roosevelt's Rough Riders, was most likely made of khaki, a very serviceable material for Arizona's desert. (Above, AHF Gill-479; below, AHF Gill-478.)

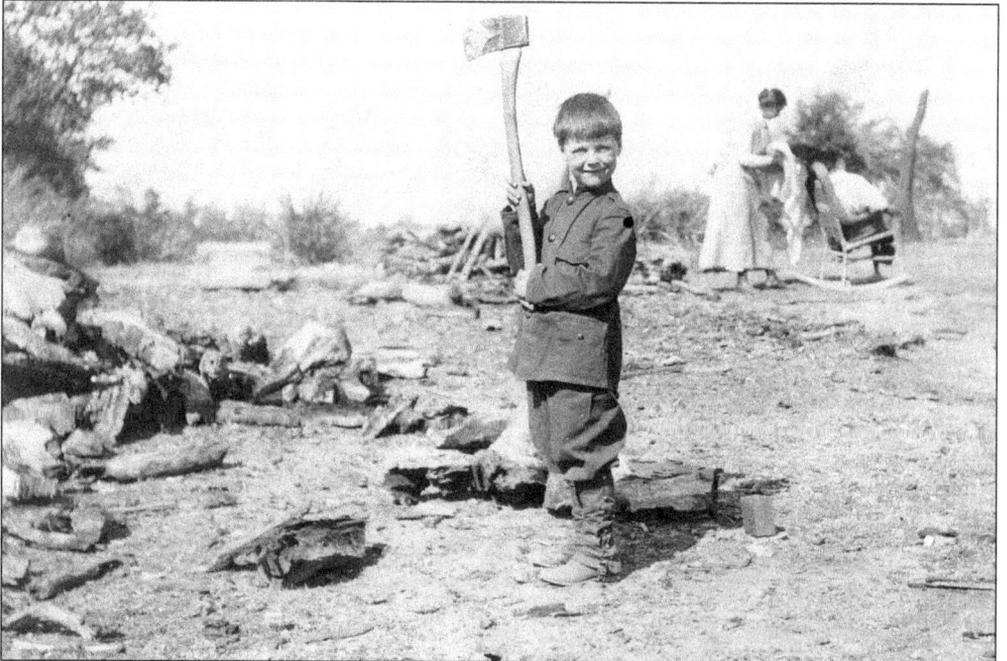

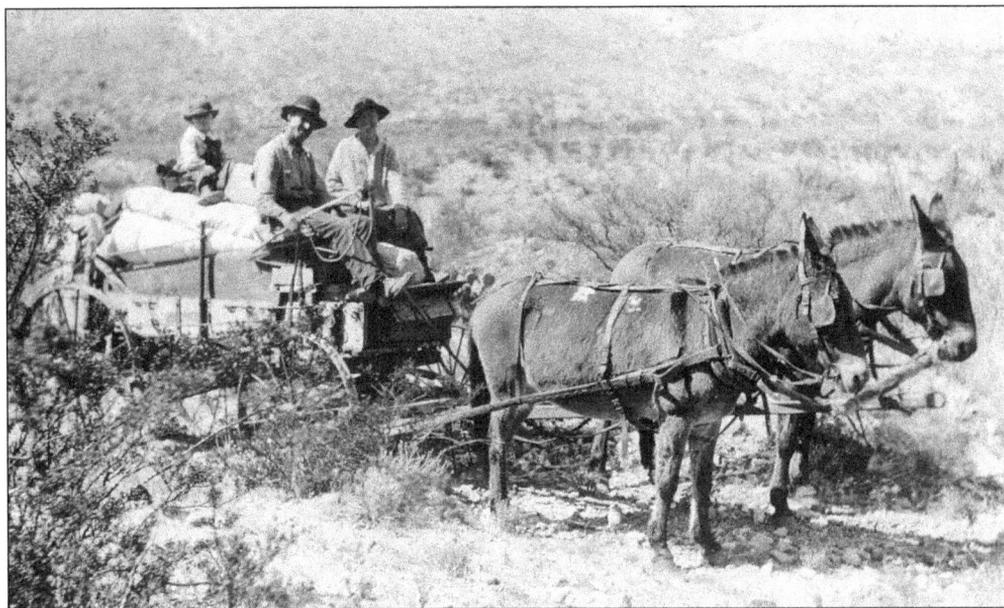

Visitors to Oracle nearly always indulged in camping trips. Elizabeth Lambert Wood recalled, "One trip we always enjoyed was the ride into Aravaipa Canyon to Trails End Ranch where our friends, Mr. and Mrs. Chauncy Buzan, were never too busy with their fruit growing to welcome us." One year, the Wood family spent six months at a cabin in the canyon. Above, a wagon takes the Gilliland family to Peck Canyon about 1915. Below, Archie Ramsay, Charles Gilliland, and other men from Oracle travel to Sonora, Mexico, via Sasabe to fish in the Gulf of California around 1925. The car being towed by the horses was presumably stuck in the sand, not mud. (Above, AHF Gill-506; below, AHF Gill-750.)

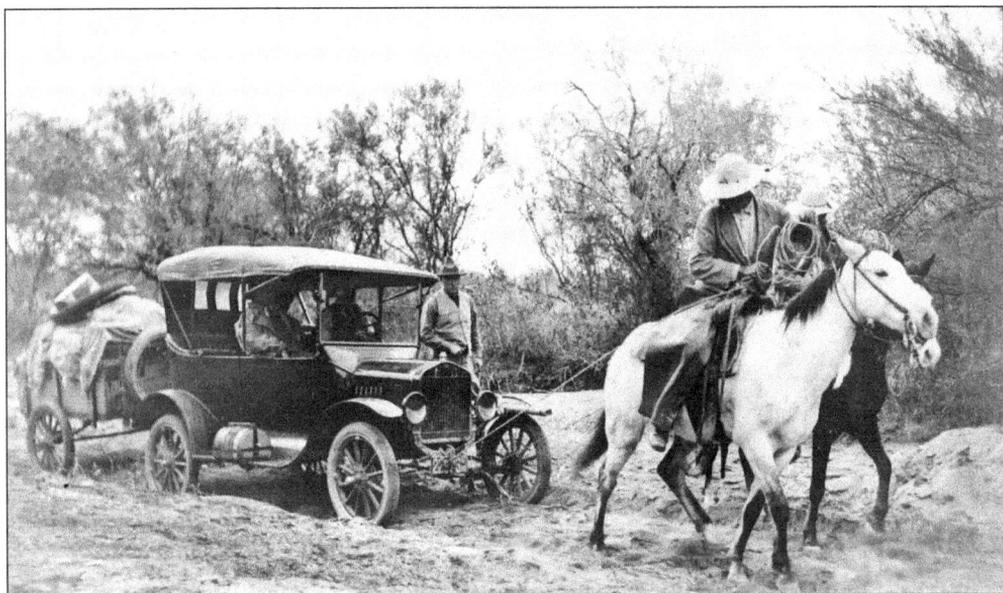

Sincerely yours
Harold Bell Wright
Tucson, Ariz.
1925

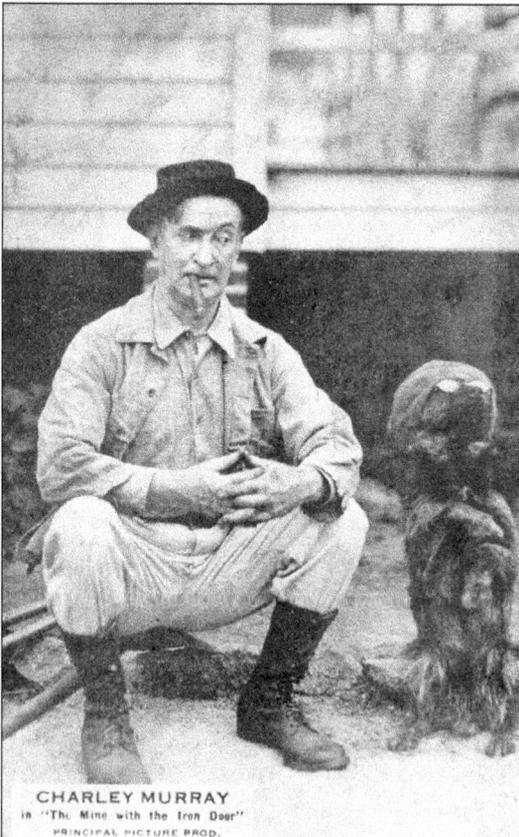

CHARLEY MURRAY
in "The Mine with the Iron Door"
PRINCIPAL PICTURE PROD.

Harold Bell Wright, pictured above in 1925, was a Disciples of Christ minister in 1902. His literary career began when he wrote *That Printer of Udell's*, from which he read one chapter per week to his congregation. By 1907, with two successful books in print, he resigned as pastor and, although despised by literary critics and clergymen alike, became a best-selling author. He lived in Tucson from 1916 to 1935; in 1923, he rented a cabin from George Wilson on the upper ranch at Rancho Linda Vista and used Canyon del Oro and Oracle as his setting for *The Mine with the Iron Door*. Hopefully no one like his character named Lizard ever lived in Oracle, but in reality, most of Wright's characters seem to have been based on real people from the area. Shown at left is Charley Murray, who played Bob Hill in the 1924 movie version of *The Mine with the Iron Door*. (Above, AHS-Tucson 45,722.)

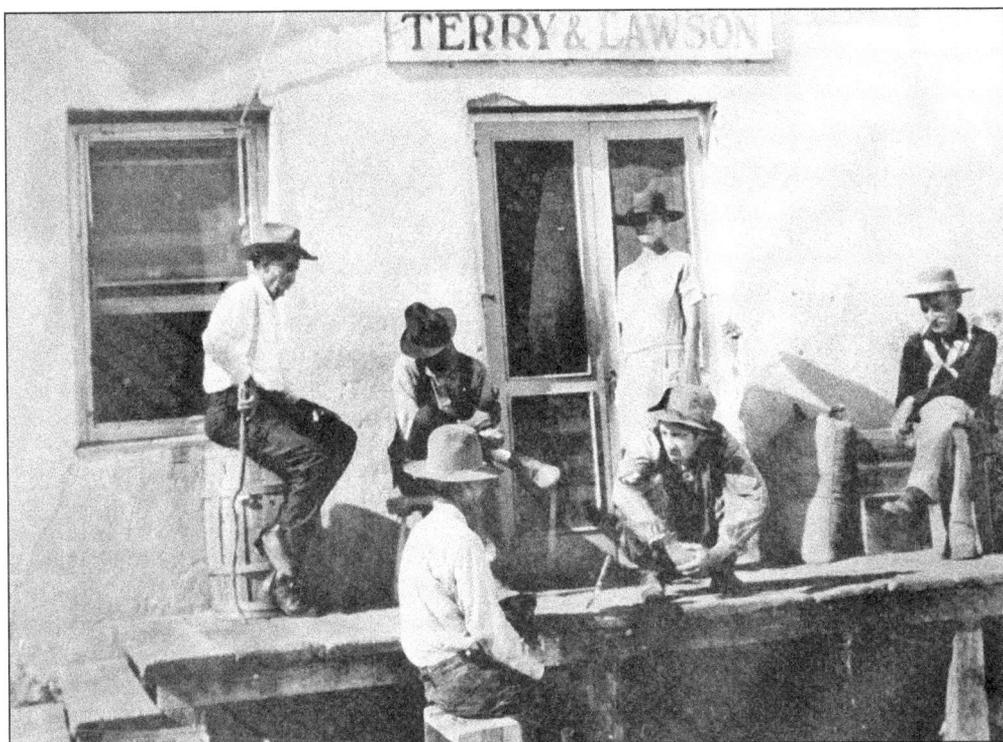

The 1924 silent film was shot on location (above), and Oracle residents were used as extras. No known copies of the movie exist in this country, though one copy is reportedly sitting in a vault in Russia. George Wilson reported that the director was careful to "not get any advertising in a picture," so although the Terry and Lawson store was used for some scenes, the name was usually covered with canvas labeled "Oracle Store and Post Office." In 1936, Columbia Pictures reshot the film, this time starring Richard Arlen and Cecilia Parker (right); this movie was not made in Oracle. As with many films of the time, the plot only vaguely resembled Wright's book. (Above, OHS 281.)

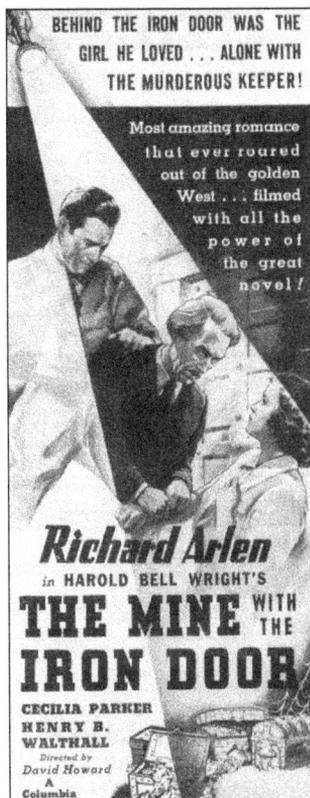

BEHIND THE IRON DOOR WAS THE GIRL HE LOVED . . . ALONE WITH THE MURDEROUS KEEPER!

Most amazing romance that ever roared out of the golden West . . . filmed with all the power of the great novel!

Richard Arlen in HAROLD BELL WRIGHT'S THE MINE WITH THE IRON DOOR

CECILIA PARKER
HENRY B. WALTHALL
Directed by David Howard
A Columbia

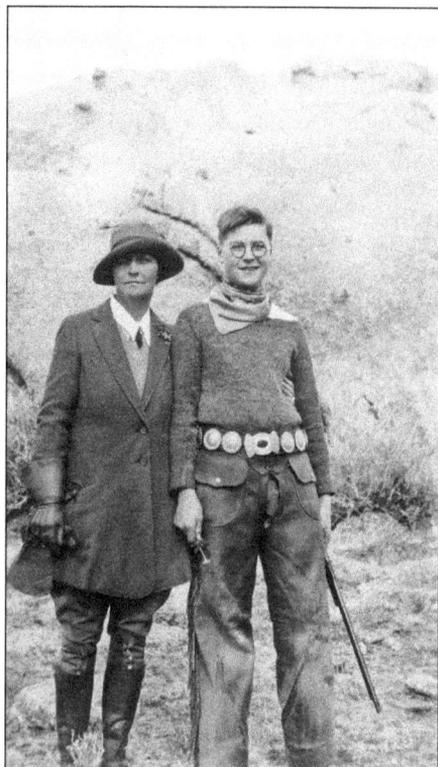

Although most Catholics in Oracle were Hispanic, both the Gilliland and Kannally families were Roman Catholic with ties to Ireland. In the late 1920s, Charles and Helen Gilliland financed a small, Spanish-style church, which was completed in 1927 at a cost of $5,000. Serving as architect was Roy Place, who also designed many of the University of Arizona buildings. The church was named St. Helen's in honor of Helen Gilliland (pictured left, with her son Charlie about 1922), the Gillilands' daughter Helen Fairrie (deceased), and St. Helen, the mother of Constantine the Great. Helen Gilliland lived only three years beyond the completion of the church. Many people visiting Oracle for the day stop to photograph the church. Bert and Myrtle Campbell captured the image below in 1943. (Left, AHF Gill-811; below, ASU Library CP.SPC.150:16.3.)

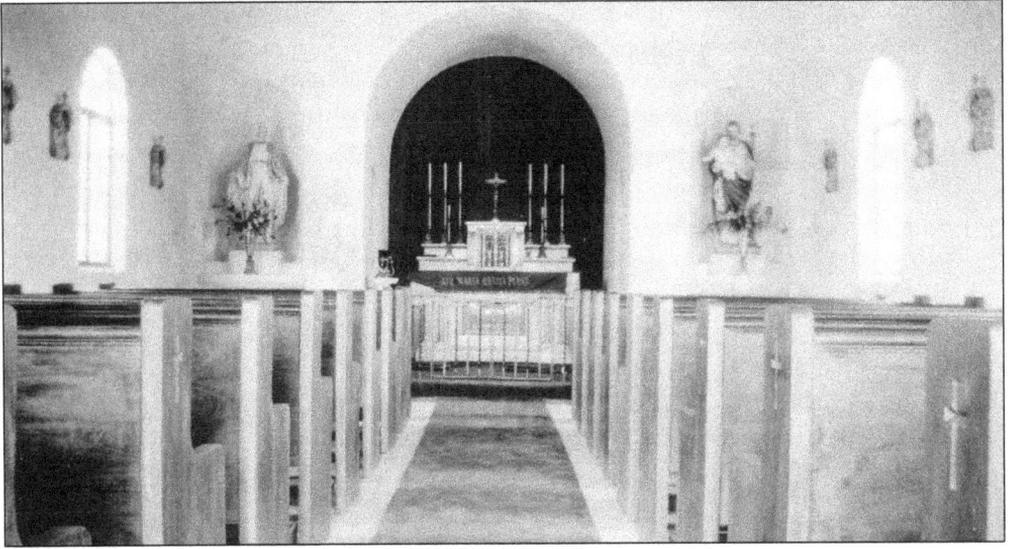

The interior of St. Helen's has changed little over the years. This photograph was taken sometime between 1927 and 1935, when the Kannally stained-glass window was added to the left. The other five stained-glass windows memorialize Gilliland family members and friends. A painting created by Mercedes Torros was installed behind the altar in 1959. (AHF Gill-1035.)

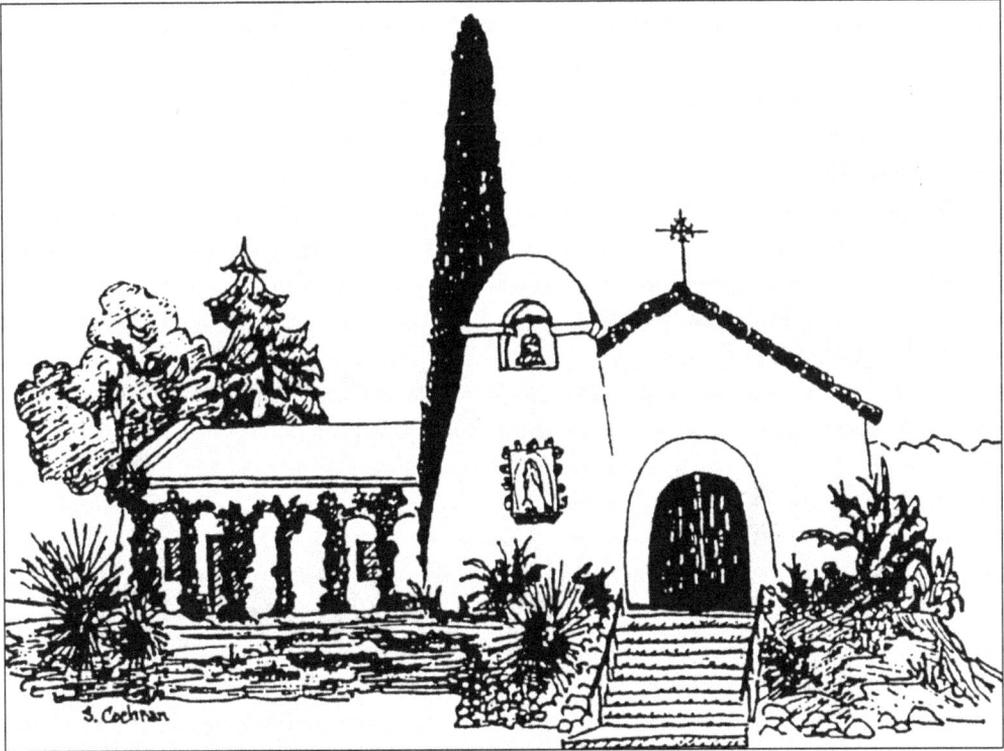

A combination reception hall and catechetical center was added to the side of St. Helen's in 1963; in 1989, the first St. Helen's Fiesta was held. Amalia Ruiz Clark wrote on that occasion, "This Church holds many memories for the Clark family as well as numerous other Oracle families who have found solace, comfort and joy within its sacred walls." (Drawing by Susie Cochran.)

69

The Gilliland family almost always had a Chinese cook. After the dedication of St. Helen's on April 10, 1927, a beautiful outdoor banquet was served at Rancho Robles. Nearly 100 guests attended, including out-of-town priests and the Clark, Kannally, Huggett, Jamison, Terry, Lawson, Trowbridge, and Wilson families of Oracle. (AHF Gill-790.)

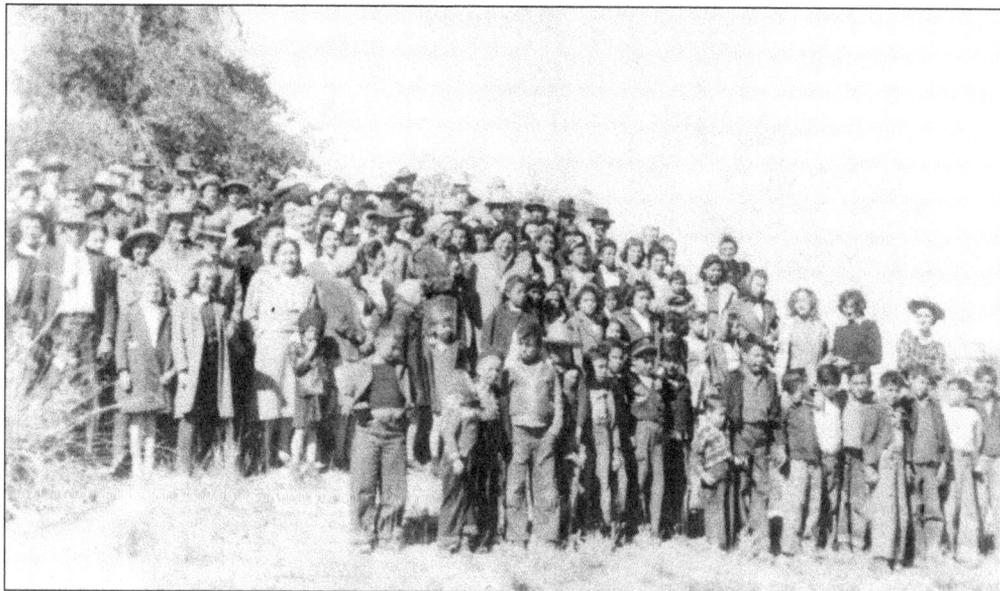

Originating in Mexico, Dia de la Muertos celebrates the lives of deceased relatives. In conjunction with the Catholic holidays of All Saints' Day (November 1) and All Souls' Day (November 2), children are remembered first and then adults. Families often visit the cemetery to clean and decorate the graves. Here a group gathers at the Oracle Cemetery in 1943. (Photograph by Otto Keller, OHS 337.)

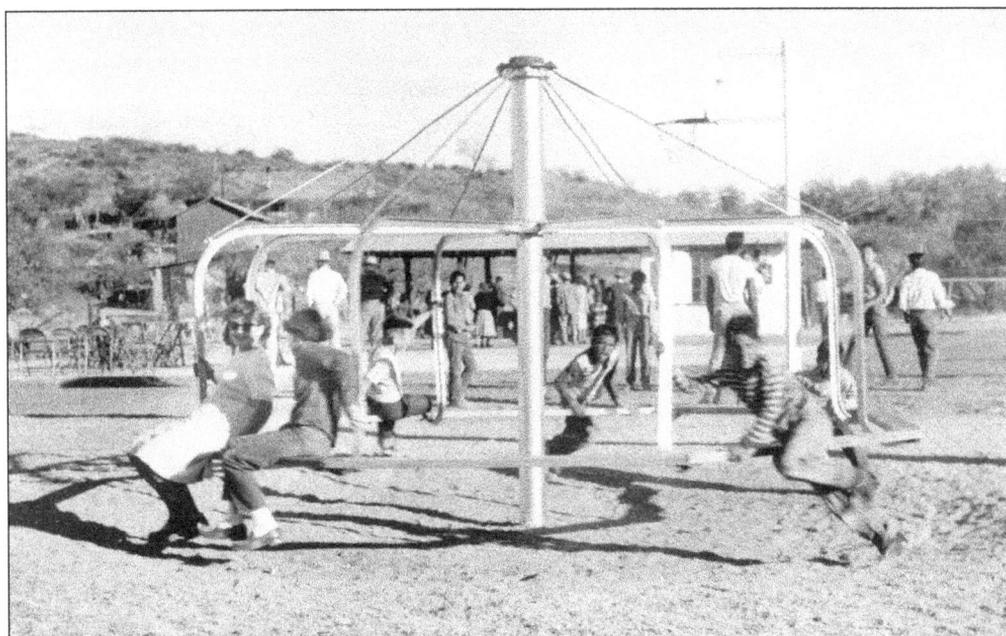

Elizabeth Lambert Wood came to Oracle from Portland in 1902 for her husband's health. Her life was filled with tragedy—her son was killed during World War I, her husband and daughter died soon afterward, and then her adopted grandson was killed during World War II. These events make her 1956 recipe for life all the more poignant: "Have faith in God, Blot out disappointments in people and events, Face danger unafraid, Get a thrill out of everything—eating, sleeping, working, visiting." She is remembered today for her generosity, especially with her donations of the Triangle Y Ranch, also known as Camp O' Wood, to the Salvation Army and a playground to the children of Oracle. The playground's construction was part of a 4-H project, and the result was dedicated around 1948. Below, Elizabeth Lambert Wood stands at the dedication; Sara Lackner (with her hand shielding her eyes) and Agnes Ramsay are to her right. (Both, Reg Ramsay.)

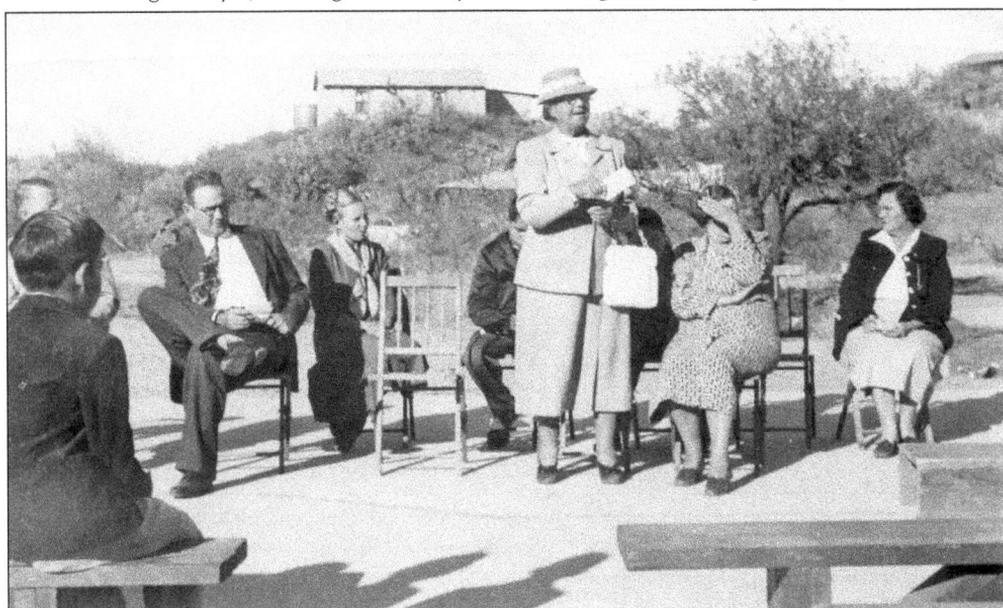

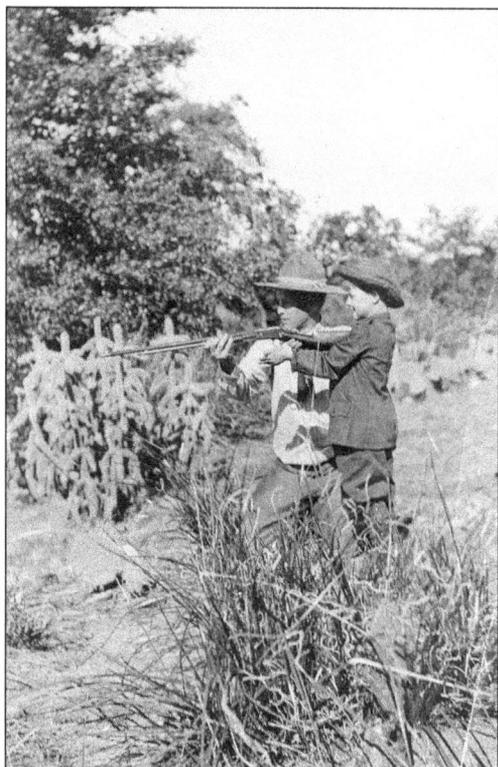

In Oracle, residents and visitors alike continue to hunt javelina, deer, and quail. Hunter safety classes are taught each fall for boys and girls 10 years of age and older. Reg Ramsay and his sons have been associated with this program for 40 years. Here Charles Gilliland Jr. is learning how to shoot at about six years old. (AHF Gill-474.)

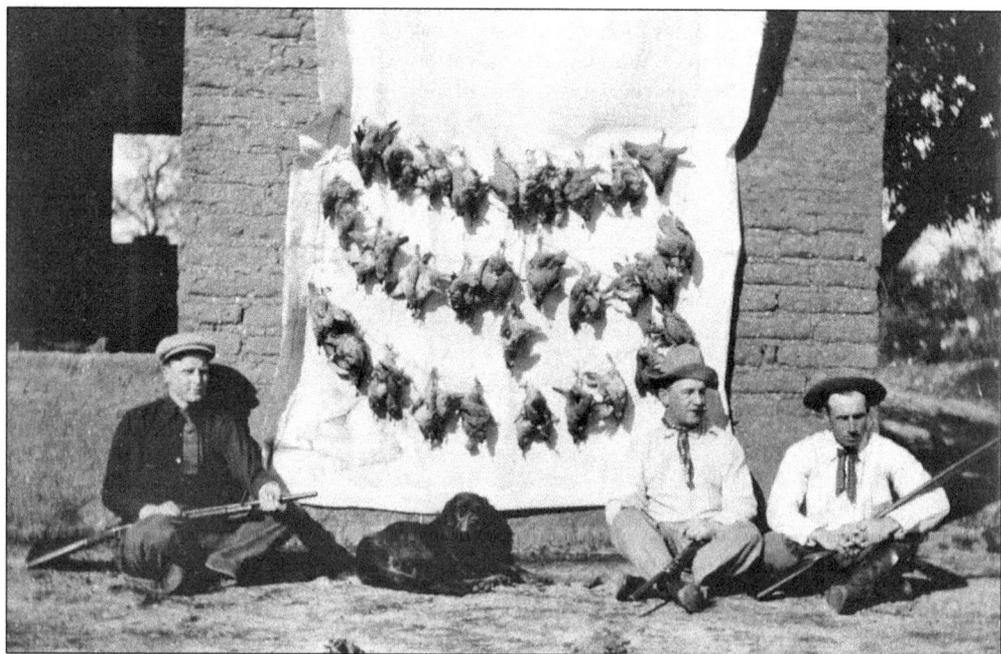

In the past, both scaled quail and Gamble's quail have been found around Oracle. These three men and a dog pose with Gamble's quail they have likely shot that day. Note the adobe wall behind them. Each year, the Mammoth–San Manuel Lions Club serves a Quail Hunter's Breakfast on the first Saturday of the season. (AHF Gill-335.)

Bobcats were never hunted other than as vermin. One photograph from Oracle shows a huge stack of bobcat and/or mountain lion skulls that had presumably accumulated over a decade or more. This man is pictured with a dead bobcat about 1925. His weapon of choice (a pistol) suggests that the bobcat was in his yard rather than the wild. (AHF Gill-654.)

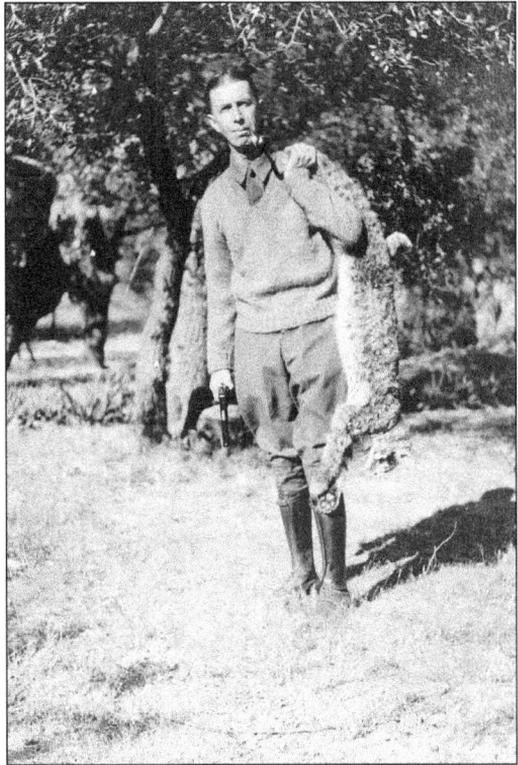

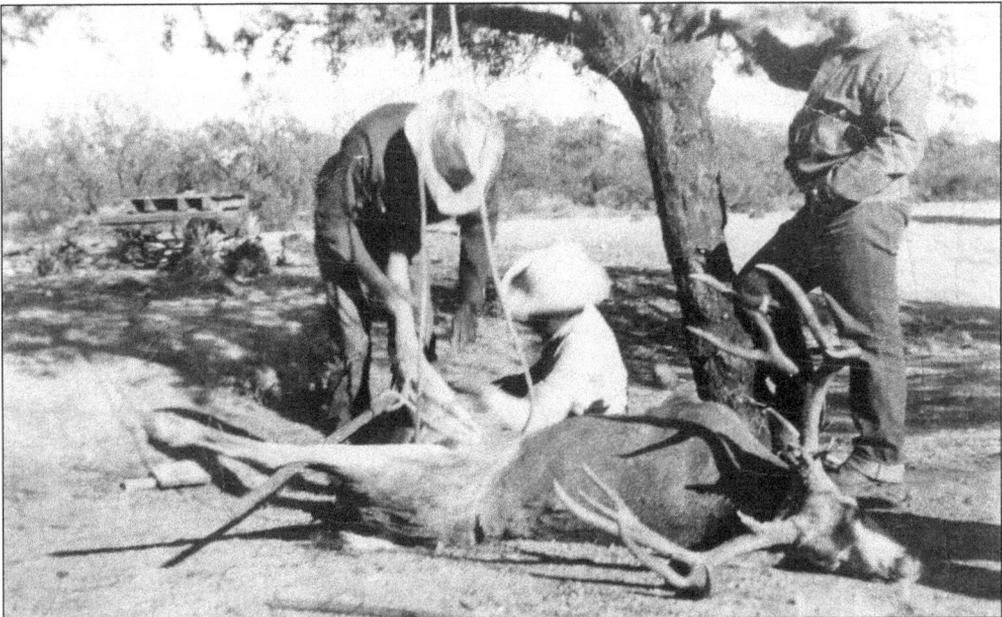

Coues' whitetail deer are common in the wooded slopes of the Catalinas; mule deer live in the mesquites. Here Jessie "Dogie" Ellis (left) and his brother Kenneth (center) prepare to string up a mule deer for skinning that they shot near Oracle in the early 1950s as Reg Ramsay looks on. The Ellis family came to Oracle from Florence about 1944. Dogie received his nickname by bringing home orphaned calves while working on a ranch near Florence. (Reg Ramsay.)

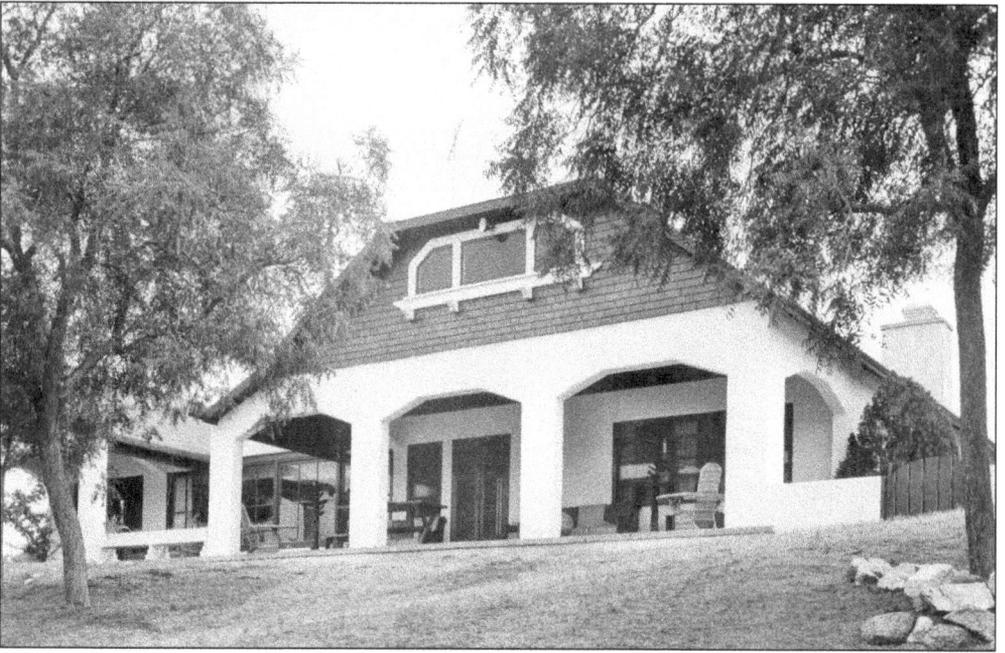

Born in Pennsylvania, George Stone Wilson moved to Oracle in 1906 for his health. In 1907, he went to Portland to work in the lumber industry, but Arizona weather was more to his liking. In 1911, Wilson purchased a 160-acre homestead, 85 cows, and some wild horses near Oracle. He worked the ranch, added other lands, including the Bockman Ranch, and named his spread Rancho Linda Vista. Referring to 1922 and 1923, Wilson stated that there was "no rain on our ranch for nearly two years." Wealthy friends talked him into borrowing money to build cabins and make other improvements during the drought; in 1924, he began using Rancho Linda Vista as a guest ranch. Its main house is shown above in the 1950s. Below, unidentified guests gather on the Patio of El Desio on Sunday, April 17, 1932. (Above, Charles Sternberg–Rancho Linda Vista; below, AHS-Tucson 780.)

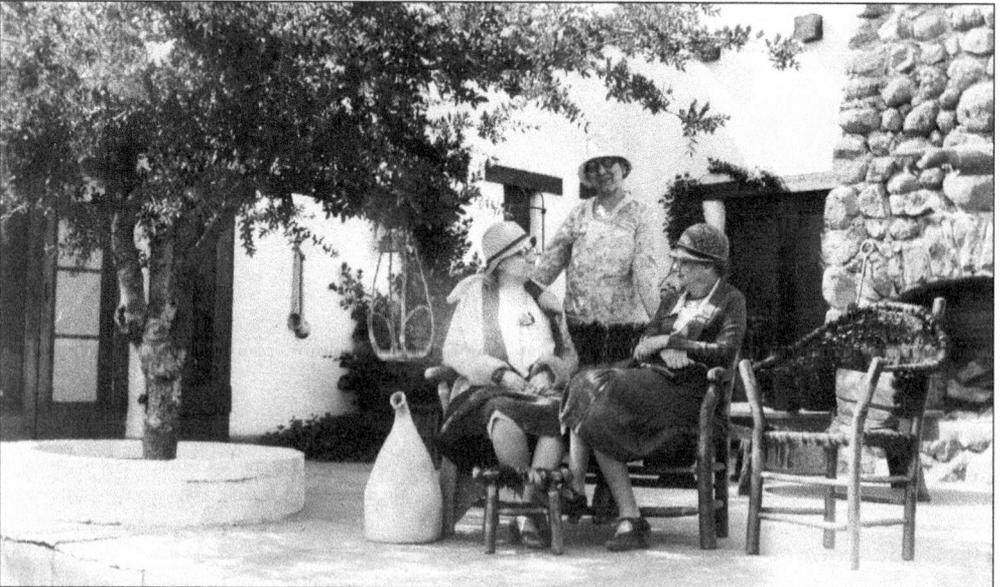

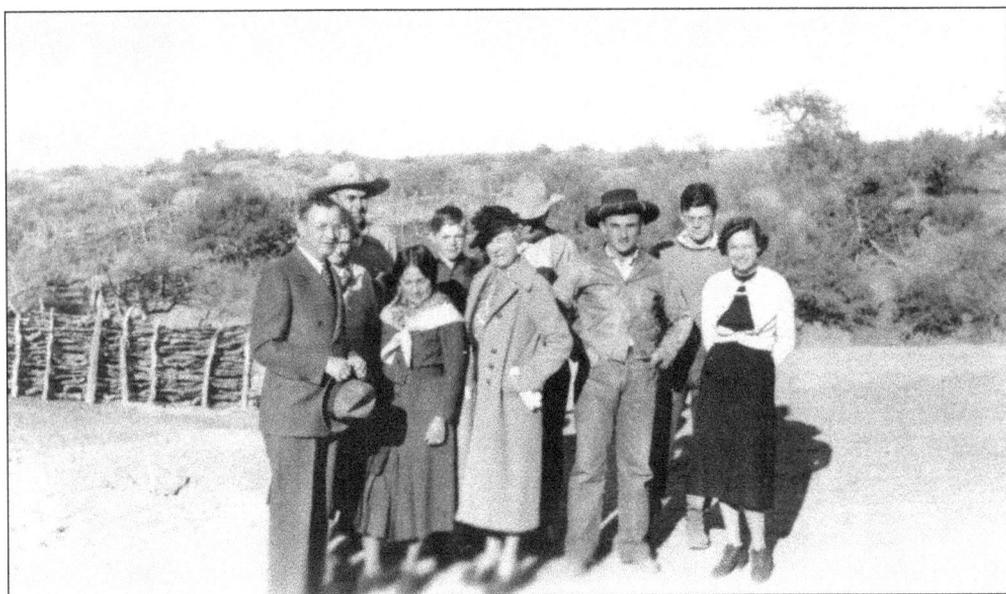

In 1912, George Stone Wilson married Charlotte "Lottie" Gonzalez; soon they had two boys—Tom and Boyd. Later Wilson wrote, "We have always been very proud of these two boys and at the present time, 1955, each one owns his own ranch." This 1938 photograph depicts the Wilson family with unidentified guests. In the first row, Lottie is second from the left, while Boyd is fourth from the left wearing a black hat. In the second row, Tom stands on the left, and George is third from the left wearing a hat. (Charles Sternberg–Rancho Linda Vista.)

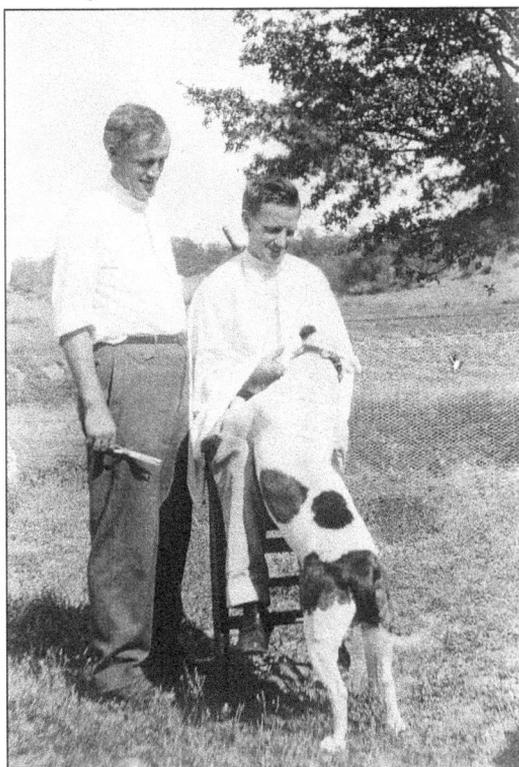

Because early Oracle did not have a regular barber, friends often cut one another's hair. Charles Gilliland Sr. gives his friend Bob a trim in 1914. (AHF Gill-448.)

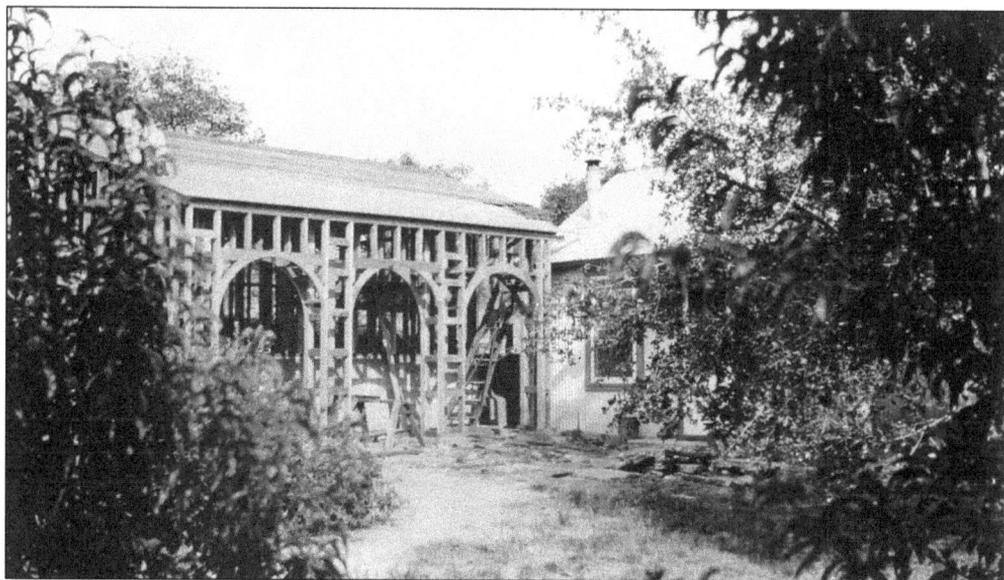

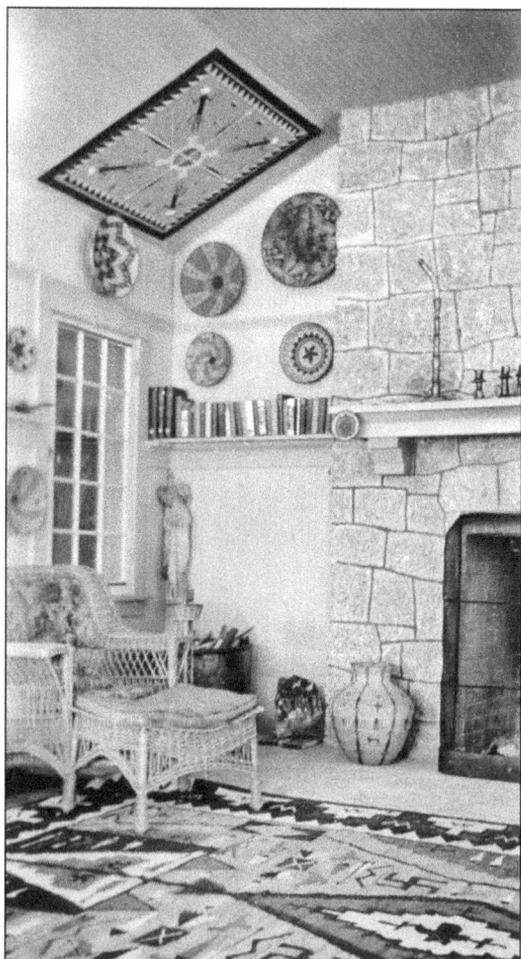

Charles Gilliland began an important building project in the early 1920s, namely Rancho de los Robles, sometimes called El Rancho Robles. The photograph above shows the internal construction of the arches. As part of the main house at Rancho Robles, the Gilliland family decided to decorate the great room completely with Native American designs, as pictured on the left. The Gillilands enlisted the help of Louisa Wetherill, the wife of John Wetherill, a noted Navajo trading-post operator at Kayenta. Clyde Colville was commissioned to paint at least four canvasses inspired by a series of 56 Navajo sand paintings owned by the Wetherills. (Above, AHF Gill-884; left, AHF Gill-929.)

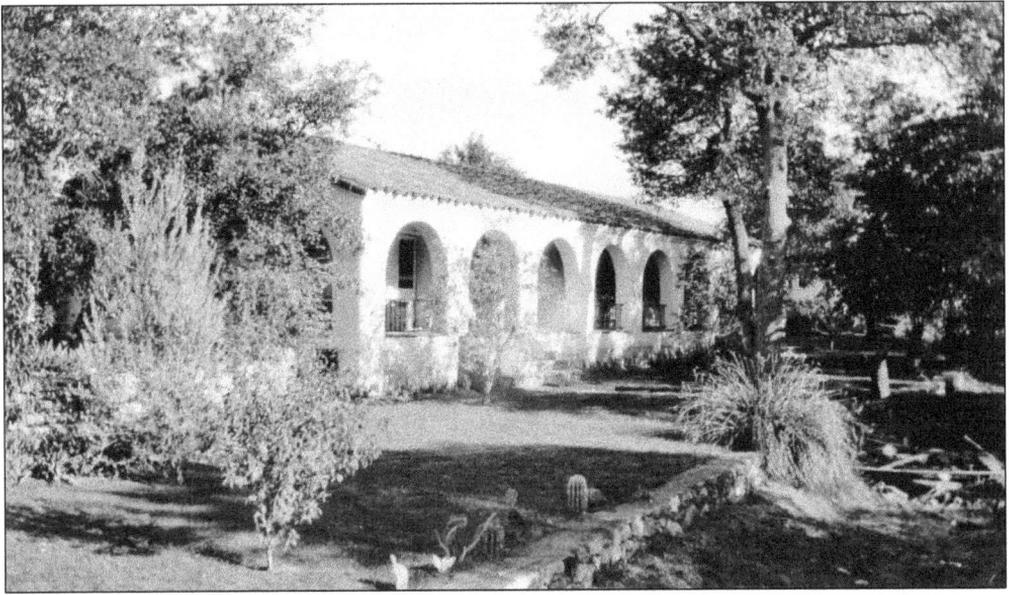

In the 1930s, after Charles Gilliland sold Rancho Robles, the site was used as a dude ranch with horses for guests to ride. Pictured are the guest rooms (above) and the stables and corrals (below). Rancho Robles and Linda Vista were both listed on a "Famous Ranches of Arizona" postcard. Clarence Budington Kelland wrote, "You can't see Arizona from a motor car. Real Arizona doesn't lie along traveled roads. There is only one place from which to see this most picturesque of all states and that is from the back of a horse. But if you can't ride a horse, the next best place to see it is from the plaza of a ranch. The Old West endures. It still exists." (Above, AHF Gill-891; below, AHF Gill-590.)

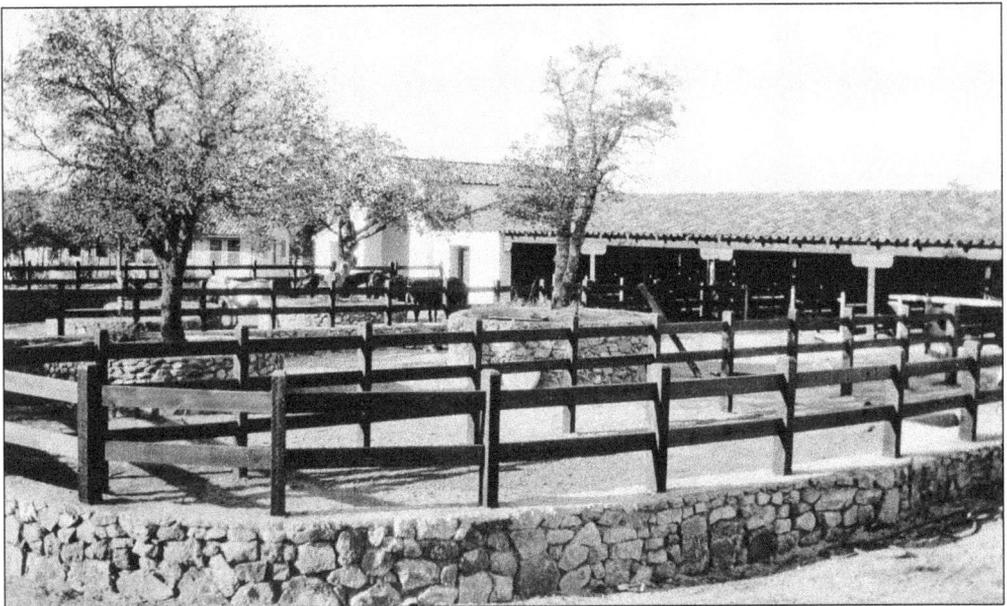

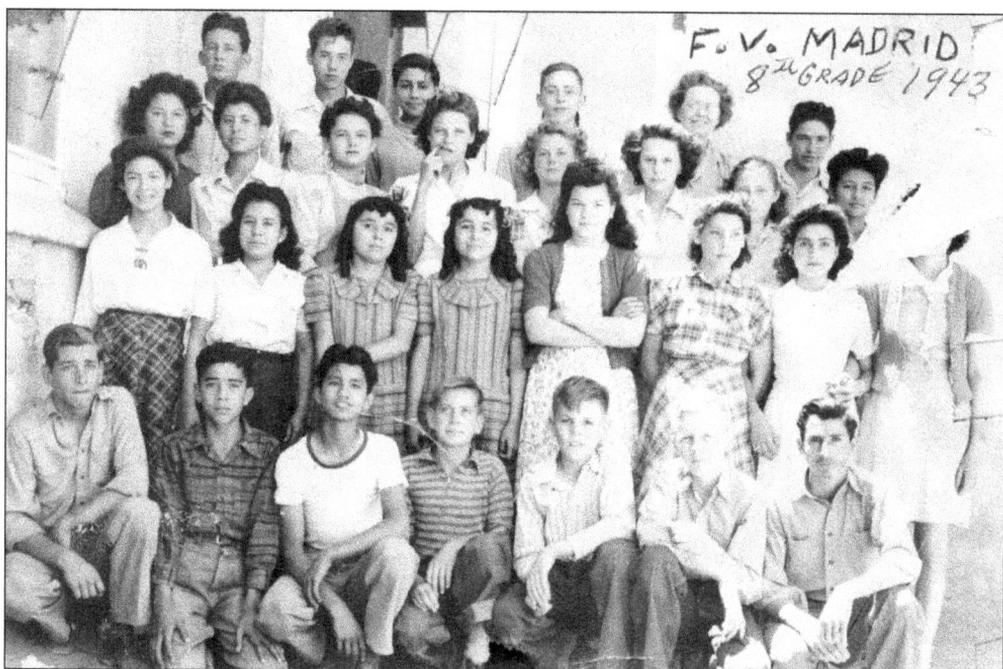

Prior to 1954, the nearest high school was in Florence. Seen above is Frank Madrid's 1943 eighth-grade class in Mammoth, though Madrid later dropped out to work in the mines. From September 1945 to May 1954, Catherine Ann Royale (below, far right) drove the bus to Florence. She picked up 10 students in Mammoth, 15 in Tiger, 15 in Oracle, and a few at ranches between Oracle and Florence. She spent the day in Florence and then, at about 5:00 p.m., began the 71-mile drive home. *Time* reported that Royale wanted to teach her students "how important it is for people to get along together" and only once had to let two boys "fight it out on the side of the road." She reported 20 blowouts the first year and even drove the students to their prom. (Above, Frank Madrid; below, Steve Brown.)

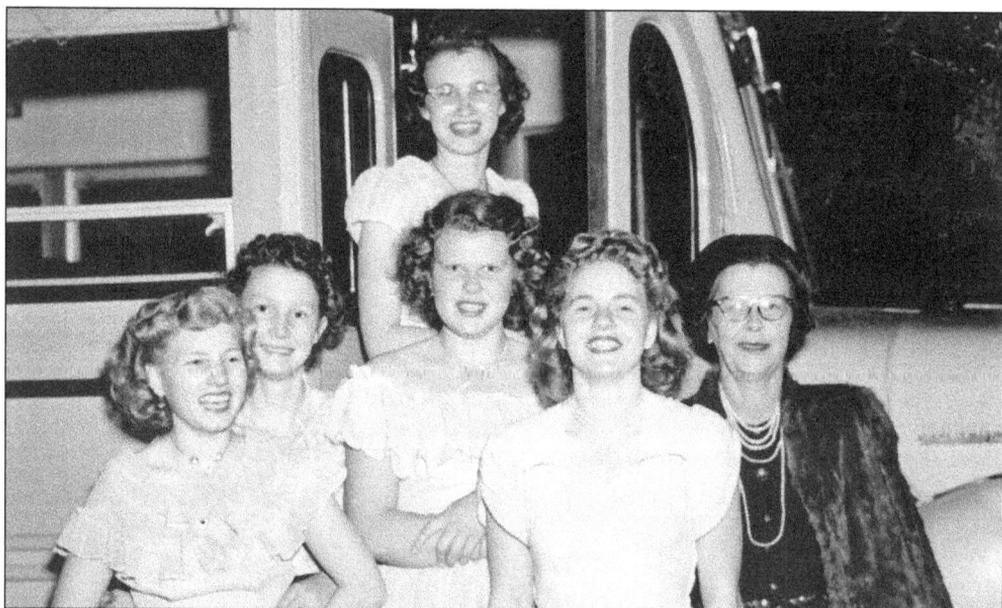

Four

CATTLE IN THE DESERT

In the 1870s, livestock promised enormous profits, and so large herds of cattle were brought into Arizona. Historians estimate that Arizona had a total of 5,000 head of cattle in 1870, 135,757 in 1880, and 927,880 in 1890. The ranchers overstocked the ranges. Herbert Brown wrote, "During the years 1892 and 1893 Arizona suffered an almost continuous drought, and cattle died by the tens of thousands. From 50 to 90 percent of every herd lay dead on the ranges. The hot sun, dry winds, and famishing brutes were fatal as fire to nearly all forms of vegetable life. . . . I saw, later, what I had never expected to see in Arizona, Mexicans gathering bones on the ranges and shipping them to California for fertilizing purposes." The cattle herds were never again this large.

In 1922, Oracle residents decided to host a rodeo patterned after the ones held in Florence. George Wilson, Jack Jamison, and resident forest ranger Jack Frieborn were selected to organize the one-day affair. Charles Gilliland Sr. offered to pay expenses if the show was not a success, but with extensive advertising, cowboys came from as far away as Texas and California. They camped for a week at the Jamisons' sheep ranch west of Oracle. Wilson later recalled the following:

> Two days before the show we killed five yearling steers weighing about 500 pounds apiece to barbeque and started to cook up a barrel of Mexican beans. On the day of the show, everything was ready and the weather [was] fine. We expected about 500 people, but a few over three thousand bought tickets. Our barbeque meal didn't last any time at all with only about half the crowd getting anything to eat. But the show was good with some of the best cowboys in the country competing. Everybody seemed well pleased even if there was [a] shortage of food.

After paying expenses, the profit was put in the bank for another rodeo the next year. However, in 1923, the Tucson Chamber of Commerce sponsored a rodeo, and Gilliland did not think it would be profitable to compete. The 1922 rodeo money was instead spent on improvements in the town of Oracle.

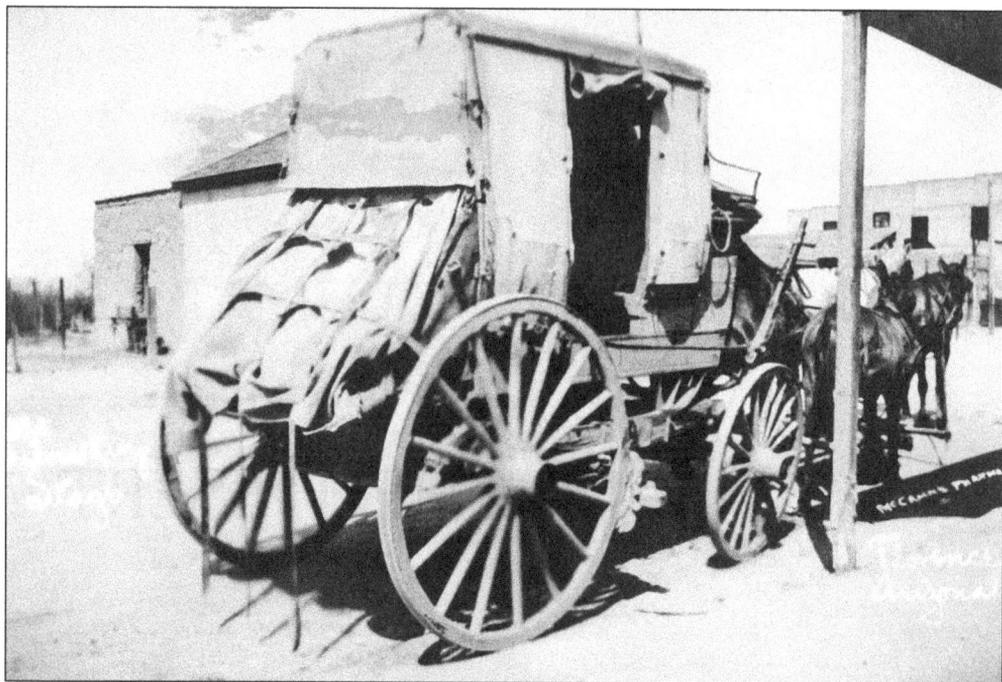

Brothers Lem and Henry Redfield migrated from California and settled near Redington to become cattle ranchers. Unfortunately, the Redfield name is also remembered from a lynching. On August 10, 1883, the stage between Florence and Globe (above) was robbed of $2,000 in gold coins; one guard was killed, and the two robbers fled. Through circumstantial evidence and doubtful testimony, Lem Redfield was arrested and incarcerated in Florence. On September 8, one hundred armed Florence men overran the authorities and hanged Lem Redfield and Joe Tuttle, a presumed accomplice, in the corridor of the jail. The *Tucson Daily Citizen* called the lynchers a mob. In Florence, however, newspaper editors thought the lynching acceptable because the men were sober, "respectable and representative citizens." In the late 1880s, Henry Redfield sold his ranch (eventually acquired by Charles Bayless) and moved his family to the safer town of Benson. Left is a portrait of Henry's son Leonard Darius Redfield. (Above, AHS-Tucson 735; left, Ethel Amator.)

Leonard Darius Redfield traveled with his parents from New York to California and then Arizona when he was a young child. His wife, Francis "Fannie" Armitage Redfield, described the San Pedro River as having no banks; instead there were marshes and beavers. Fever was prevalent. According to Fannie, "A bottle of quinine was always on the table. Nearly every meal one would dip the knife into the bottle and take a little on the tip of the knife." Leonard Redfield kept his ties to California. In fact, the photograph on the right of his daughter Malvina was taken on a visit to California about 1913. Below, Malvina (left) plays with her brother Leonard in a wheelbarrow at Redington in the early 1920s. (Both, Ethel Amator.)

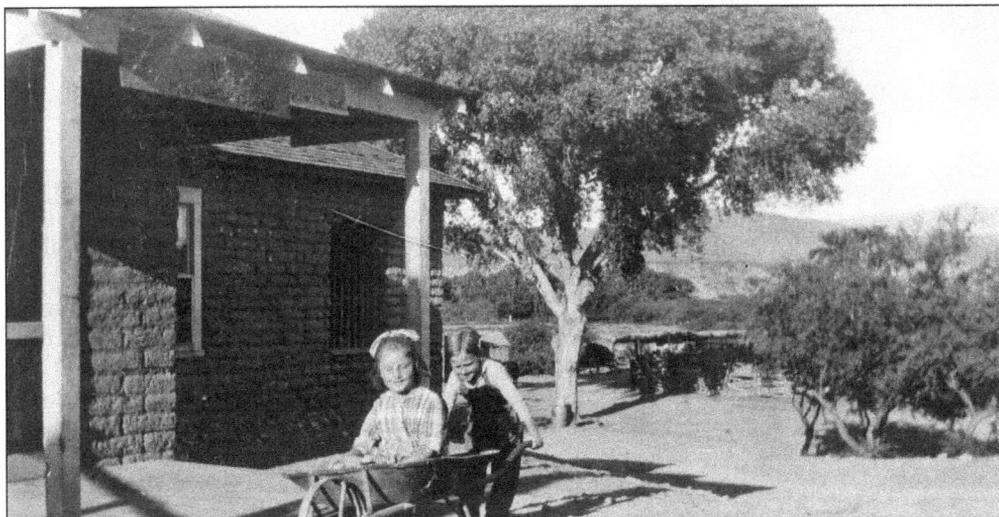

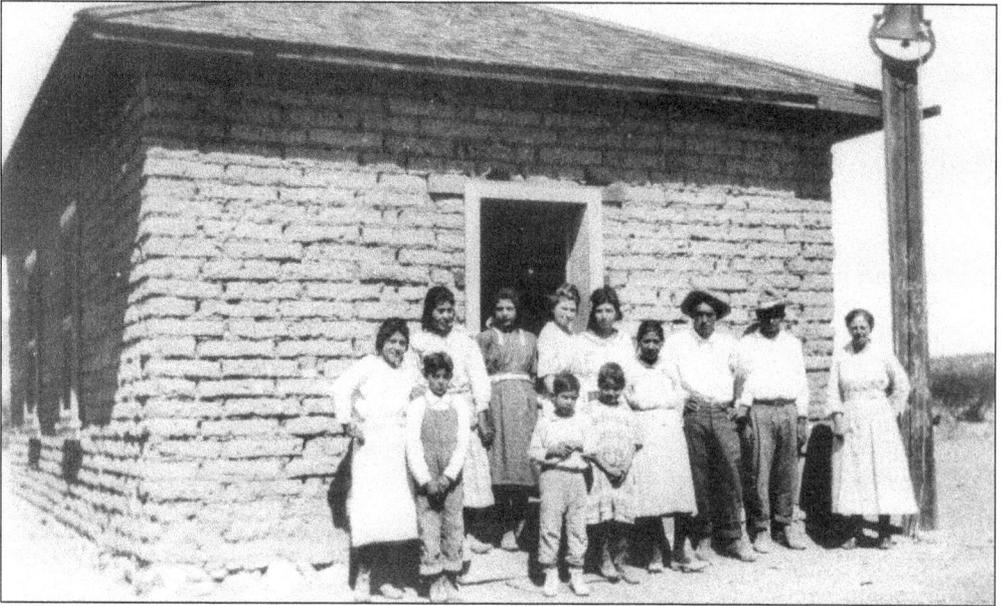

Henry Redfield served as Redington's first postmaster. He also helped build this schoolhouse, pictured in the early 1920s with teacher Florence Armitage (far right). Charles Bayless, always interested in the welfare of the community and a believer in education, donated land on the Carlink Ranch for the schoolhouse in 1906. (Ethel Amator.)

The best-known teacher at Redington, however, was Eulalia "Sister" Bourne, who taught there from 1930 to 1933. She refused to submit to Arizona's law that only English be used in school. She sometimes let the children in Redington write in Spanish, but her most defiant action was staging a three-act Christmas play in Spanish after leaving Redington. She also worked her own ranch at Peppersauce. (OHS.)

For the 1932–1933 school year, "Sister" Bourne began the student newspaper the *Little Cowpuncher*, which was named by Gareth Bingham. The paper reflects the ranching community of the students. For example, after reading *Little Women*, all the children made their wills and nearly every child mentioned his own saddle, horse, boots, spurs, bridle, and/or rope. In the children's art, horses are prominent. One illustration depicts a cowboy bringing home a Christmas tree by dragging it behind his horse; Jesus Valdez drew a cowboy pony, complete with Mexican silver on the bridle and a saddle with *tapaderos* (covered stirrups). Bourne took her little cowpunchers to Tucson for the rodeo parade, as pictured here. (Lois Kelly.)

George Kelly (right) came to Arizona from Texas, moved around while working mostly in law enforcement, and was at Aravaipa when the Japanese bombed Pearl Harbor. He is pictured here with his grandson, Dale White, and the results of their hunting trip in Galiuros around 1950. (Jep White.)

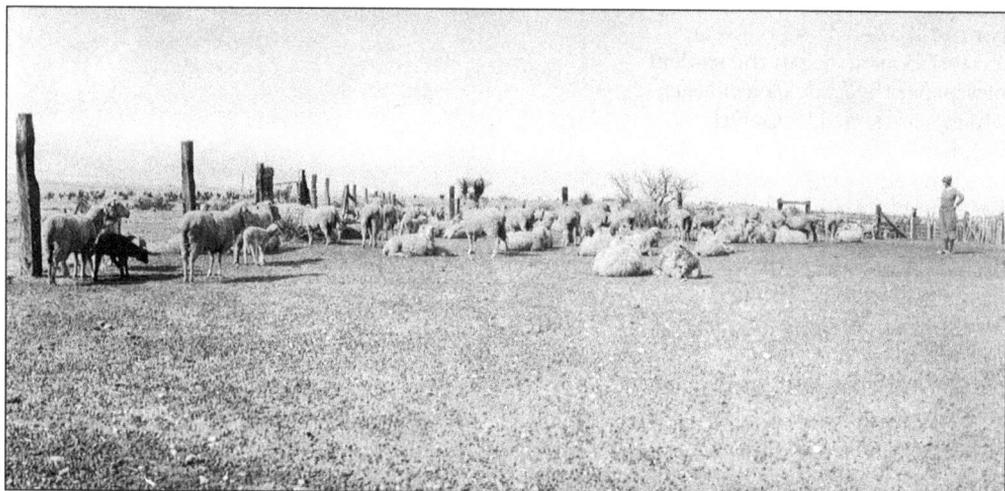

In 1892, when Charles Bayless came west to help his father with the Carlink Ranch on the San Pedro River, one of his first actions was to diversify. The Bayless and Berkalew partnership purchased the Alexander McKay sheep ranch west of Oracle. Bayless then upgraded the stock, particularly with Merino rams. By 1899, the ranch owned 4,000 sheep, and in 1900, it shipped 35,000 pounds of wool. Bayless and Berkalew sold their sheep operation to J. C. Jamison of Willcox in 1913. Taken by the Gilliland family, these photographs depict sheep likely belonging to Jamison. Seen above are the corrals near Oracle. Below, a sheep herd grazes along the San Pedro River. (Above, AHF Gill-1028; below, AHF Gill-1026.)

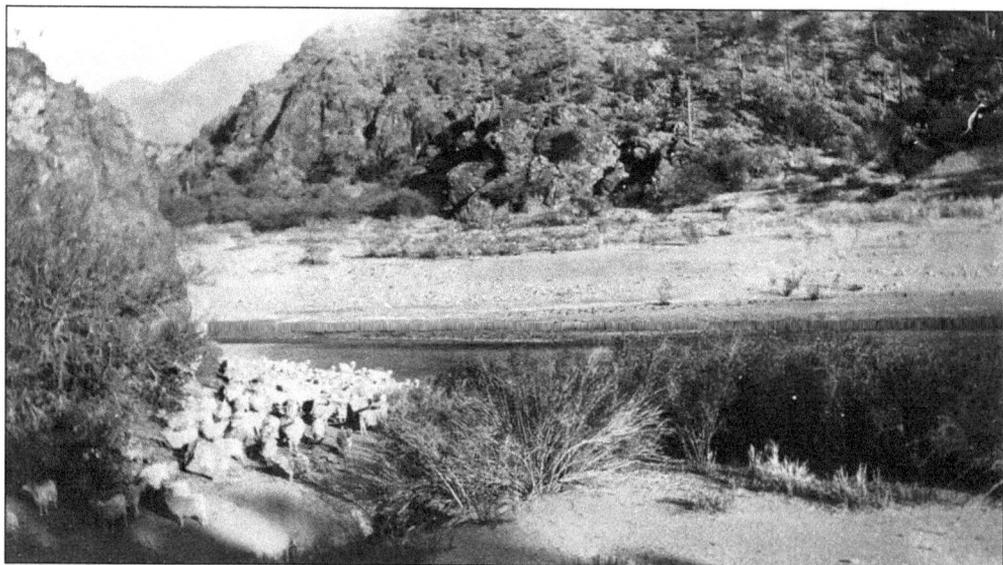

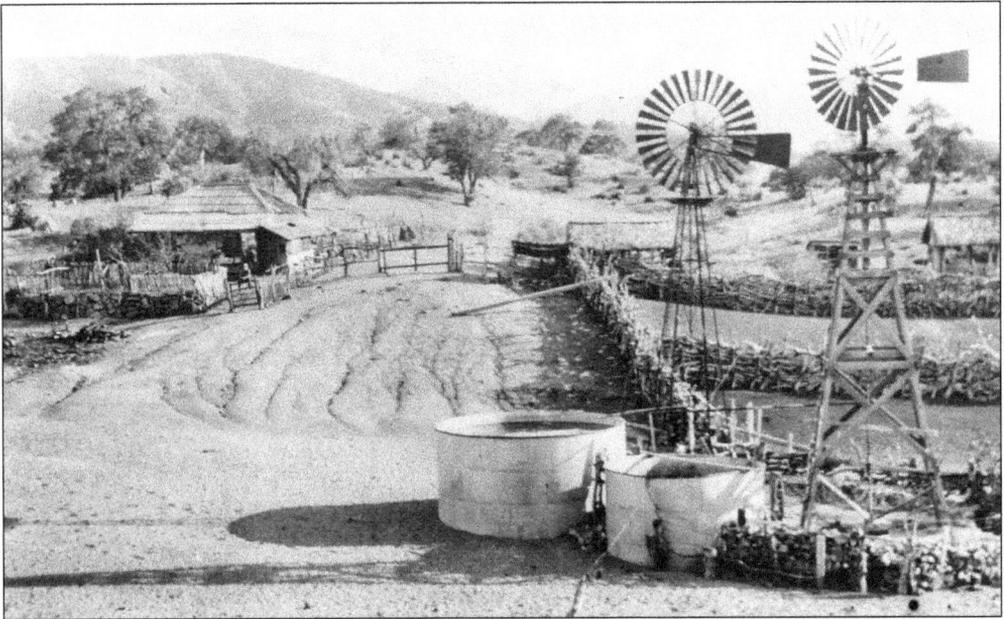

The above photograph of Rancho Linda Vista shows the early ranch house in 1903. George Wilson purchased the ranch in 1911 and began building up a cattle herd. Richard Schaus wrote the following for the *Cattlelog*, "In 1924 a drought brought the Wilson fortunes to a low Ebb, so they started up the West's first dude ranch, the Linda Vista, where the guests really roughed it and took part in the work. The ranch became famous and many well-known people stayed there—Harold Bell Wright, Vice-Pres. [Charles] Dawes, Senator [Arthur] Vandenberg, Herbert Brownell, and many others." Below, Wilson (center front) rides a white horse between sons Boyd (left) and Tom, along with some of his guests. Note the solid wood corral typical of this area. (Both, Charles Sternberg–Rancho Linda Vista.)

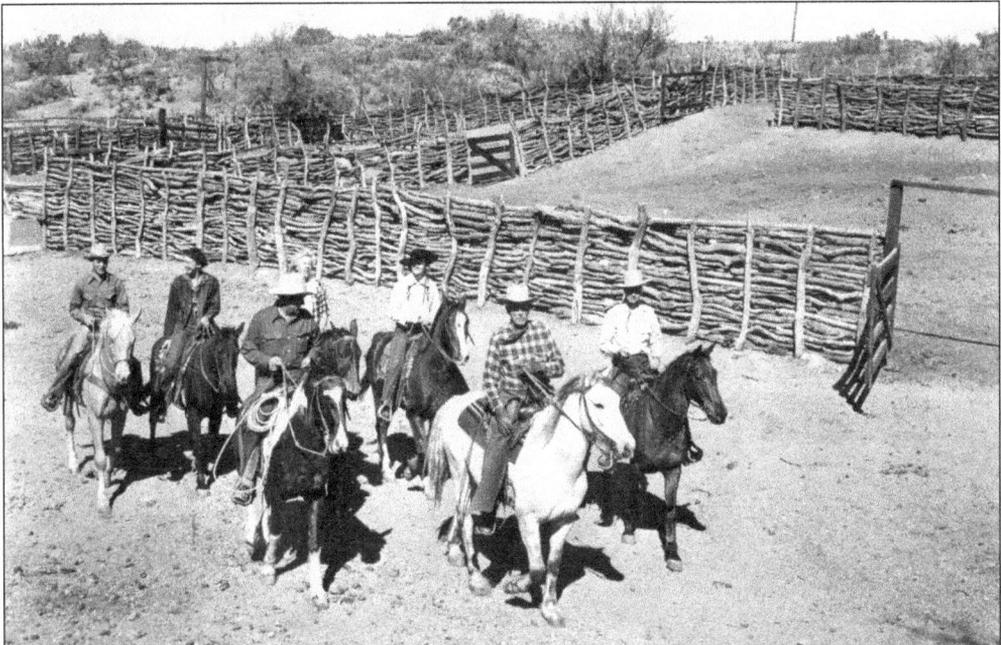

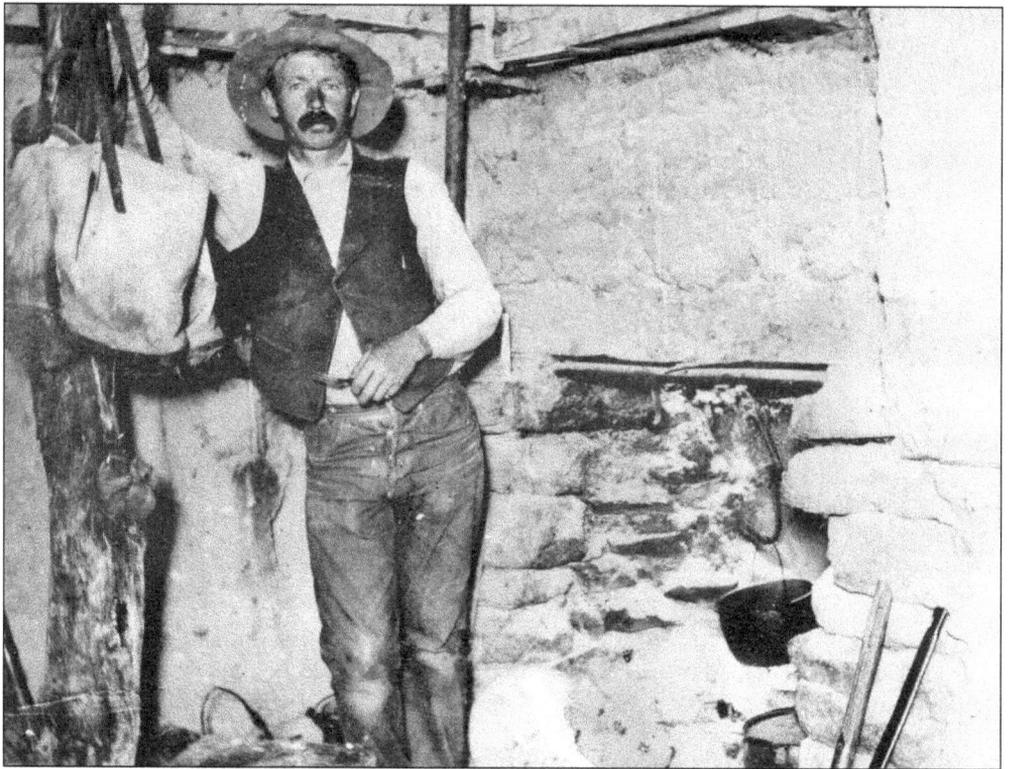

Archibald Ramsay's early homesteading and ranching experiences in Oracle led him to say, when he was 88 years old, "Days in the saddle keep your liver shaken up and makes you stay hungry, healthy and fit." Also on his list of things he loved most was "getting on a bucking horse first thing on a frosty morning." The above image is believed to depict the interior of the house on the Ramsays' homestead near Tiger; Ramsay's father-in-law, Willis Black, helped build the house. Pictured left, Ramsay poses with his gun and lasso near an early well. He had a windmill and watering tank where he let freighters water their mules for 5¢ a head. (Both, Reg Ramsay.)

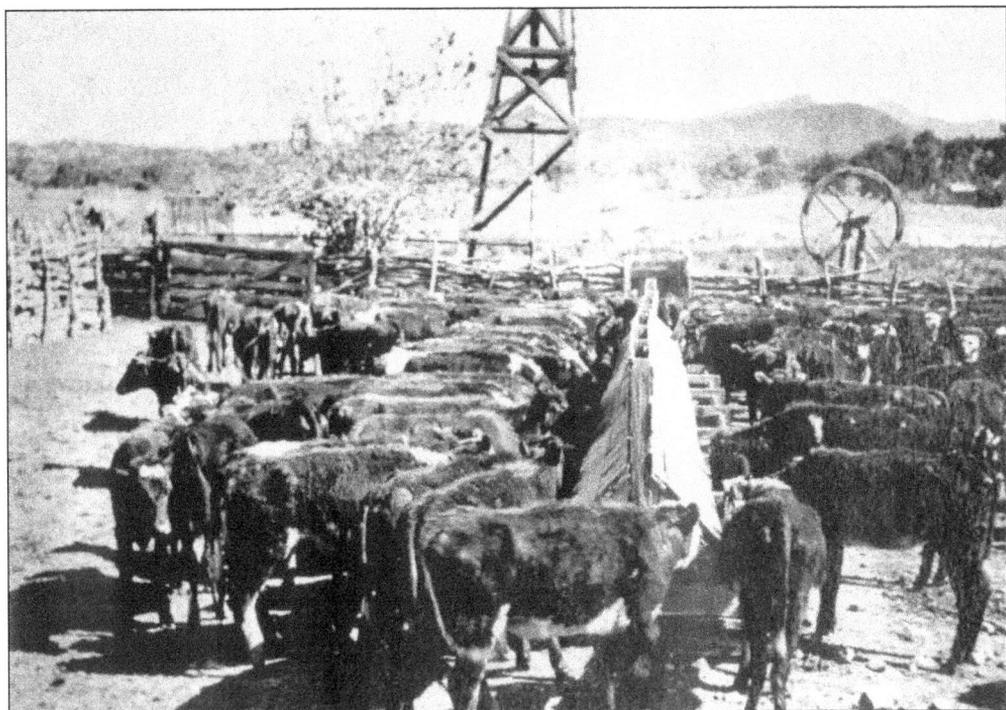

Cattle were simply a part of Oracle. Elizabeth Lambert Wood wrote of being a "more or less active spectator" on cattle drives. Above, Archibald Ramsay's cattle are being fed inside a corral at Oracle. Below, cattle are driven through Oracle and past the Ray house (later known as the Manzanita Lodge— a café, a hotel, and a grocery store run by the Huggett family). Wood described the native grasses around Oracle about 1910: "Between Bayless' Sheep Camp and Big Wash, not a cactus, catclaw, mesquite or eroded gully marred the perfection of the vast hay pasture." (Above, Reg Ramsay; below, AHF Gill-379.)

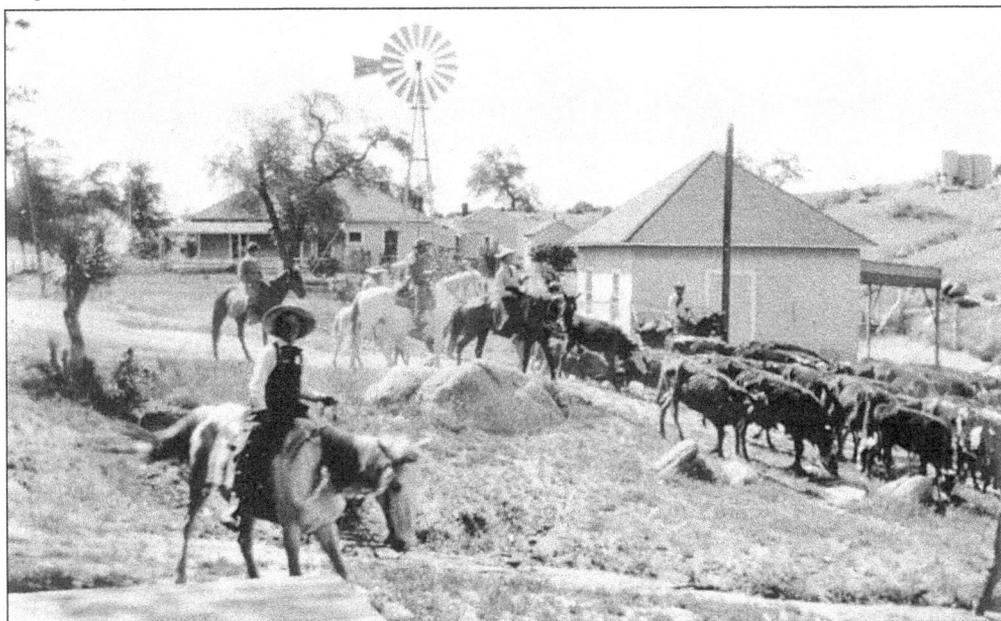

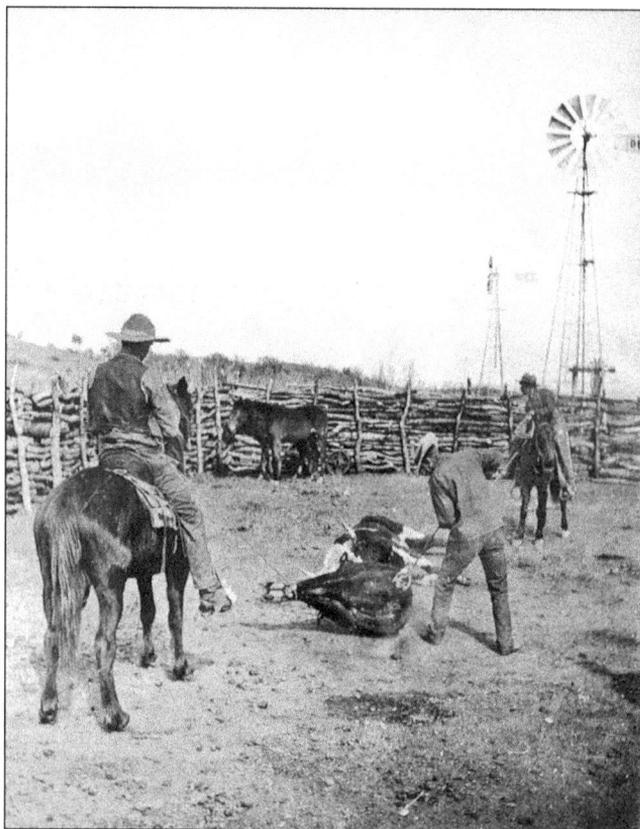

Land in Arizona was open range. According to Elizabeth Lambert Wood, "At that time many wild cattle roamed at will through the rough upper reaches [of Cañada del Oro], longhorns as free as the deer." Branding was imperative to identify cattle in the mixed herds. It was also an easy and sometimes spectacular activity for visitors to witness and even participate. (AHF Gill-389.)

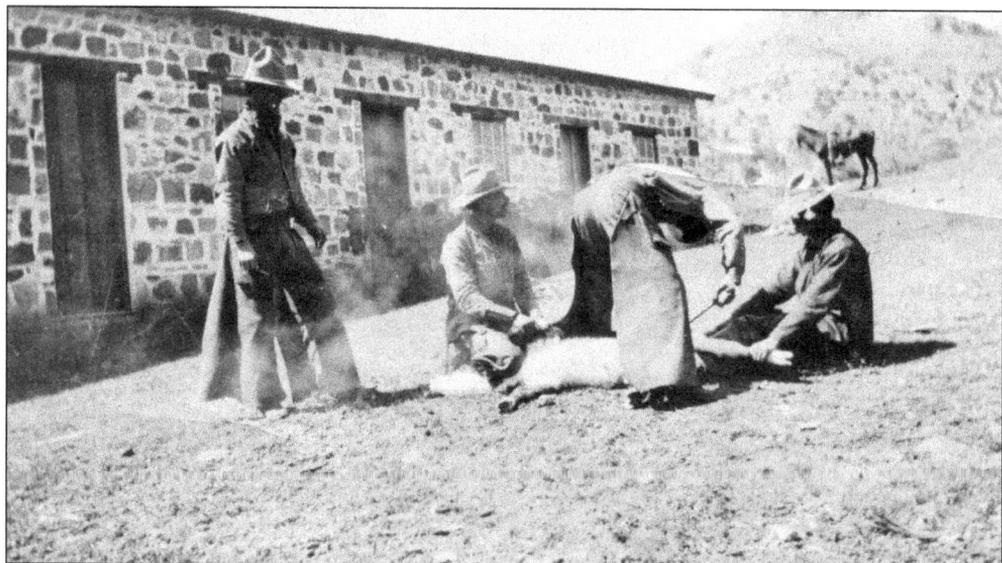

These cowboys branding in front of the buildings at Copper Creek are probably Rhodes and Mercer men who ran cattle near the mine. Chester Proebstel worked as the mine superintendent at Sombrero Butte in 1930, and his children remember cowboys coming in "to pick up their mail [wearing] chaps with the outline of guns showing—a very scary looking bunch to the children." Several shootings took place in this area over disputed cattle and land. (Harry Hendrickson.)

By 1928, Charles Bayless had acquired nearly 1,300 acres in Tucson along the Rillito. Most of this he rented to Mormons, particularly the Binghams, for use in producing milk and vegetables. A lifelong friendship developed between Floyd Bingham and Bayless. When Bayless wanted to plant wheat along the San Pedro River during World War I, he convinced Bingham to move to Redington; Mormons were considered experts in irrigating the arid West. Here Bingham's wife, Lavita, poses with the couple's daughters (from left to right) Lavita Mae, Donna, and Belva. (Lois Kelly.)

Floyd Bingham also homesteaded land in Davis Canyon. Traveling from Redington to Tucson meant going through Oracle or Benson; Bingham lobbied for a shorter route—over Redington Pass. He used this horse-drawn road grader to make that first road. Bingham's great-grandson Derek Kelly sits on the grader, while son-in-law Jack Kelly stands behind it in this 1982 photograph. (Photograph by Trudy Lucas.)

Ranching in the Sonoran Desert can be summed up with two cartoons drawn for Jo Flieger. The caption for the cartoon above reads, "Best ranch anywhere. Calves oft weight 600 lbs.—all together, that is!" A roundup of gaunt cattle progresses below in the mid-1920s. Flieger, however, purchased a farm on the San Pedro and planted five fields with oats. He pastured his calves in the fields over their first winter and his yearlings immediately before sending them to market. Flieger boasted, "For the twenty years that I owned the farm my steers ready for market averaged 602 pounds, much more than other ranchers were getting. (Above, Ethel Amator, drawing by Joyce Harris; below, AHF Gill-394.)

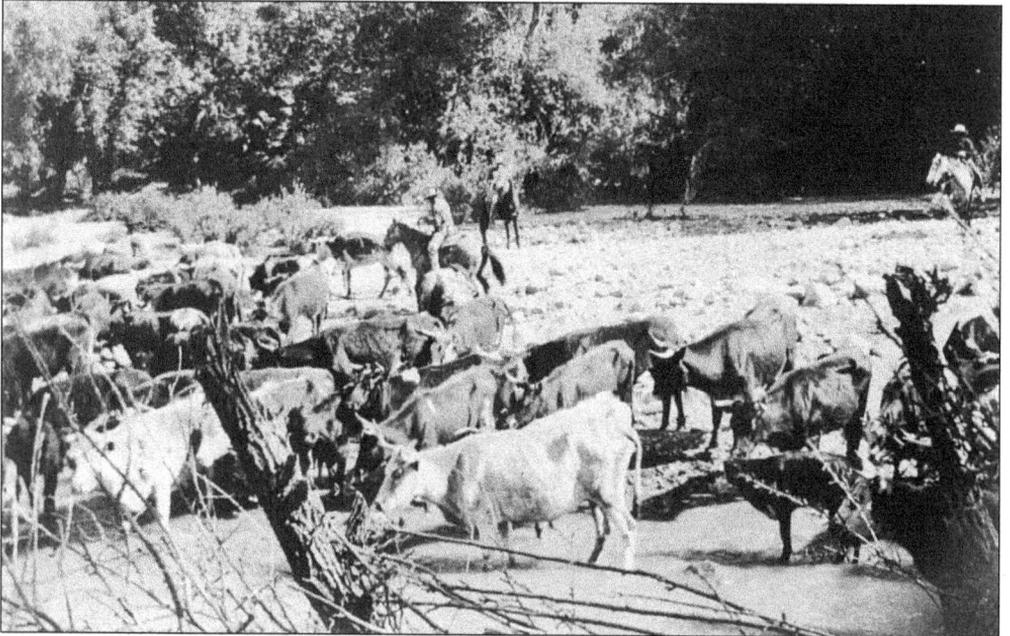

In 1981, Joyce Harris drew a second cartoon (above) for Jo Flieger with the caption "Awright, so it ain't done this way, but she's about loaded ain't she?" Ethel Amator said that Flieger admitted to having actually loaded cattle (maybe only once) with this method. Normally cattle were driven to market, as seen below in the 1903 Bayless and Berkalew cattle drive along the San Pedro River. Rounding up the cattle and driving them 35 miles to the railroad at Benson often took a month. In 1900, the Phoenix and Arizona Eastern Railroad began a spur down the San Pedro River Valley to connect Benson with Phoenix. The railroad went bankrupt upon reaching Winkleman, however, and the connection was never made. (Above, Ethel Amator; below, AHF Schaus-Bayless-2.)

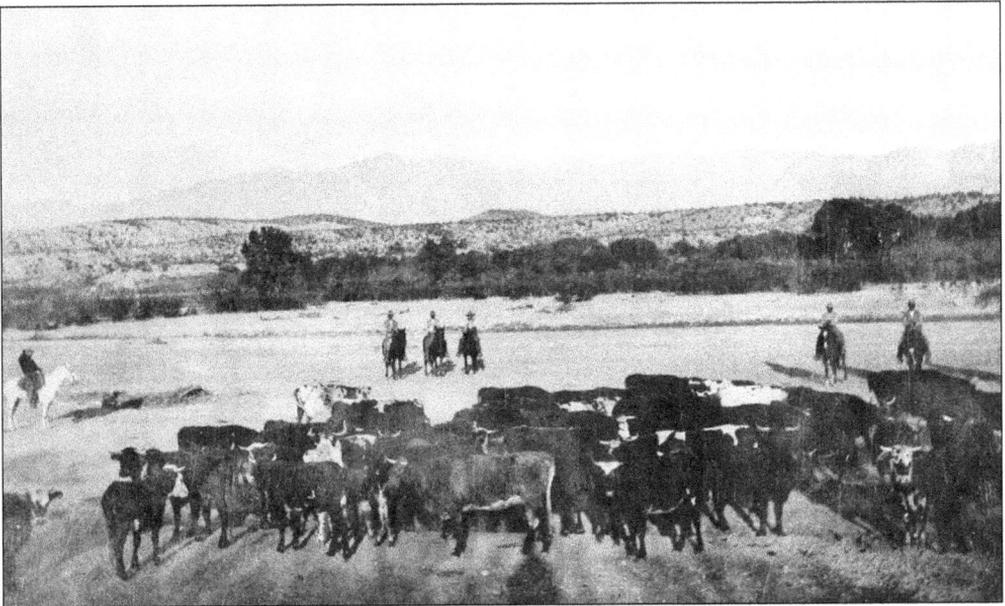

In August 1961, Jo and Gussie Flieger (left) hosted the Southern Arizona Cattlemen's Association meeting at their ranch house in Aravaipa Canyon. They planned on 100 people for a dinner of beef, beans, potato salad, apple pie, and coffee but fed 200 with food left over. The teenagers enjoyed the swimming pool, and among the smaller children who attended were Susan and Charley Goff (below), the children of Joe Goff from Oracle. Of interest at the Flieger ranch were the Santa Gertrudis cattle; in Texas, three Santa Gertrudis bulls had broken records by gaining more than 600 pounds each in a 140-day feedlot test. These photographs were published in the September–October 1961 *Cattlelog*. (Left, AHF Schaus Flie-11; below, AHF Schaus Flie-17.)

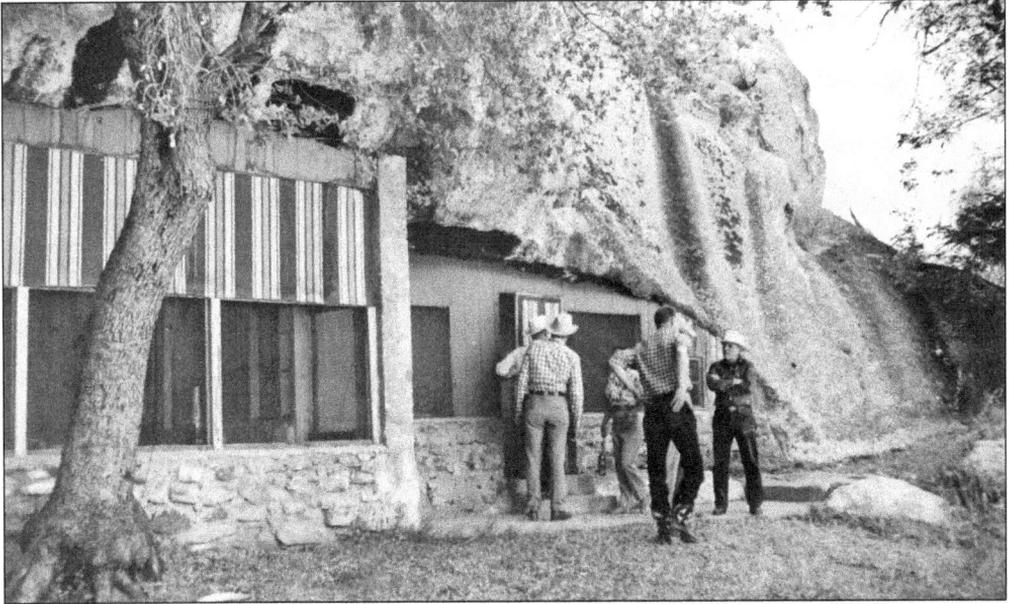

Jo Flieger was born in New Brunswick and spent his early adulthood in British Columbia, where he became a cowboy and trick rider. In 1930, he came to Arizona and eventually ranched in Aravaipa Canyon. At this remote location, he fixed a cave into a home, as pictured above, and engaged in ranching ventures associated with the name Painted Cave. Abbie Keith, the secretary of the Southern Arizona Cattlemen's Association, wrote of the Aravaipa, "It requires experience and great skill to raise cattle in rugged country where some mountain tops in Eastern Pinal County seem to reach forward and almost touch mountain ridges in Western Graham." In 1993, Flieger (below, left) was inducted into the Cowboy Hall of Fame and was honored at the Mountain Oyster Club in Tucson. The festivities are seen below. (Above, AHF Schaus-Flie-5; below, Pauly Skiba.)

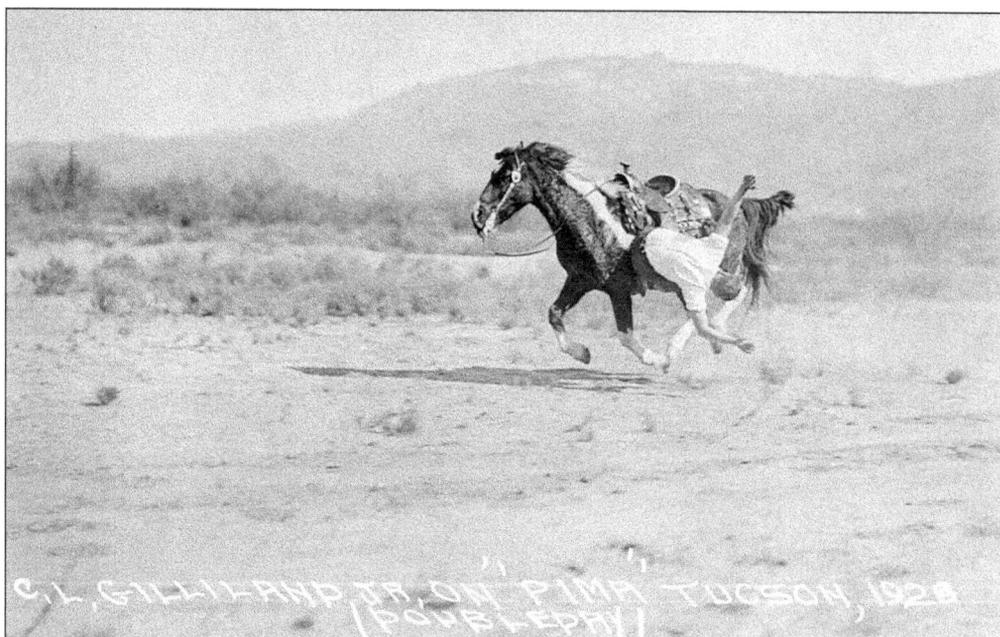

The notation on these two postcards suggests that Ralph R. Doubleday photographed Charles Gilliland Jr. trick riding at Tucson in 1928. Doubleday was the most important rodeo photographer from 1910 to 1955. When Will Rogers introduced Doubleday to the public in 1926, he rhetorically asked, "Where in the world was the photographer when he shot that?" Rogers then said, "He is right down under them shooting up at 'em. [Doubleday] has had horses jump over him, wild steers run over him. But he always comes up with an exact likeness of the animal." Above, Gilliland is in approximately the same position that Jo Flieger described as the Russian Drag— that is, hanging from the saddle by one leg. Flieger, however, did not use a bridle on his horse while doing tricks. (Above, AHF Gill-1159; below, AHF Gill-1160.)

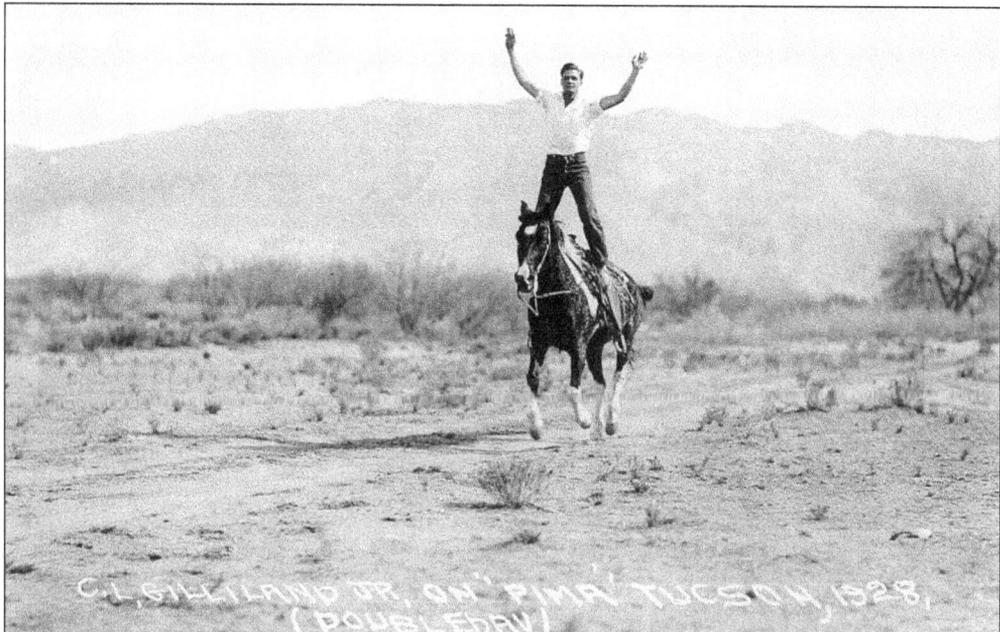

The Kannally Ranch involved each brother and sister. Neil and Lee worked the cattle; Vincent handled business affairs; and Mary and Lucile kept house. The Kannallys came from Illinois in 1902–1903. Each filed his own homestead patent, and eventually, the siblings' combined ranch ran from Oracle to San Manuel. When they sold land to the Magma Copper Company, they made a fortune. This 1910 poker game includes, from left to right, Lee Kannally, John Lawson, Larry Grant, and Neil Kannally. (OHS.)

William Huggett worked as an early guide in northern Arizona, especially for excursions to the Grand Canyon. By 1917, his services were associated with the San Marcos in Chandler. George Wharton James wrote that Huggett had "a specially-equipped camping-out wagon, tents with canvas floors, comfortable cots, cooking-outfits that enables him to supply every reasonable and unreasonable demand." He was willing to take clients for "a day, a week, a month, or six." Huggett purchased land in Oracle in 1924. (OHS 375.)

Rulon Goodman began his grocery store career in Tucson in 1929 at age 19. By 1953, he owned six stores and had branched out into cattle ranching and quarter horse breeding and racing. From 1975 to 1981, he ran the Rillito Race Track in Tucson. Yearly he treated his store employees to pit-barbecued beef (left) from cattle he had raised himself on his ranch near Oracle. Goodman (below) poses with his winning two-year-old named Traveler Sam at Prescott in 1961. (Both, Joyce McRae.)

Ben Patten (pictured right at an unknown date, below in 1965) traveled to Arizona about 1950 to escape Montana winters. He first worked for the A-7 or Bellota Ranch at Redington and then for the Kannallys in Oracle, creating the entrance gate for their ranch. He also bought a ranch by Mammoth. Late in life, he began writing poetry. A 1996 poem begins, "While I can still write and am still above ground / Here is a farewell verse for the friends still around / Two of my best friends I will tell you now / Are a good cutting horse and a tiger stripe cow." He ended a 1994 poem about a nightmare as follows: "If I should happen to wake before I die / I will swear off the green tomato pie." Presumably, green tomato pie was mincemeat made with tomatoes still green at the first killing frost (common in Montana). (Both, Kathy Brown.)

For most of the 20th century, 4-H programs were part of agricultural America. Starting in 1924, 4-H was part of the USDA's Cooperative Extension Service. These clubs introduced new technologies to youth so that they would share these techniques with adults who were not necessarily amenable to new ideas. By the 1940s and 1950s, many adults were volunteering time as leaders and also supporting the clubs by purchasing sheep and cattle raised by 4-H members. Pictured above around 1950 are, from left to right, Agnes Ramsay, 4-H leader for Oracle; Kenny Ellis; Elizabeth Lambert Wood; Reg Ramsay, 4-H officer; and Goldie Calvin, 4-H representative for Pinal County. Below, Rulon Goodman purchases the 1957 first-place steer from an unidentified 4-H member. (Above, Reg Ramsay; below, Joyce McRae.)

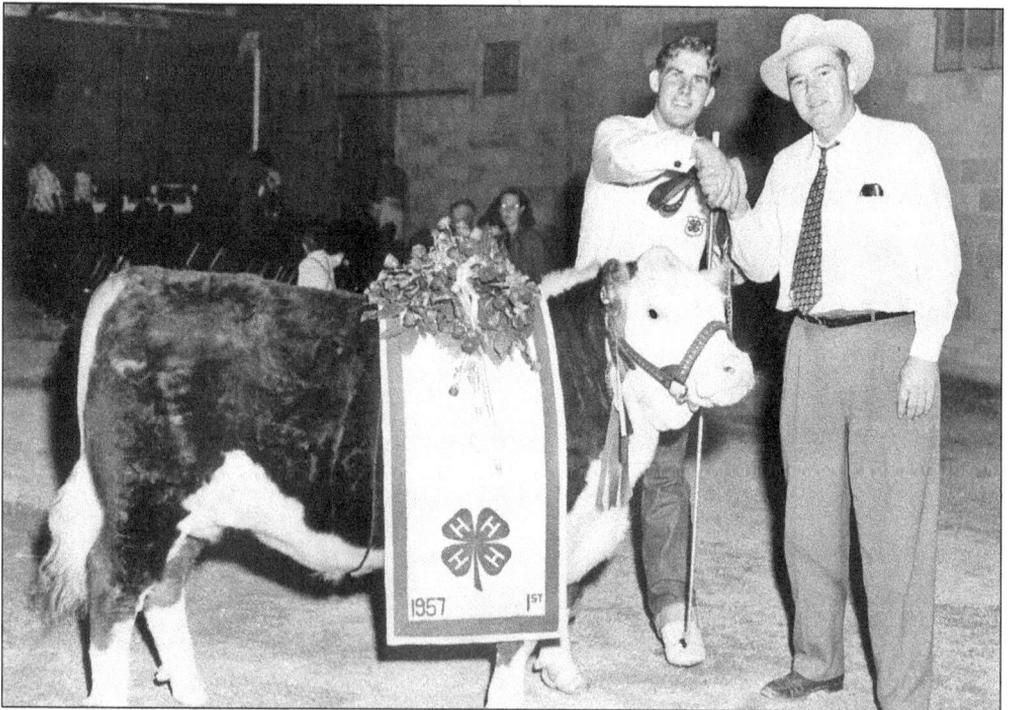

Linda Bingham's girls and their Oracle friends persuaded her to become a 4-H advisor in 1983. The first year, they raised lambs and named their group the Oracle Wool-lights. The next year, they decided to raise pigs in addition to lambs. The 4-H kids not only had to care for the lambs while they were growing, but at fair time, they had to show the lambs. In preparation, they met each week at the Bingham property to practice. Above, Kim Bingham attempts to control her lamb (with disastrous results) while the 4-H leader and other members watch. The proper method of showing a lamb is demonstrated below at the 11-Mile Corner Fairground (11 miles from Florence, Casa Grande, and Coolidge). (Both, Linda Bingham.)

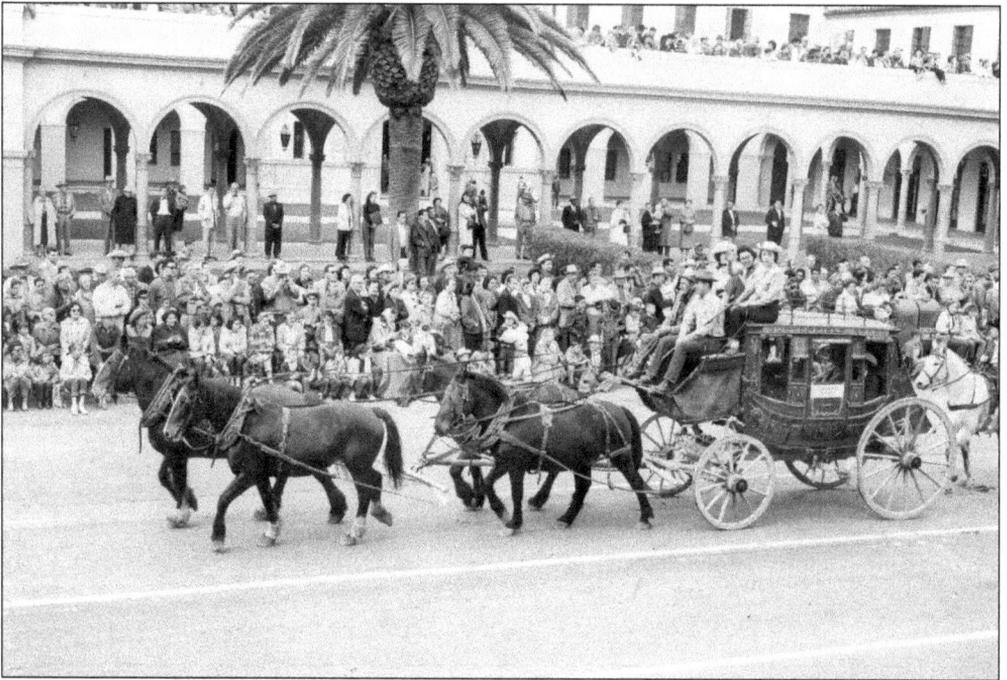

The Tucson Rodeo Parade, or *La Fiesta de los Vaqueros*, began in 1925 and is touted as the longest non-motorized parade in the country. Horses, with the occasional mule or burro, pull every imaginable conveyance. Most spectacular are the horses with Mexican silver on their saddles and bridles; their riders are also in period costume. Rulon Goodman's stagecoach (above), advertising "Goodman's Markets," passes the Old Pima County Courthouse and El Presidio Park in downtown Tucson. Elna Huggett (left) rides in the parade while promoting her ranch; she ran the 3C Ranch (and later the COD) with her daughter Wilma for more than 50 years after her husband's death in 1937. (Above, Joyce McRae; left, OHS 436.)

In 1975, journalist Dean Prichard purchased Buffalo Bill Cody's High Jinks Ranch and gold mine. He restored the rock house built by Cody's foster son Lewis H. "Johnny" Baker, and the house is now on the National Register of Historic Places. He enjoyed posing as Buffalo Bill; here Prichard (right) rides in the 1982 Tucson Rodeo parade (with Jack Assini as Johnny Baker) under the banner "The Oracle Historical Society—Buffalo Bill's Wild West Show." (OHS.)

Wilma Huggett, seen here with an unidentified man, competed in rodeo events while attending the University of Arizona. In 1956, she was awarded the All-Around Girl's USA Championship. Later in life she said, "I've probably lost more spurs, wore out more ropes, drunk more bad coffee and more good whisky than most men." (OHS 458.)

Besides sheep and cattle, goats were also raised in Aravaipa Canyon and at Dripping Springs. In 1920, the Abe White family moved from Silver City, New Mexico, to Aravaipa. During the trip, Abe drove a Ford Model T car, his 11-year-old son Lawrence herded 17 head of horses, and Abe's wife and aunt each drove a wagon. One mare gave birth to a colt on the way, so the colt rode in the Model T. Abe White (left) is pictured along with his son Lawrence. The family had owned angora goats in New Mexico, as shown below, and soon had a herd of 3,500 at Aravaipa, where they continued to raise goats until about 1950. These animals were sheared and dipped twice a year. A clip from a goat usually weighs about five pounds. (Both, Jep White.)

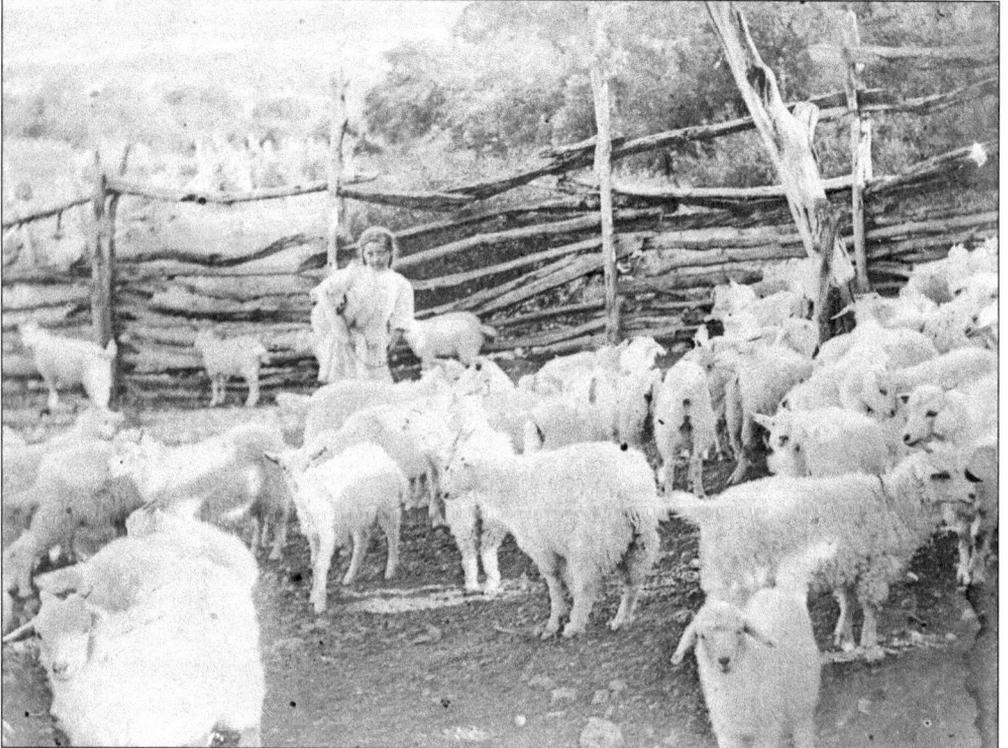

Five

DEL WEBB'S
SAN MANUEL

In 1953–1954, newspapers and magazines heralded the birth of a new town. Mitchell Jamieson wrote an article for *Fortune* magazine titled "A Copper Valley Comes to Life: San Manuel Revives an Arizona Ghost." Jamieson suggested that both Tiger and Mammoth could be considered ghost towns but with radically different futures. "Tiger's day is done, while Mammoth is reborn," he wrote. Because Tiger would be in the subsidence area of the mine, all Tiger homes had to be moved. Most were moved to Mammoth and a few to Oracle. Globe's *Arizona Record* ran the headline "Town of Tiger Doomed by Rise of San Manuel."

An article in *Business Week* emphasized the potential of the new town: "Setting Up a Town with a Built-in Boom." The reporter wrote, "Less than six months ago the town of San Manuel was just another clump of cactus in southeastern Arizona. Next week, proud city fathers will invite the neighbors in to preview what is probably the most carefully planned boomtown in modern mining history. And, unlike old-time boomtowns, it has a future that is practically guaranteed."

Men came from all parts of the world and all walks of life, attracted by the advertisements for good-paying jobs. John Sablich and Harvey Willeford were supervising mines in Peru. Taffy Tafoya came from a brickyard in Phoenix and then brought his two brothers. Some traveled from other Arizona mines, and others were local men just glad for a better-paying job.

Historians have suggested that an average mining town lasts 20 years. Some of the San Pedro River Valley mining towns have become ghost towns quicker, while others, like Mammoth, have reinvented themselves. San Manuel lasted 50 years as a mining town. Still producing, the mine only closed because Magma was bought out by an Austrian competitor bent on having a world monopoly of copper. With the mine closed and the smelter dismantled, San Manuel is in the process of reinventing itself.

Del Webb was a builder of silos and skyscrapers, resorts and office buildings. After World War II, he contracted to construct Pueblo Gardens in Tucson to provide housing for its influx of residents. In 1953, his company took on another challenge—designing a complete new town to be named San Manuel for the Magma Copper Company. This became Webb's first planned community. (Herb and Dorothy McLaughlin Collection, ASU Libraries.)

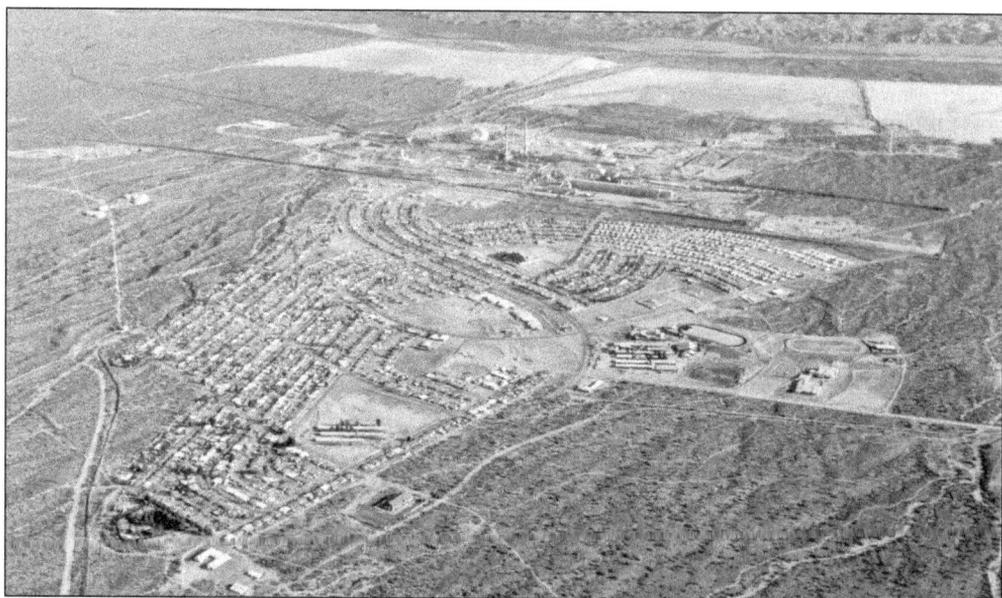

The San Manuel venture taught Webb much about building an entire town. In 1955, he sold his interest for 23,375 shares of Magma stock and then began constructing Sun City retirement communities. With curved streets, these communities looked much like this aerial view of San Manuel but without the smelter in the background. The main thoroughfare was named McNab Avenue after Alexander McNab, the former head of Magma. (SMHS/Magma/BHP, photograph by Ray Manley.)

In December 1953, *Business Week* published this photograph and reported that the "first 50 houses were built in six months." One year later, 1,000 homes were ready for occupancy even though construction crews had battled unusually heavy rains in 1954. All houses included a brown marble asphalt tile universally disliked by the female residents. (SMHS.)

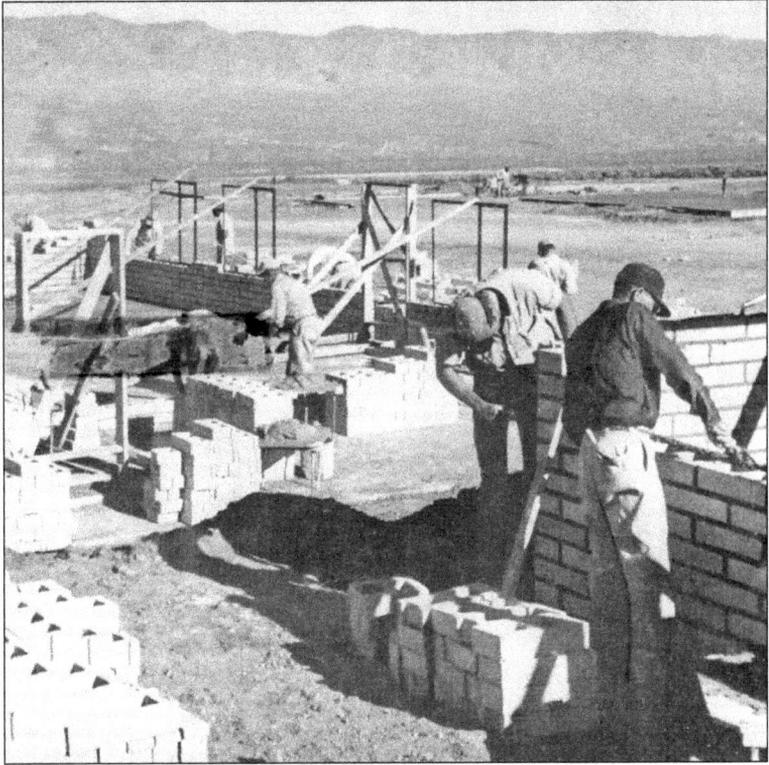

Although most houses in San Manuel look much the same, a 1953 advertisement listed "five floor plans and 39 different exterior styles." When copper miners first moved in, landscaping was minimal. In this photograph, however, trees and shrubs dot the landscape 10 years later. As Taffy Tafoya said, "I had a [three] bedroom home with [one bath] for $70 a month and [Magma] did all the maintenance. If anything happened, they fixed it!" (Juanita McLennan.)

To celebrate the 75th anniversary of his family coming to Arizona—and to advertise his newest market opening in San Manuel—Rulon Goodman organized a wagon train with a stagecoach and three freight wagons for a two-day trip from Tucson to San Manuel. Goodman's family entered the upper San Pedro Valley in 1879 behind a team of mules; after his grandfather's death in 1884, his grandmother opened St. David's first market. The 1954 wagon train included four generations of the family (Goodman's mother, wife, two daughters, and 10-month-old grandson) and offered interested community members a campfire and musical program at the halfway point, Oracle Junction. Both photographs were taken in Tucson as the entourage began. Below, Linda and Laura Stead sit by the unidentified driver; standing from left to right are Rulon, his daughter Kathleen, and his uncle Abe Busby; and Rulon's mother, Florence, and his daughter Myrna rest inside the stage. (Both, Joyce McRae.)

The Magma Copper Company not only provided the miners homes to rent, but also built a clinic and a hospital at San Manuel. Joseph Virgil served as the first doctor. Pictured right, Dr. Francis Findley proudly displays an award he received. He graduated from Harvard Medical School and then came to San Manuel. Below, an unidentified nurse checks a newborn baby. One project of the San Manuel Garden Club was landscaping around the hospital; Magma provided the plants, and the women in the community provided the expertise. (Right, Juanita McLennan; below, SMHS/Magma/BHP.)

Schaul's Variety Store published the above real-photo postcard of the San Manuel swimming pool with this caption: "Busiest spot in Arizona's copper city of San Manuel during summer months is the big community swimming pool. With the modern Community Building in background, it was presented to the town by San Manuel Copper Corporation and the Del E. Webb Construction Company of Phoenix, which built San Manuel's homes and initial business center." This 82-by-40-foot pool was eventually filled in and only the other, larger pool is used today. Wilma Huggett of Oracle worked as the first lifeguard. The children pictured left could be playing in either pool. (Left, SMHS/Magma/BHP.)

This photograph was taken during an opening event at the pool on June 17, 1954. Sigmund and Rosemary Schaul dressed in old-time bathing costumes, and their antics resulted in both being sopping wet (including the derby hat Sig is holding) before the day was over. (SMHS.)

Businesses were located in a Lower and an Upper Arcade (pictured); the Lower Arcade was built first. Daisy Willeford remembered, "All was well until the summer floods hit the town. The builders had not realized how much water could pour down and it had to run some place." The water ran down Avenue A, over a bank, and flooded the businesses. "The bank had money floating on the water," and the grocery store had cereal boxes in the mud. Deep dips were added to reroute the runoff. (SMHS/Magma/BHP.)

The San Manuel Women's Club was organized by 1956. Above, early officers pose for a group portrait. Pictured from left to right are the following: (first row) Mabel Sablich, Pauline Smith, and Helen Boone; (second row) Mary Hernandez, Mary Peterson, Katherine Deviney, Leonore Compton, and Juanita McLennan. Below, the women are assembled for a 1956 Christmas program. Shown from left to right are Annie Given, Leonore Compton, Clara Berry, Mrs. Merten Henry, Mrs. Harry Rose, and Mrs. George Beinhorn, with Eunice Nichols in the back. Offshoots of the club included the San Manuel Garden Club, organized to help residents understand what plants were best suited to the area, and the Tri-Community Democratic Women's Club, active through the 1960s. Many hours of community service were given by these women; Mabel Sablich helped with Red Cross blood drives for 60 years. (Above, Juanita McLennan; below, SMHS.)

The women of San Manuel used both crafts and bridge as social events. Seen above from left to right are Arlene Henderson, Orean Hussey, Mary Ferris, Juanita McLennan, Helen Coxon, and Ralphie Bunch. They have gathered to learn decoupage, possibly the most popular 1970s craft. Below, teacher Eunice Nichols (left) and Juanita McLennan play bridge. In January 2008, McLennan passed away. Her children found this clipping in her Bible, which her grandchildren modified slightly, believing it represented her philosophy: "Life should NOT be a journey to the grave with the intention of arriving safely in an attractive and well preserved body, but rather to skid in sideways, crafts in one hand, car keys in the other, body thoroughly used up, totally worn out, and screaming 'WOO HOO, what a ride!'" (Both, Juanita McLennan.)

The San Manuel Public Library has always been part of the Library Extension Service of the Arizona Library and Archives (true also for the Oracle and Mammoth libraries), meaning bookmobiles bring new and/or requested books to small, outlying communities on a regular schedule. These libraries are staffed by volunteers. In the left image, Juanita McLennan (left) and Katherine Diviney prepare to shelve new books in August 1957. Below, Rosemary Schaul (McCullum) reads to a group of children that same year. (Both, Juanita McLennan.)

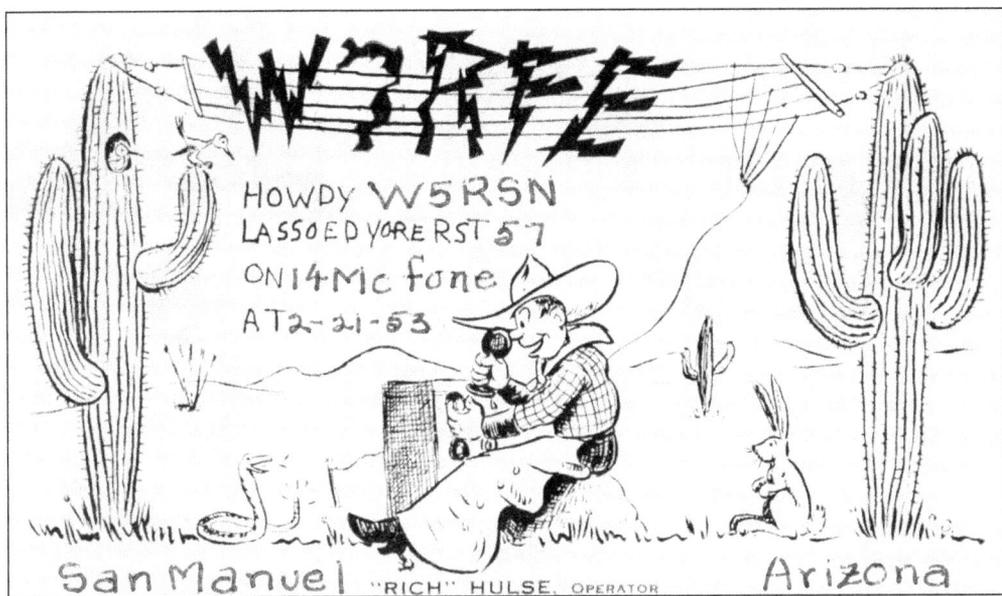

Richard Hulse came to San Manuel in 1953 as a supervisor for the Arizona Public Service. After leaving San Manuel, he helped develop the Cholla power plant near Holbrook. Hulse was also an amateur ham radio operator, beginning as a Boy Scout and continuing during World War II. His "conversations" with people around the world led to this postcard, sent to W5RSN in Halingen, Texas, on March 22, 1954.

Elsie Meitz grew up in Montreal but, after becoming a registered nurse, moved to San Manuel to work in the hospital. She served the community as a nurse for 20 years. When she retired, Meitz moved to Oracle and sent her friends this Christmas card in 1982. She has always had a tender heart for stray dogs and cats. (Juanita McLennan.)

In September 1961, Judy Pederson (left) and Linda McLennan (right) received $5 checks for their winning posters in the Anti-Litterbug Contest. Linda's poster read, "Don't be a Litter-bugger. Be a Picker-upper." Here Mrs. Jack Mitchell (back) is presenting the girls with their awards. (Linda Bingham.)

Along with the construction of the town of San Manuel, a high school was built. Children from Oracle and Mammoth no longer had to attend high school in Florence either as boarding students or day students with a 70-mile ride. High school kids could now go to class in San Manuel. This bus accident left children more scared than injured. (Juanita McLennan.)

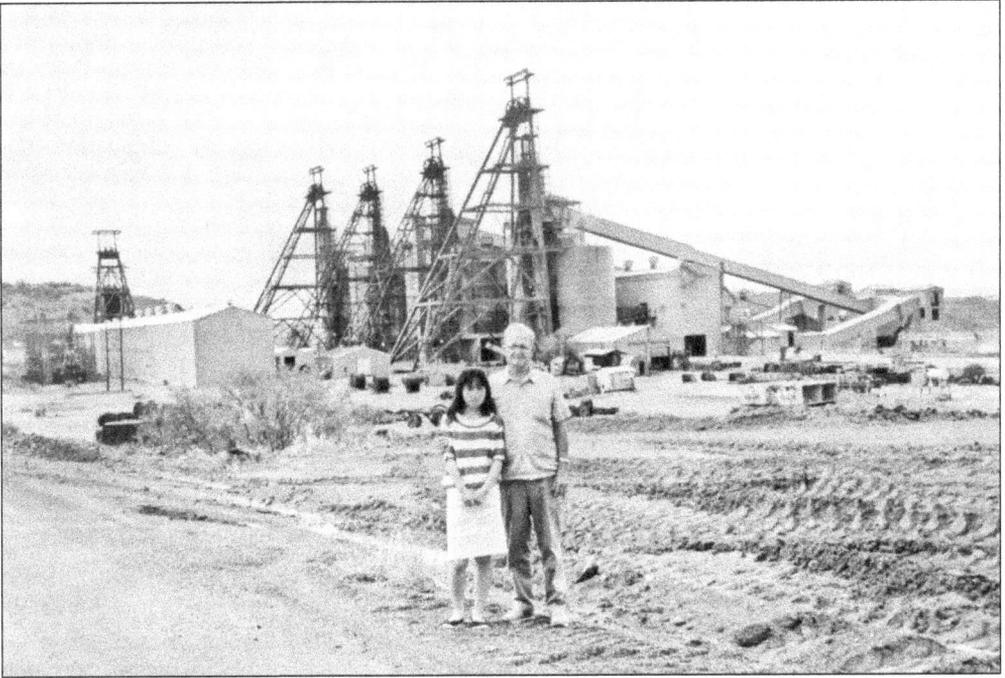

In 1985, C. N. "Ted" and Juanita McLennan hosted a Japanese foreign exchange student for the school year. San Manuel's ties to Japan had previously included Japanese visitors to the mine and smelter. An end product from the smelter was shipped to Japan for the final separation of the gold and silver. Above, McLennan stands with the student at the mine. Below, the exchange student poses in front of a mural at the high school. San Manuel High School has always been "Home to the Miners," as written on the saguaro marquee. (Both, Linda Bingham.)

Miners not only lived in San Manuel, but also in Mammoth, Oracle, and even Tucson. Standing in front of Frank Madrid's Mammoth home in 1957 are, from left to right, George, Frank, Pete, and Ignacio Madrid. Frank began working at St. Anthony in 1944 at the age of 16; he received $3.50 per day for an eight-hour shift. (Frank V. Madrid.)

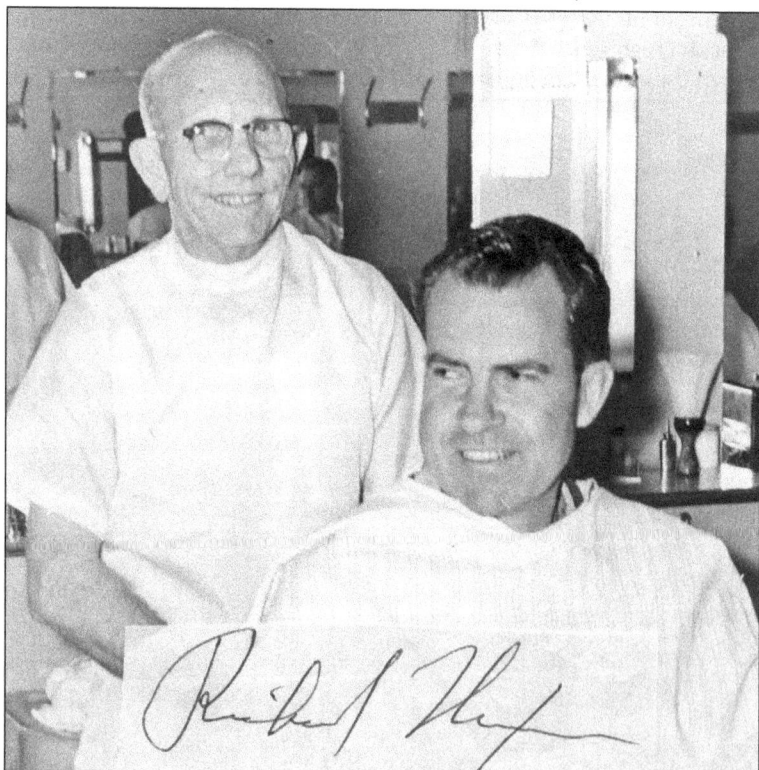

In February 1961, Vice Pres. Richard Nixon and his wife, Pat, came to the 3C Ranch in Oracle for a brief rest. They visited San Manuel for a haircut and riding clothes for Pat. Charley Buster, editor of the *San Manuel Miner*, took photographs while Nixon (right) was visiting with barber Charles "Doc" Tindall. Buster wrote, "First vacation in 14 years: Nixon, Pat visit area." (Juanita McLennan.)

Six

TODAY

Each winter, storms in the Galiuros and Santa Catalinas leave between six inches and one foot of snow in Oracle. The next morning, snowmen appear at the edge of the road, sometimes in town, but more often to the east at Holy Cross Canyon. These are the handiwork of children brought by parents from Tucson, Mammoth, or San Manuel, where snow seldom accumulates.

Mining and winter visitors have defined the communities of Oracle and Mammoth for more than a century. Today Oracle State Park invites all to come for a hike through the granite boulders and bear grass. The Oracle Fine Arts Weekend and art show openings at Rancho Linda Vista's Barn Gallery bring visitors from Tucson and Phoenix. The COD and 3C Ranches have been restored to accommodate retreats, weddings, and family reunions. Biosphere 2, a 3.15-acre greenhouse with a rainforest, an ocean with a coral reef, mangroves, a savannah, a farm, and a human habitat, was built west of Oracle from 1987 to 1991. Today the facility is used by the University of Arizona and is visited by interested tourists.

In 1999, BHP Billiton closed the San Manuel Mine, which had employed 2,200 people. With 356 miles of tunnels, it was the largest underground mine in the country. After the closing, most miners younger than retirement age moved to Utah or Nevada, Superior or Morenci. Low-cost housing available in San Manuel has attracted retirees, some of whom come just for the winter months and others year-round. A small airport and wide-open skies combine to make San Manuel an ideal home base for gyrocopter pilots, who often fly on the weekends.

But the real attractions of this area are the spectacular scenery and varied outdoor experiences. Youth groups come to explore Peppersauce Cave. After good winter rains, the wildflowers at Mammoth are spectacular. Aravaipa Canyon is world renowned for its wildlife and desert scenery, the upper reaches of which have been designated a wilderness area. The more adventurous visitors can hike to the Powers cabin, a slot canyon, or a hanging garden. "Sister" Bourne loved these mountains, writing, "They are at their best at certain early and late hours of the day and under special weather conditions with light and shadows give illusions of unearthliness." Drew Signor titled his book of essays and verses about the Galiuros *This Gloryland*.

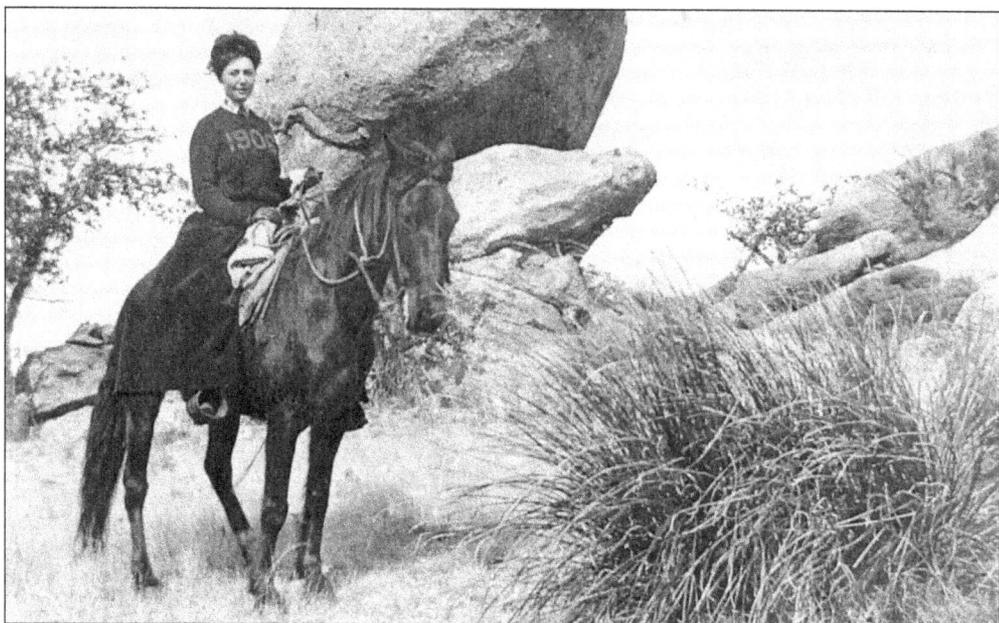

Oracle's granite boulders have been used as a place for picnics and scenic horseback rides. Here Helen Galey (later Gilliland) enjoys a ride amid the rocks and bear grass around 1906. Elizabeth Lambert Wood titled her second chapter in *Arizona Hoof Trails* "On Horseback—Good-By Sidesaddle," because, taking a shortcut, she found herself "with both feet hanging over a cliff and the saddle skirts on the other side brushing the wall of the hill." (AFH Gill-313.)

The turkey vultures that are seen soaring or sunning themselves around Oracle on a summer morning nest in the high granite dells. Here Keith Eagar restrains a baby vulture before it runs back into its nest cavern. Young vultures are large and would be easy prey. That they survive is probably due to their diet of rotting flesh. (Photograph by David Ellis.)

Today homes are built amid the rocky dells and live oaks. Unless great care is taken, these homes are vulnerable to forest fires, especially before the monsoons. The beautiful natural setting is preserved at Oracle State Park, the former Kannally Ranch. The area is used for hiking (above) and sometimes for practice climbing and rappelling (right). Pictured are Heather McRae (top), her father, Kent McRae, (midway), and at the base (from left to right) Nicholas Hogg, Mary Ann McRae, Keith Eagar, and Cody Richards. (Photographs by David Ellis.)

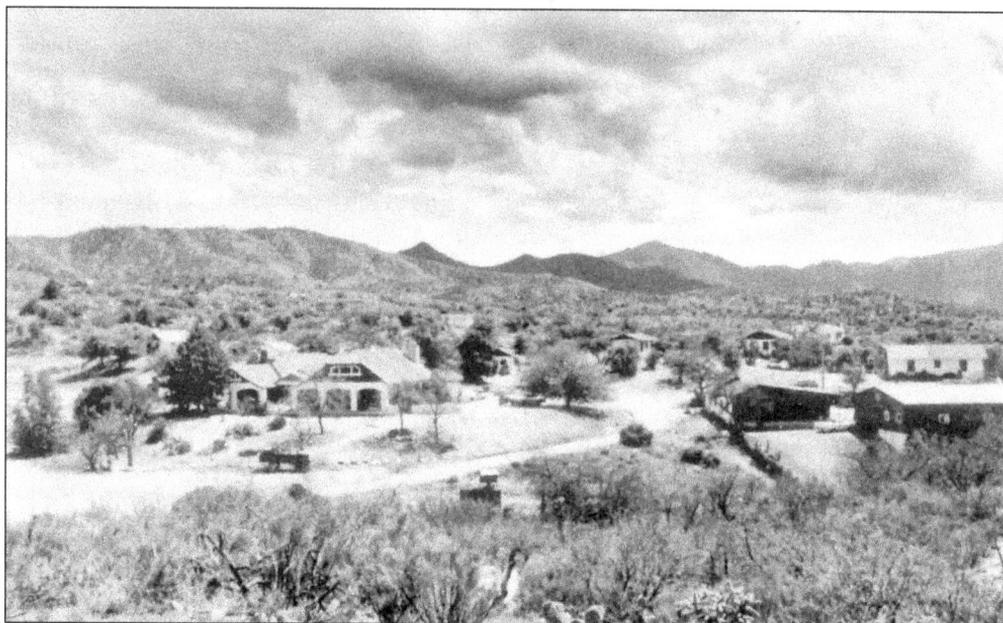

In May 1968, a group of artists, mostly associated with the University of Arizona, purchased Rancho Linda Vista (above) as a place to live, raise their children, and produce their art. The Rancho Linda Vista residents pose (below) in 1974. Many of the Linda Vista children have retained ties to the area. Turner Davis occasionally exhibits his paintings at the Linda Vista gallery. Stephen Malkin lived at Rancho Linda Vista in the 1970s and then returned to Oracle as a restorer of old buildings. He purchased the COD Ranch (previously owned by Elna and Wilma Huggett) and spent five years restoring its buildings. (Both, Charles Sternberg–Rancho Linda Vista.)

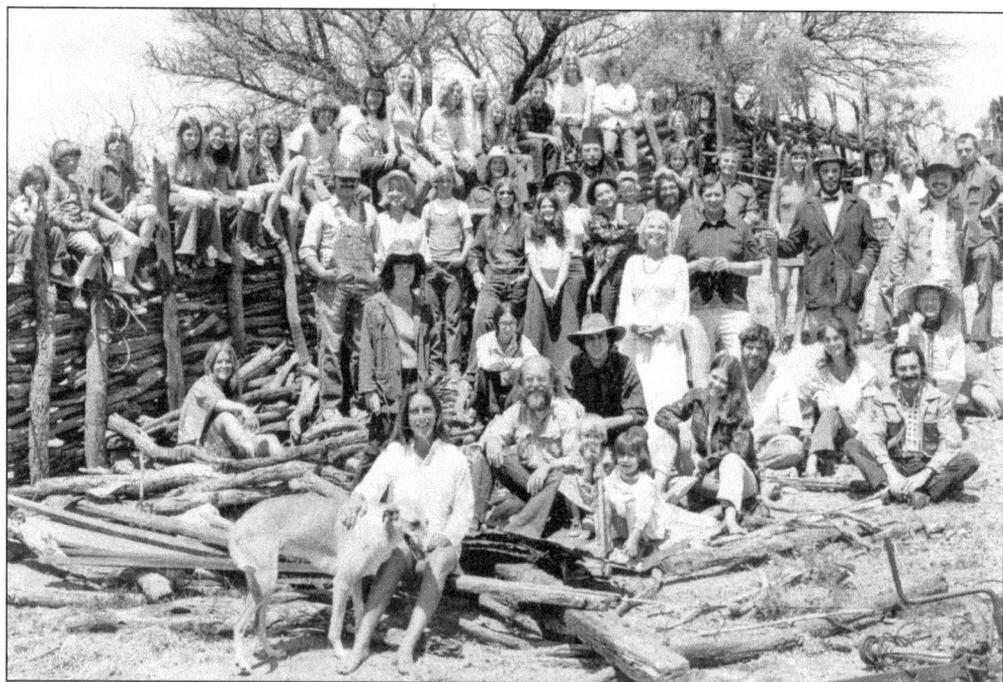

Alice Carpenter lived in a world that included ranchers and miners, soldiers from Camp Grant, Father Kino and the Sobaipuris, the Salados and Hohokams, mammoth hunters, and gatherers. An archeologist by avocation, she had an interest in different cultures and their artifacts, enlisting the help of friends and professionals in her investigations. Born in 1898, she first came to Oracle in 1924 and made it her permanent home by 1927. Carpenter is pictured on the right with her catch from a trip to the Gulf of California, a fishing expedition she took every year from 1943 to 1970, usually with Em Trowbridge. Below, librarian Pauly Skiba holds a bowl from Carpenter's collection, a portion of which is on display at the Oracle Library in the Alice Carpenter Room. (Right, OHS 299; below, photograph by the author.)

Edna Mae Haynes grew up on an Angora goat ranch at Dripping Springs, situated between Hayden and Globe; the goats were sheared twice a year and the hair sold as mohair. She graduated from high school in Hayden, married Harry Hendrickson, and moved to Oracle. She served as a judge from 1975 to 1990 and is pictured here about 1980. (Harry Hendrickson.)

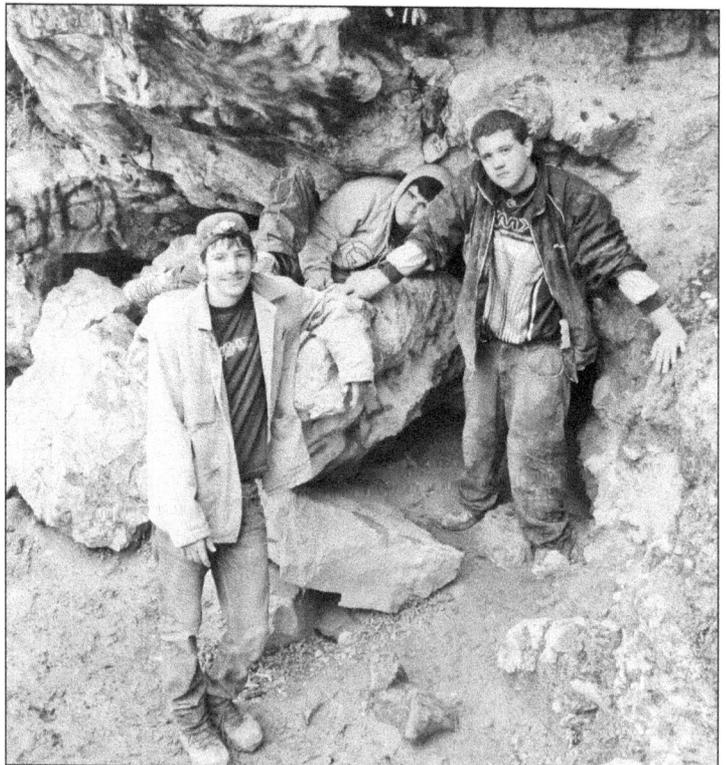

Youth groups from all over Arizona (these boys are from Coolidge) come to explore Peppersauce Cave. Everyone who has previously entered Peppersauce Cave knows to dress in old clothing; after mucking through the wet parts of the cave, and especially after wriggling through the rabbit hole, everyone comes out muddy. (Photograph by David Ellis.)

In 1985, Cyn-d Turner was an Oracle schoolteacher, pilot, and parachute jumper. During summer vacations, she hiked in Idaho, Wyoming, Utah, Colorado, and Montana. After an airplane crash, she could no longer carry a 40-pound pack and so began looking for a pack animal. She bought her first two llamas in 1986 and owned five by 1987. She currently works as a part-time ranger at Oracle State Park and offers hikes with llamas to the general public. The photograph above was taken at Rattlesnake Canyon in the Galiuros. Note the old mining equipment behind Turner—perhaps a two-stamp mill. (Photographs by Scott McMullen.)

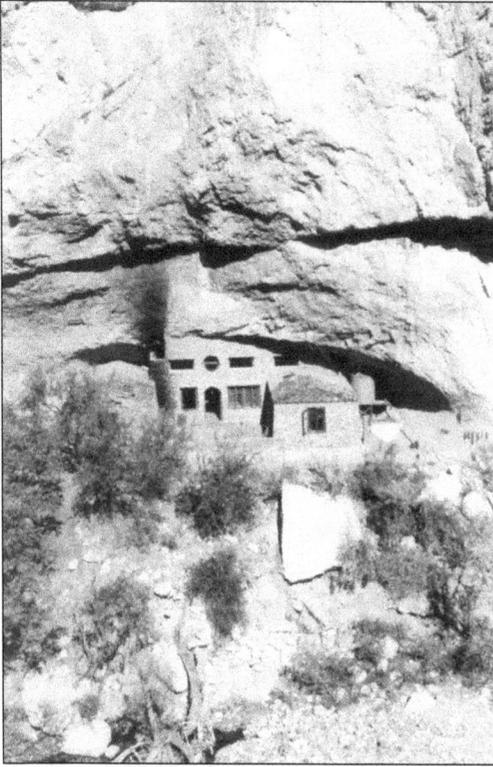

When hiking the canyons of the Santa Catalinas and Galiuros, people often encounter old mining equipment, abandoned mine shafts, and empty houses. This abandoned rock house was built in Redfield Canyon in 1934; its bathtub, commode, hardwood flooring, and windows were brought in by mules. (Photograph by Carl Matthews.)

The Powers cabin is also located in the Galiuro Mountains. In 1918, Tom and John Power were involved in a controversial "shoot-out at dawn" that left their father and three law enforcement officers dead. More than 1,000 soldiers and citizens searched the mountains of southeastern Arizona. The brothers escaped into Mexico only to surrender to the U.S. military for treatment of their eyes, lacerated by glass shards in the gun fight. The lower San Pedro Valley has had its share of such incidents. (Photograph by David Ellis.)

Early cowboys, including Ben Patten, sometimes roped javelina for fun, and these animals are regularly seen in the streets of Oracle today. The quintessential javelina story is told by Reg Ramsay. Ramsay often digs the graves at the Oracle Cemetery, usually the night before the service. One day, his team sent word to Father Jackson: please keep the coffin at the church while we figure out a way to get three javelinas out of the grave. (Photograph by David Ellis.)

White-winged doves eat both seeds and fruit, particularly saguaro fruit. The oak groves of Oracle are critical for nesting, but the birds then must fly long distances to utilize this food source. Dove hunting, for both mourning and white-winged doves, has always been popular. Hunters from around the state come and often leave with their limit. (Photograph by David Ellis.)

ORACLE HISTORICAL SOCIETY, Inc.
Box A, Oracle, Arizona 85623

Two centennial events for Oracle were remembered in 1980 with these special envelope cancellations. On the left, this stamp of a miner and his burro laden with mining tools was issued by the Oracle Historical Society. On the right, the house at American Flag Mine is remembered as the first post office for the miners. When the post office was moved to the Acadia Ranch, the one-word name of Oracle was chosen. (Both, Linda Bingham.)

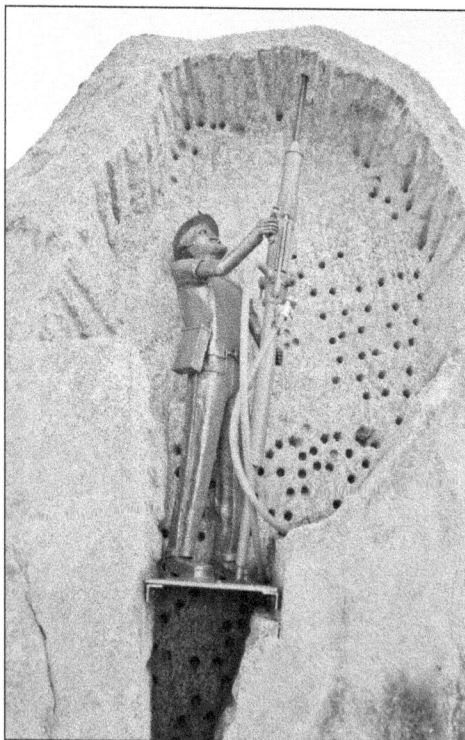

This monument was dedicated on Memorial Day in 2007 to honor the miners who died from 1939 to 1998. Taffy Tafoya said, "Each tragic death forced changes to be made and resulted in a safer, better mine for each of us." He also stated that, although each ounce of precious metal was carefully recorded, there was no tally of these deaths. Nevertheless, the lives lost were "etched in the hearts of widows and orphans [and] their fellow workers." *The Miner in the Rock* is the artwork of Jeff and Bruce Butler. (Photograph by David Ellis.)

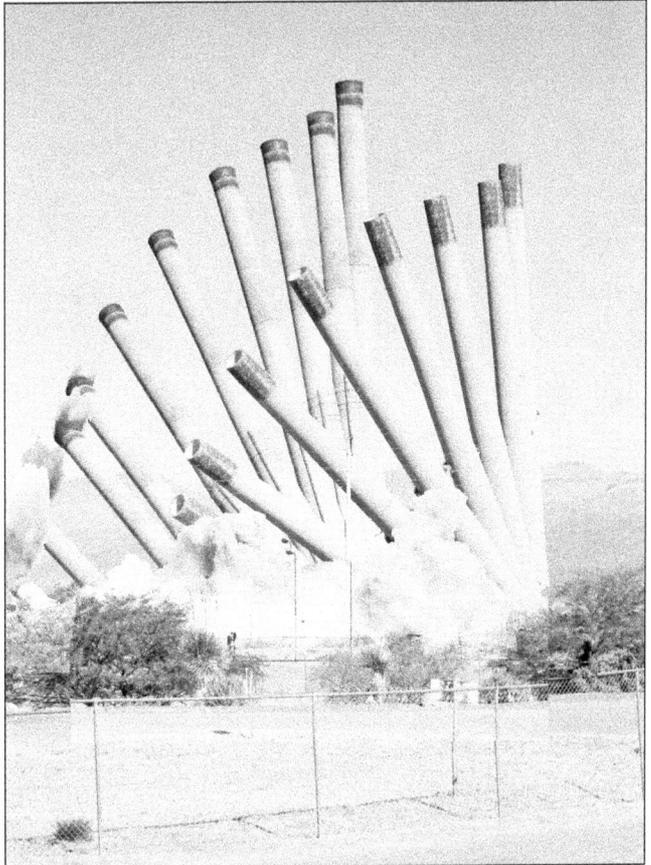

On January 18, 2007, the two smelter smokestacks that had defined the skyline of the lower San Pedro Valley for more than 50 years were reduced to rubble in a mere 20 seconds. Both amateur and professional photographers recorded the event. BHP Copper had already closed the mine and dismantled the smelter. Interested people from the surrounding communities gathered on rooftops and desert hills to watch; others left town because the demolition was too sad. (Above, photograph by the author; right, composite photograph by Jennifer Carnes.)

Visit us at
arcadiapublishing.com

www.ingramcontent.com/pod-product-compliance
Lightning Source LLC
Chambersburg PA
CBHW050711110426
42813CB00007B/2153